The New Acropolis Museum

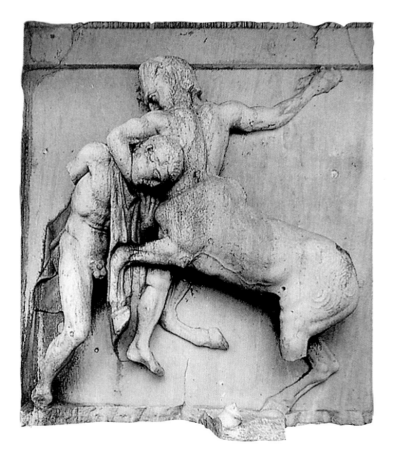

The New Acropolis Museum

Edited by Bernard Tschumi Architects

Edited by Bernard Tschumi Architects
Contributions by Dimitrios Pandermalis, Yannis Aesopos,
Bernard Tschumi, and Joel Rutten

Skira RIZZOLI
NEW YORK

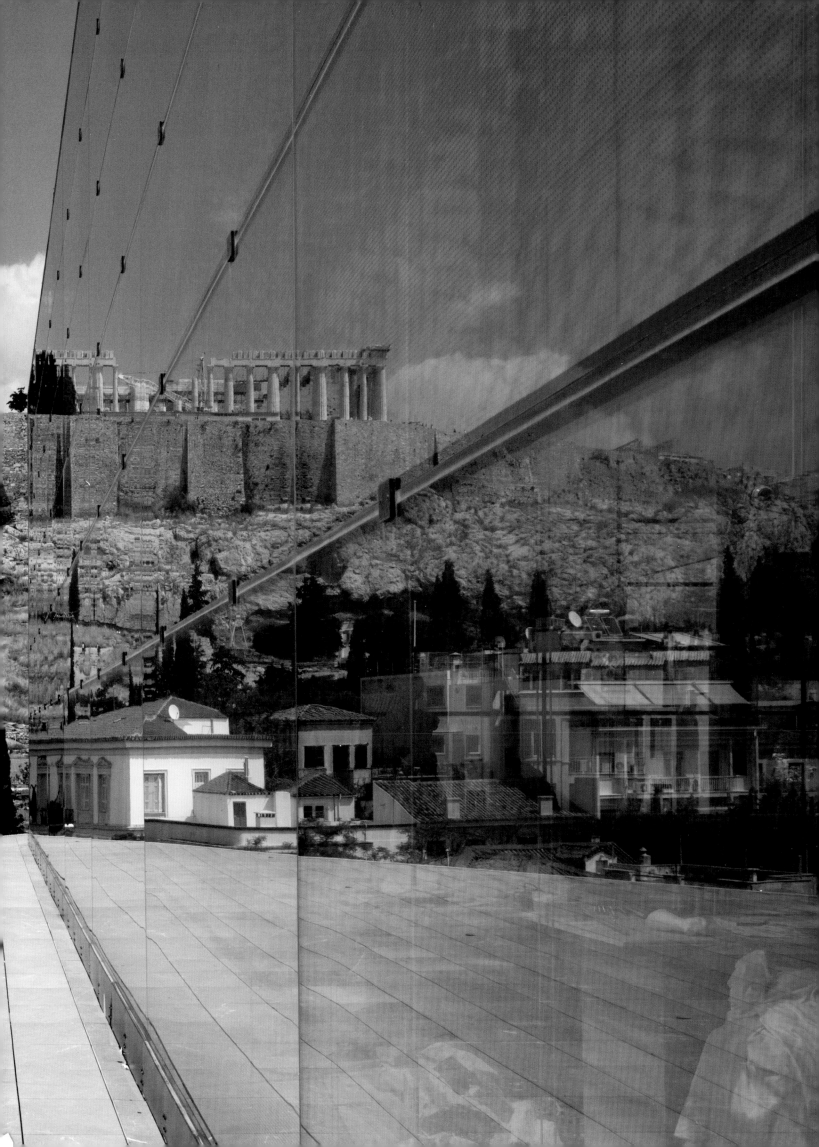

1: Detail of the Parthenon Frieze

2–3: View of the Acropolis from outside
the Parthenon Gallery

First published in the United States in 2009 by
Rizzoli International Publications, Inc.
300 Park Avenue South
New York, NY 10010
www.rizzoliusa.com

2009 2010 2011 2012 / 10 9 8 7 6 5 4 3 2 1

ISBN 13: 978-0-8478-3419-8

Library of Congress Control Number: 2009929382

Designed by Abigail Sturges

Printed in Italy

Contents

Acknowledgments

An architectural project always represents the confluence of many minds. In the case of the New Acropolis Museum, the people of Athens, through discussion, argumentation, and consequent consensus, are the true authors of the project. Their inspired dialogue, developed over nearly four decades and four architectural competitions, resulted in a building that reflects its mission, site, and unique heritage. It is a building that, quite literally, could not have been constructed anywhere else in the world.

Among the names listed in the project credits, several deserve particular mention. Foremost is that of Dimitrios Pandermalis, President of the Organization for the Construction of the New Acropolis Museum, who joined his dedication to archaeology and the Museum collection with unexpected talent for architectural thinking. Professor Pandermalis proved to be not only an adept leader for the client body, but also an inspiring interlocutor, and many key elements in the project evolved out of discussions with him. Niki Dollis provided masterful assistance in Athens and in the many world cities in which the Museum project and collection were presented. Leonidas Pakas of AKTOR S.A. brought exemplary initiative and expertise to the intricacies and overall difficulty of coordinating a construction site that spanned not only centuries, but also millennia.

I am grateful to associate architect Michael Photiadis of ARSY Ltd., whose initial overture in spring 2001 led to my participation in the definitive competition for the Museum. In Athens, George Kriparakos should be singled out for work in the early design phase at adapting the design team efforts to local site conditions. The engineering consultants Michael Aronis of ADK in Athens and Leo Argiris of Arup in New York addressed the many challenges of building a complex and innovative structure in an archeological site amid earthquake conditions with unsurpassed effort and skill. Working under the aegis of AKTOR S.A., the architect Kostis Skroubelos was an invaluable asset during construction.

Among consultants, few have made larger contributions than our frequent collaborator, Hugh Dutton of Hugh Dutton Associates in Paris. The glass envelope of the Parthenon Gallery, which reconciles a unique climate with the light and viewing conditions of the original Acropolis site, is indebted to his expert work. In the New York office of Bernard Tschumi Architects, project architect Joel Rutten demonstrated both design talent and command over the minutiae of construction; his site chronology testifies to the dedication and intelligence with which he approached this and other projects. Kim Starr brought her customary diligence and precision to the early design phases. Kriti Siderakis offered insight into

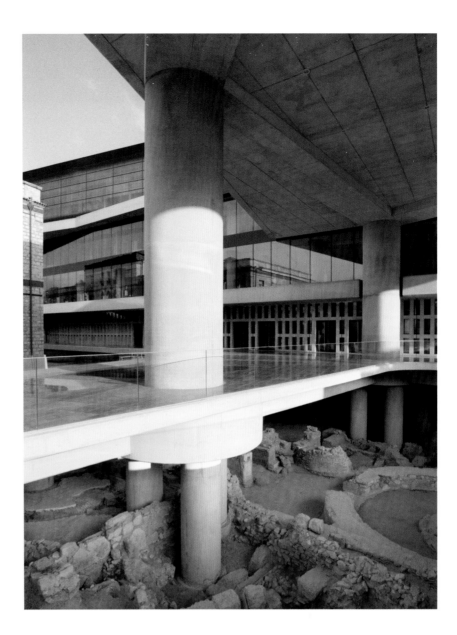

The entrance to the Museum, a ramp over an archaeological excavation

aspects of Greek culture and construction. Additionally, Bernard Tschumi Architects has been fortunate to have several talented Greek architects on its staff. We are particularly grateful to Eva Sopeoglou and Aristotelis Dimitrakopoulos for their work on the New Acropolis Museum.

This book was an independent project, "constructed" during the final stage of Museum preparation. I wish to thank the editor, Isabel Venero, and designer, Abigail Sturges, for their expertise, calm, and resourcefulness under the abundant constraints of time and circumstance. I am indebted to the architect Yannis Aesopos for his essay, which demonstrates both his intellectual accomplishment and his dedication to past and present Greece. Special appreciation is due to the photographers Christian Richters, Peter Maus, and Nikos Daniilidis; to my assistant, Lexi Tsien-Shiang, for many aspects of coordination; and to Kate Linker for editing. Finally, I would like to thank Colin Spoelman for his multifaceted skills, often-surprising insights, and unflagging good humor in work on this and other publications.

Bernard Tschumi
New York, May 2009

Preface

Testing alternatives for exhibition strategies in the Archaic Gallery with temporary installations

The power of the symbolism associated with the Acropolis prevented architects, archaeologists, and the public at large from agreeing on the location, form, and mission of a new museum. After over thirty years of gestation, the public accepted the decision to build on the Makriyianni site with a minimalist, contemporary design and a fresh view of the celebrated finds of the Acropolis.

For the first time, visitors now have a complete sense of the magnitude, narrative, and themes presented in the architectural sculptures of the Parthenon, due to the daring combination of the original sculptures located in Athens with copies of the sections in the British Museum in London.

The layered floor plan of the Museum allows the public to have a full appreciation not only of the classical Acropolis, but also of the Archaic Period, and to follow the development of ancient Athens from an aristocratic state to a tyrannical regime and, finally, to the first democratic system of government in the world.

This major public project developed without the traditional conflict between architect and client. Accordingly, there was no winner and no loser, but instead a particularly effective cooperation that resulted in an excellent architectural environment for the most emblematic works of classical Athens. A similarly positive and productive relationship with the contractor led to the successful realization of this sensitive cultural project.

Dimitrios Pandermalis
President,
Organization for the Construction
of the New Acropolis Museum

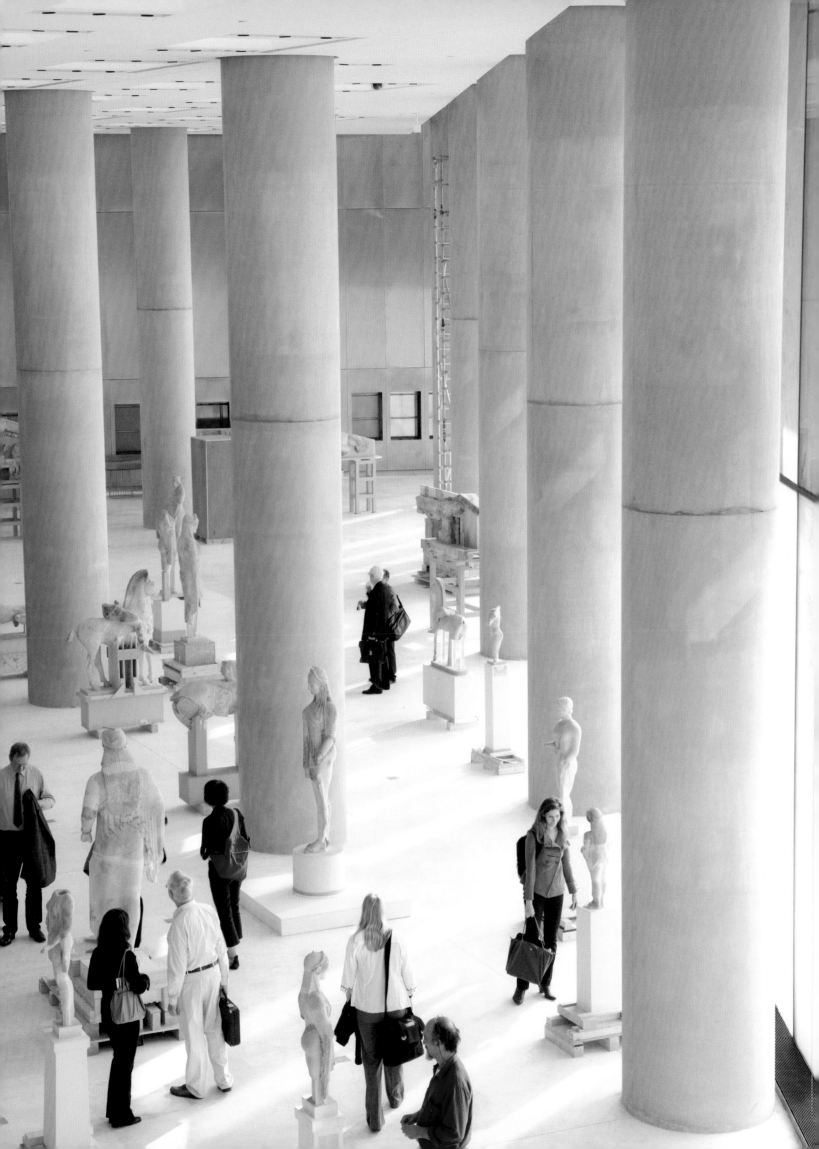

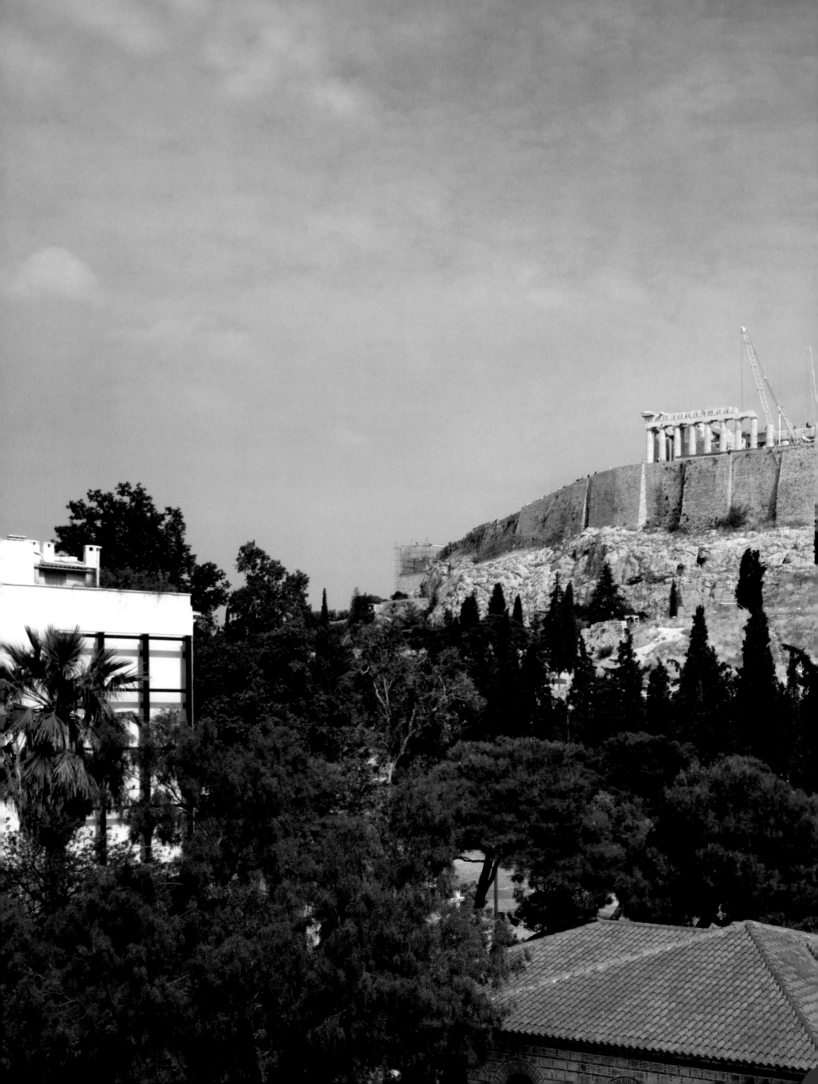

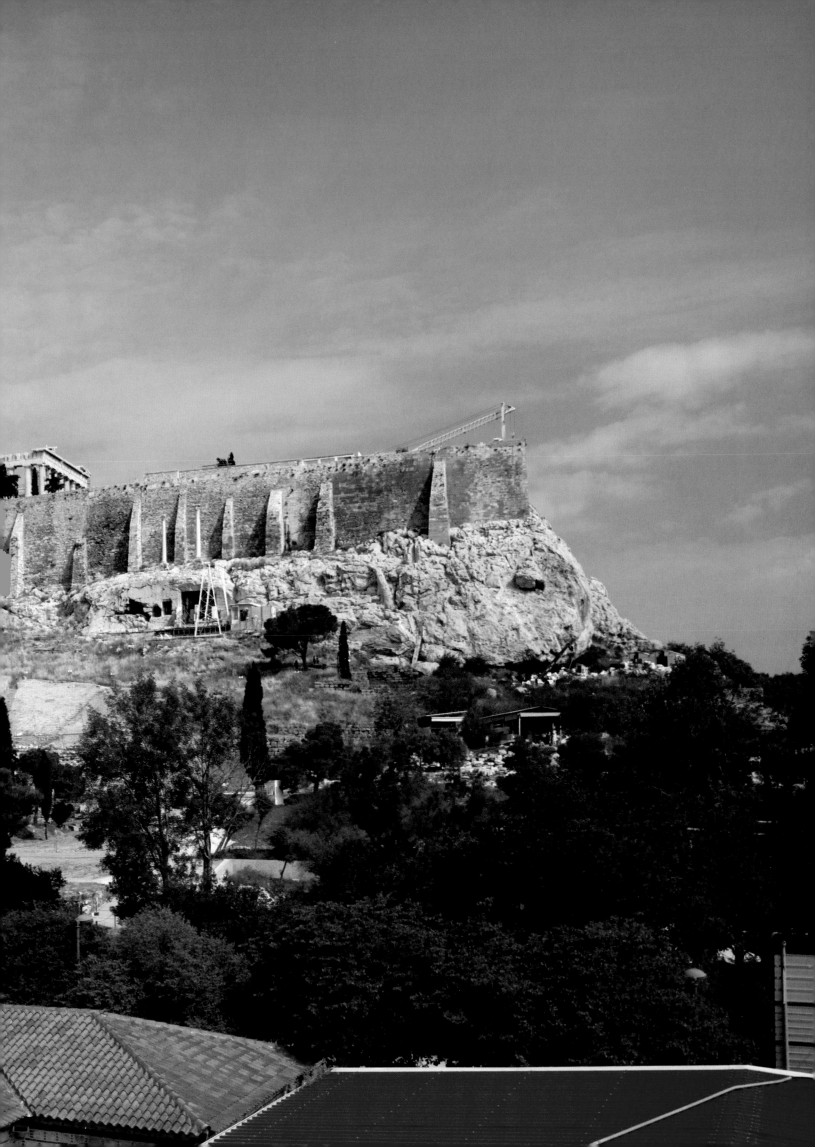

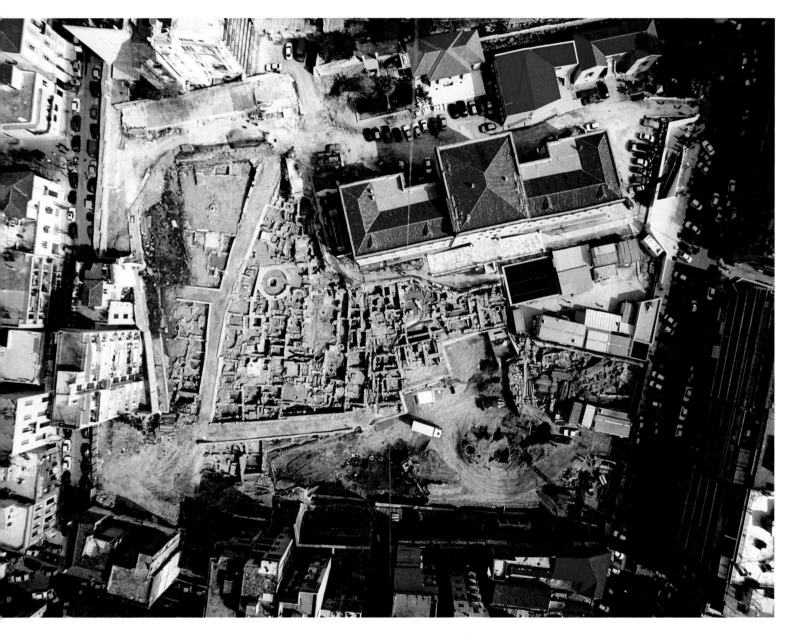

Aerial view of the Makriyianni site
showing the ruins of the ancient city that
are preserved under the new Museum

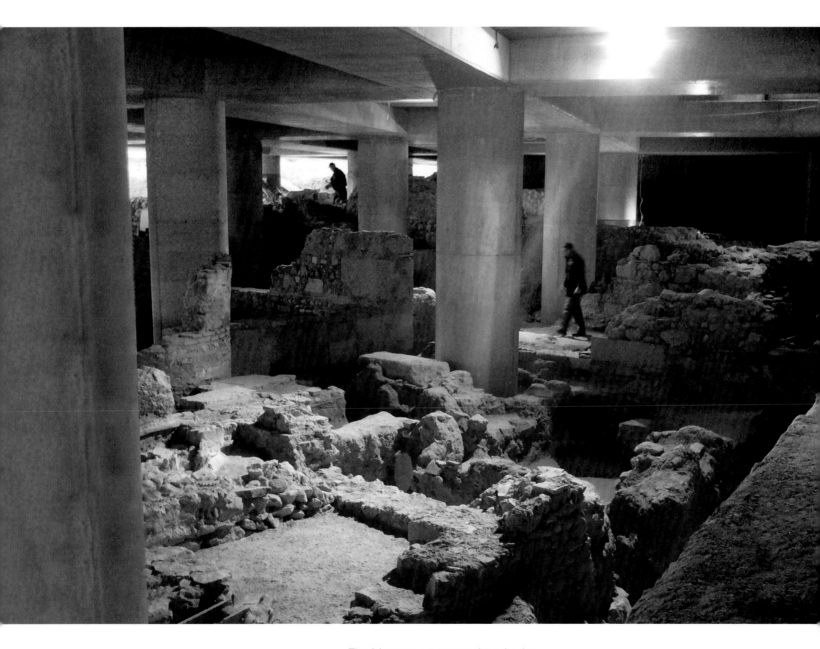

The Museum preserves the ruins by a group of columns, placed carefully with the assistance of archaeologists.

14–15: Aerial view showing the relationship of the Museum to the city, the Acropolis complex, and the Parthenon

16–17: The Museum entrance at dusk

18–19: The Caryatids overlooking the Gallery of the Slopes

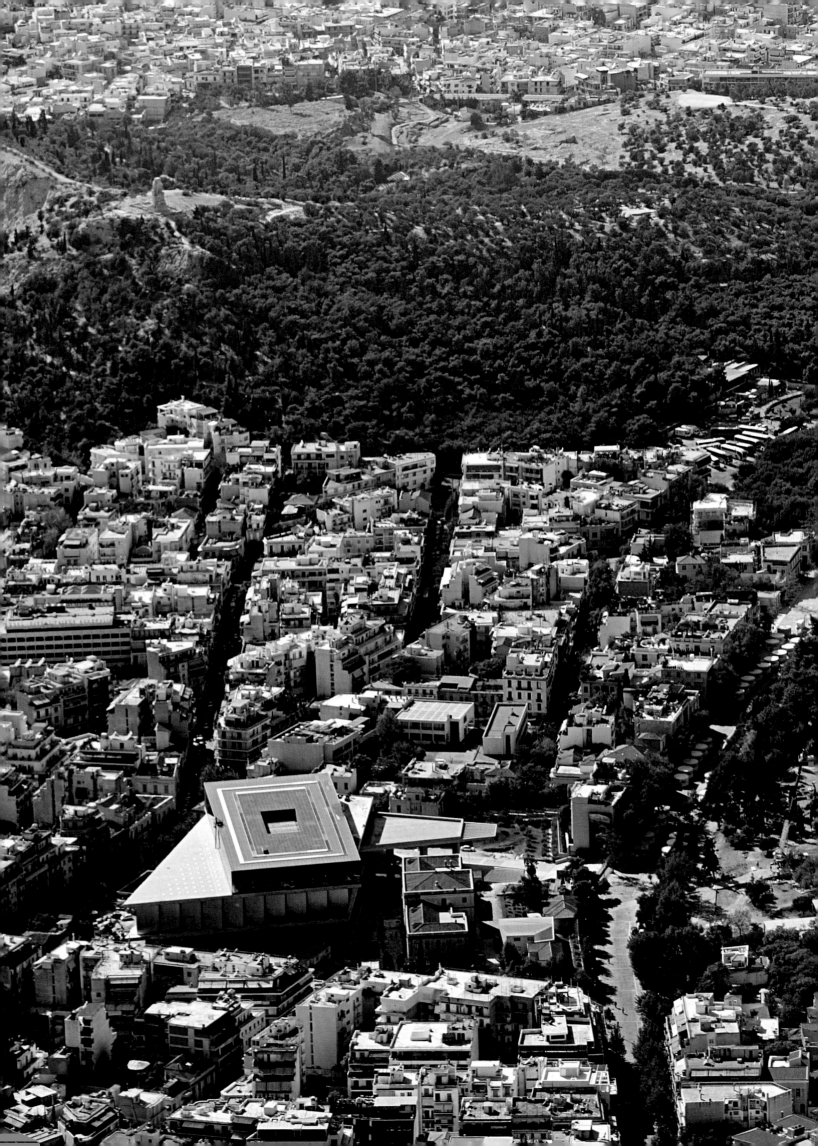

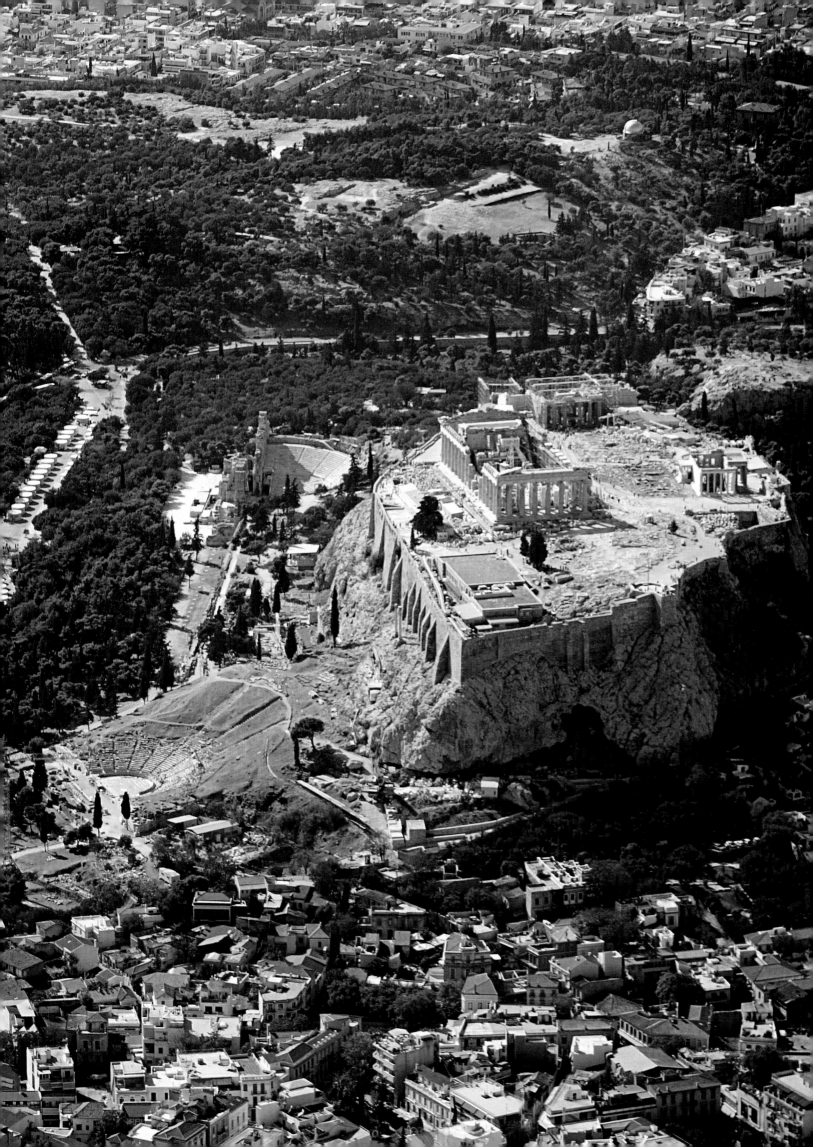

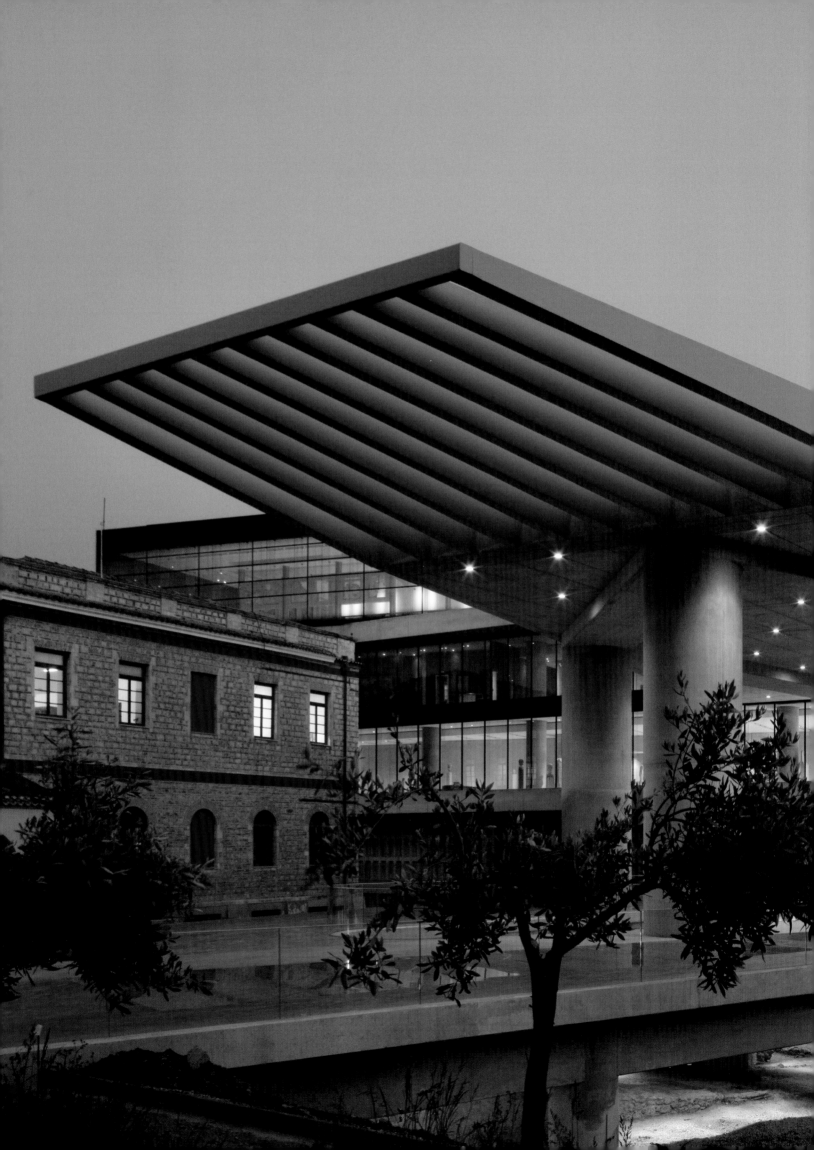

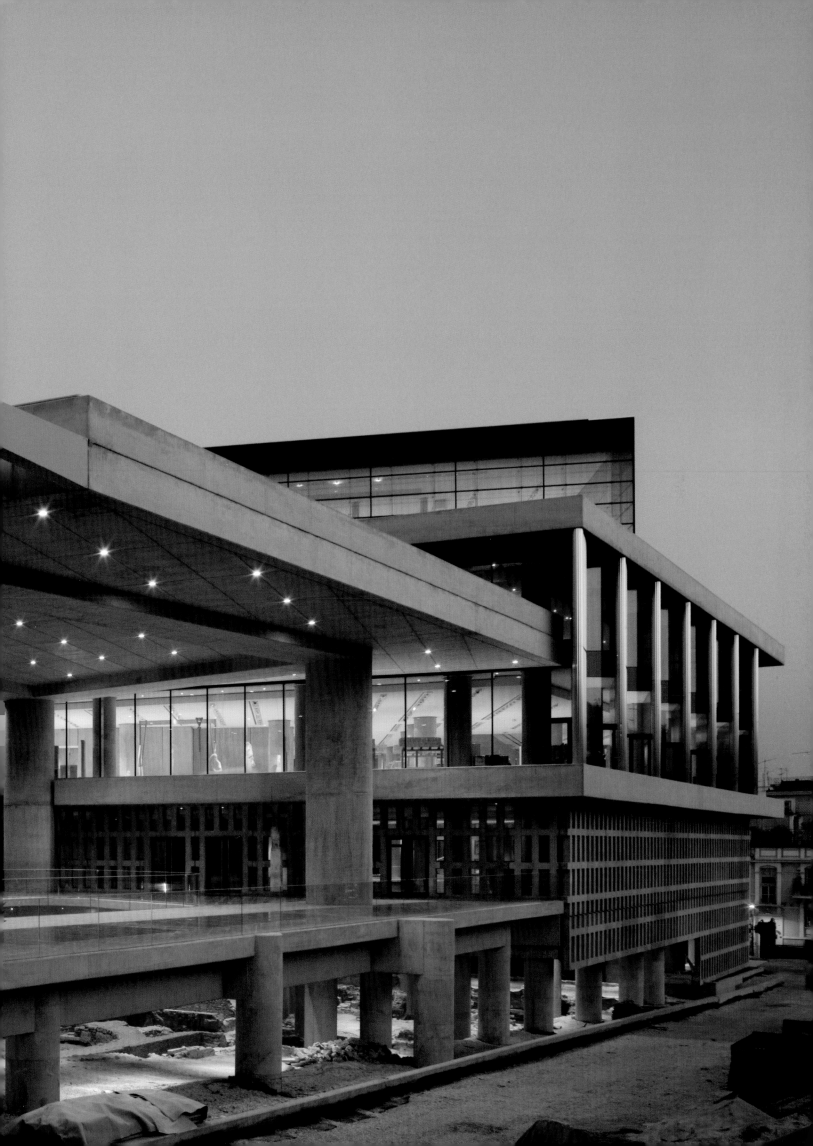

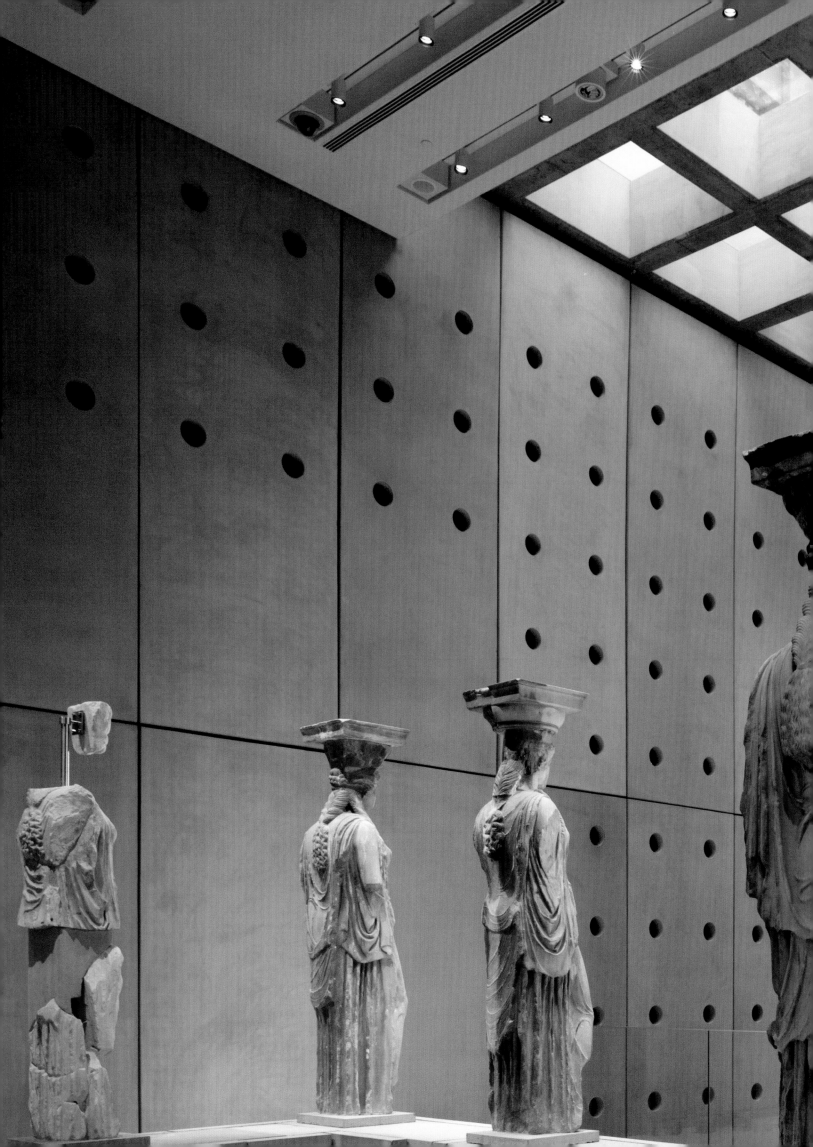

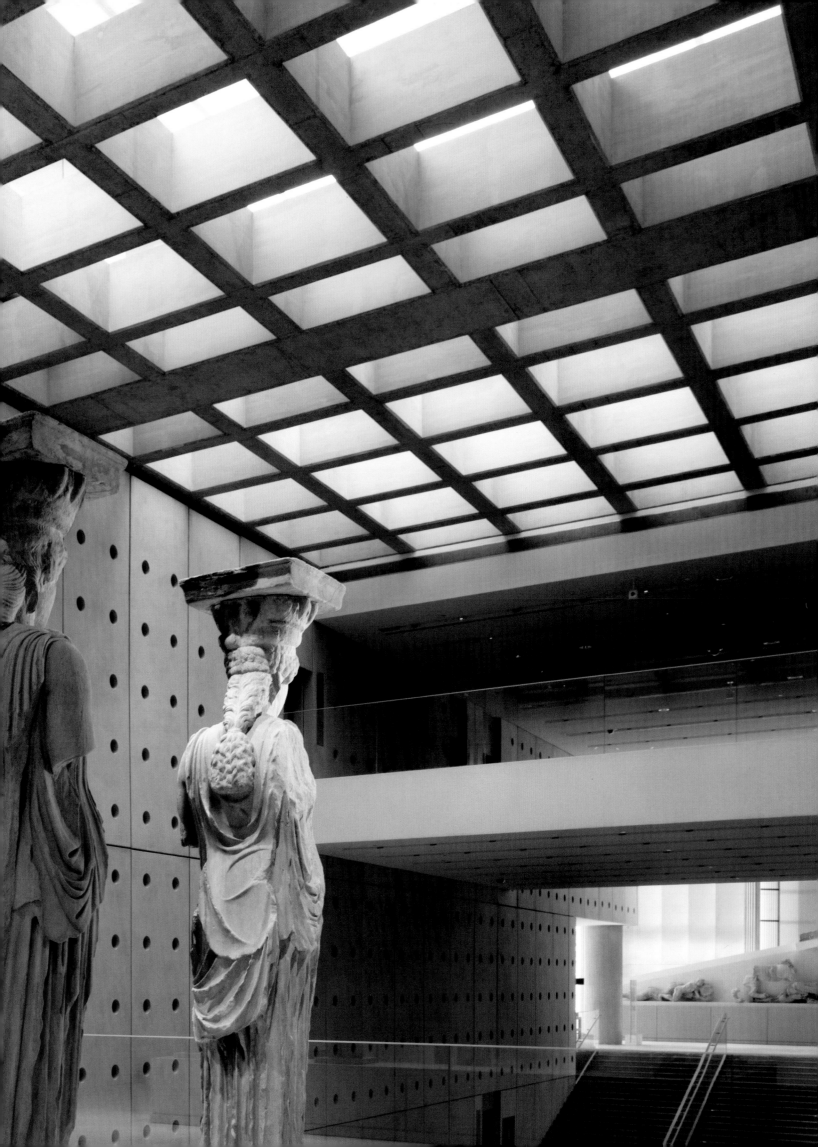

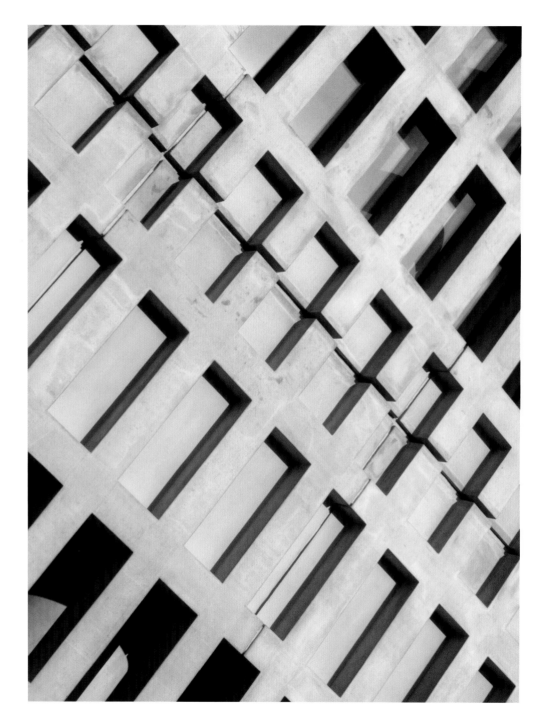

Details of the precast panels
on the lower levels

Opposite: Detail of the
cantilevered Parthenon Gallery
on the south facade

22–23: View of the Parthenon
with glazing detail

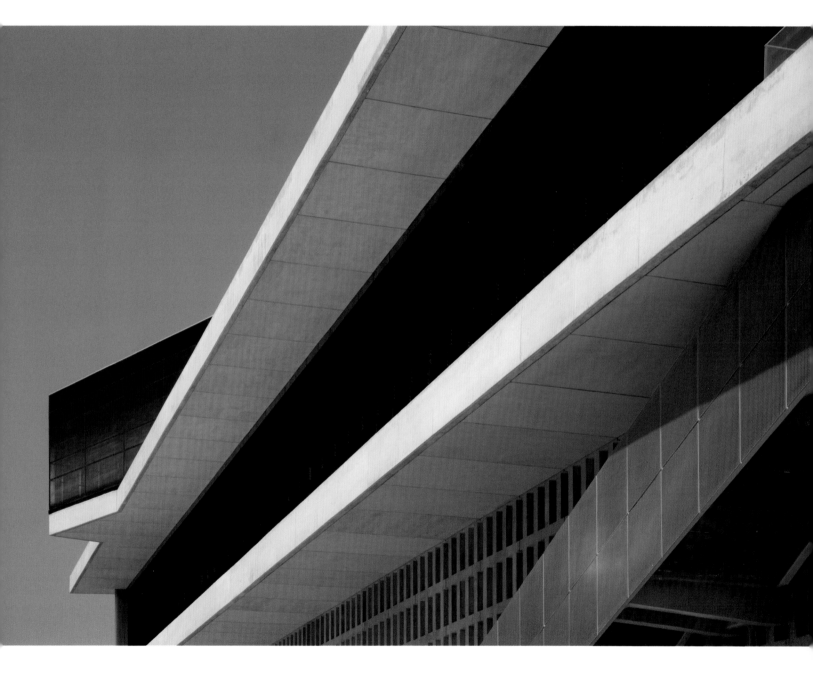

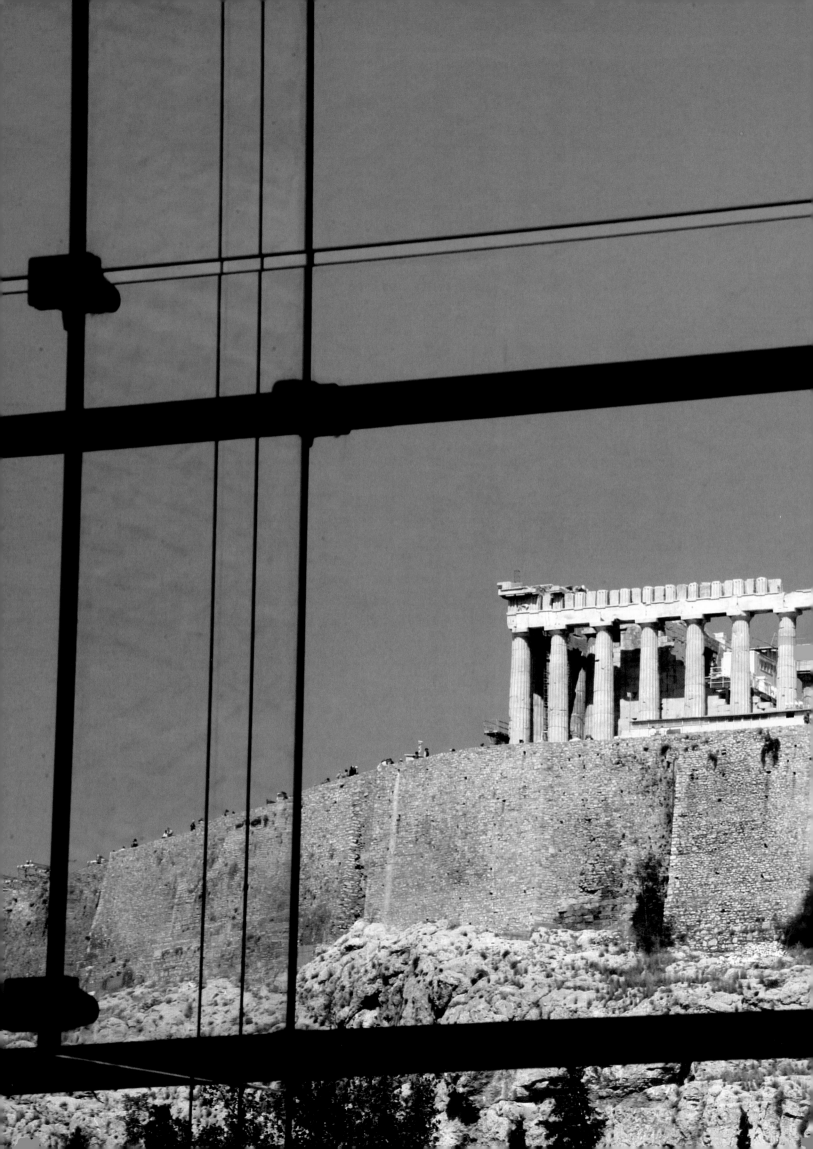

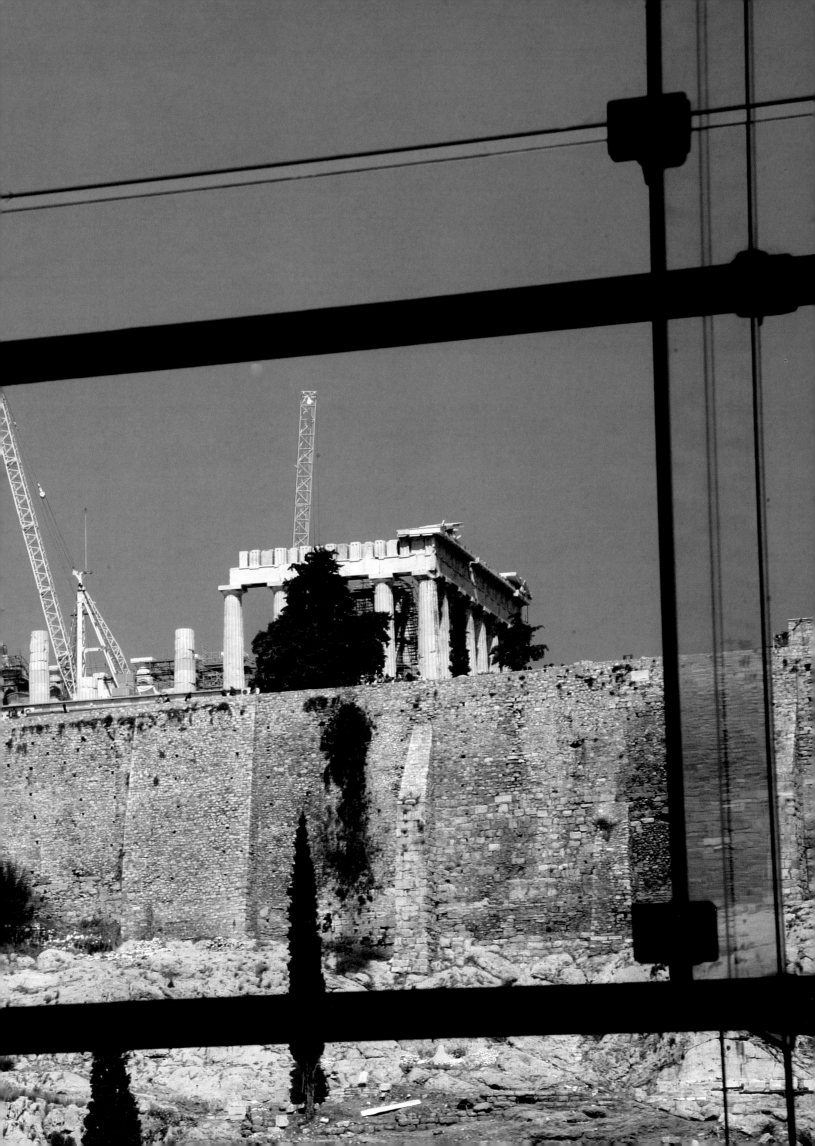

The Museum and Its Content

Dimitrios Pandermalis

The Calf-Bearer

The foundations of the first Acropolis Museum, designed by Panages Kalkos, were laid in 1865 after thirty years of debate about its location on the Sacred Rock. After 1885, the year of the stunning discovery on the Acropolis of large pits containing sculptures that were desecrated by the Persians in 480 B.C., a decision was made to construct a second museum, the so-called Small Acropolis Museum.

The Museum took on its current shape only after World War II, officially opening in 1965 with an admirable exhibition designed by Yiannis Miliadis. However, the establishment of the Committee for the Restoration of the Acropolis Monuments in 1975 and the decision to remove the remaining Parthenon sculptures from the Acropolis created additional demands for museum exhibition space.

The first architectural competition for the construction of a new museum of the Acropolis was held in 1976 on the Makriyianni site, a location selected by then–Prime Minister Constantinos Karamanlis. Yet that competition and a subsequent competition held in 1979 were inconclusive.

In 1982 Melina Mercouri, a former Minister of Culture and renowned actress, announced Greece's intention to request the return of the Parthenon Marbles, which had been removed from the Acropolis by Lord Elgin at the beginning of the nineteenth century. The issue of the construction of a new museum for the Acropolis was raised once again.

In spring 1989 the Ministry of Culture tendered a third competition with the submission of 438 architectural proposals. The Evaluation Committee selected a proposal by the Italian architects Nicoletti and Passarelli that could not be implemented due to the discovery of significant ancient ruins on the Makriyianni site.

Finally, in 1994 the State established a specific organization for the construction of the New Acropolis Museum, appointing the diplomat Sotiris Mousouris as President. Dimitrios Pandermalis, Professor of Classical Archaeology, succeeded him in 2000, the year in which the process for the fourth international architectural competition began. This competition led to the selection of the definitive proposal by Bernard Tschumi Architects in association with Michael Photiadis and to the construction of the New Acropolis Museum.

At the time of this writing, the Board of Directors of the Organization for the Construction of the New Acropolis Museum consists of the following members:

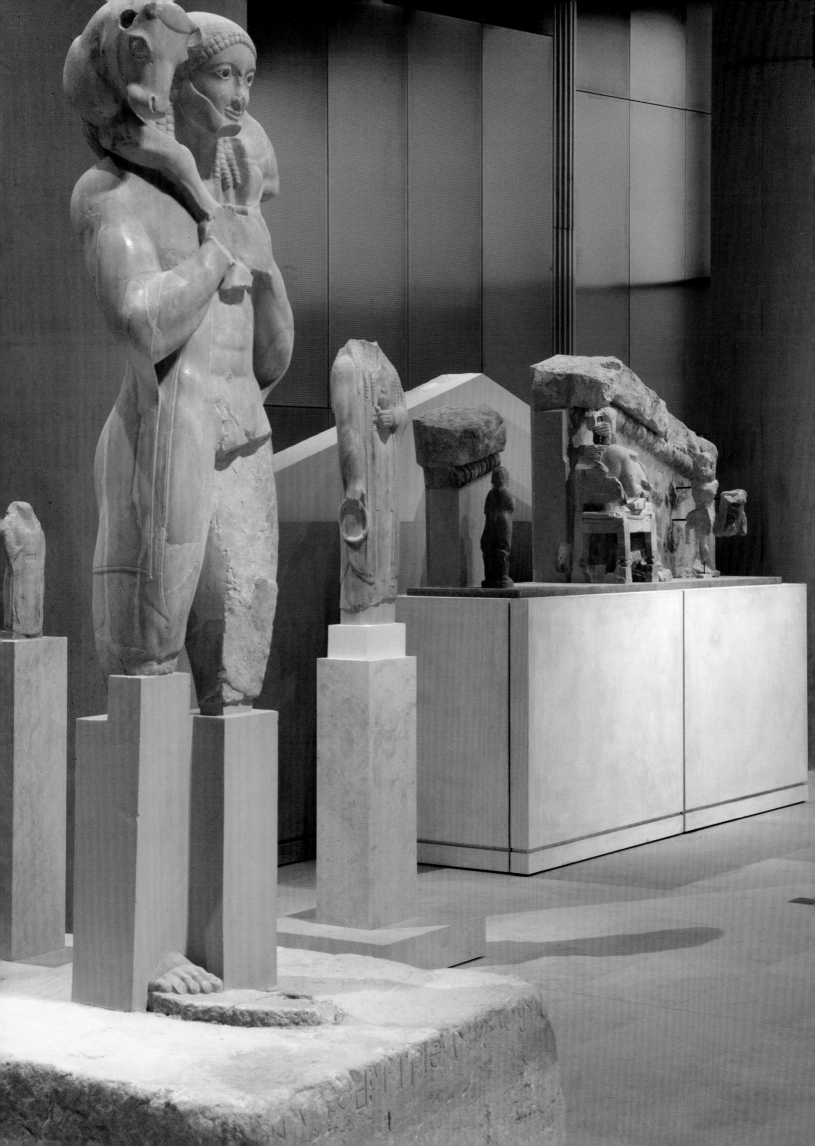

Dimitrios Pandermalis (President), Professor of Archaeology; George Agapitos (Vice-President), Professor of Economics and Former Minister of Finance; Nikolaos Damalitis, Director, Technical Project Team and Civil Engineer; Konstantinos Alavanos, Lawyer and Former General Secretary of the Ministry of Culture; Panayiotis Carydis, Civil Engineer and Emeritus Professor of the National Technical University of Athens; Angelos Delivorrias, Professor of Archaeology and Director of the Benaki Museum; Julia Iliopoulos-Strangas, Professor of Law; Ioannis Loulourgas, architect representing the Ministry of Public Works; and Manuella Pavlidou, General Secretary of the Melina Mercouri Foundation.

The Architectural Competition of the Year 2000

The New Acropolis Museum was designed during a period of heightened interest in museum architecture. Many daring concepts and designs have been introduced, reflecting new attitudes toward the role of the museum in contemporary society.

Today, more than ever, museums are focused on their visitors, exciting public interest in buildings and daring to implement architectural solutions that go far beyond stereotypical museums of the past. Modern materials and advanced technology result in innovative and sometimes radical exhibition designs.

By 2000 the design requirements for the New Acropolis Museum, as set by the Organization for the Construction of the New Acropolis Museum, were both precise and inflexible, following ministerial decisions that were also based on advice by the Central Archaeological Council about archaeological remains on the Makriyianni site. The recommendations of a Ministerial Working Group that had developed the Museum's exhibition program for the architectural sculptures of the Parthenon were also taken into account.

The competing architectural teams submitted designs and models responding to explicit specifications. Among the directives were innovative proposals for incorporating the on-site archaeological excavation into the Museum so that the archaeological remains would become an integral Museum installation; the use of natural light to create the sense of an outdoor environment keyed to the original outdoor siting of the majority of the Museum's exhibits; a balanced relationship between the Museum architecture and the urban environment in which it is located; and the ability of visitors to view the Parthenon on the Acropolis and the architectural sculptures in the Museum at the same time.

The Evaluation Committee for selecting the complete architectural, structural, and electromechanical design of the New Acropolis Museum consisted of the following members:

Professor Dimitrios Pandermalis, Professor of Archaeology at the University of Thessaloniki and President of the Organization for the Construction of the New Acropolis Museum; Santiago Calatrava, architect based in Zurich; Dr. Alkestis Choremi, First Archaeological Ephorate; Nikolaos Findikakis, architect, representing the Technical Chamber of Greece; Professor Dr.-Ing. Karl Gertis, engineer and Professor at the University of Stuttgart and Director of the Fraunhofer Institute for Building Physics; Panayiotis Georgakopoulos, President of the Union of Greek Architects; Professor Wolf-Dieter Heilmeyer, Professor of Archaeology at the University of Berlin and Director of Antiquities at the Museum of Berlin; Nondas Katsalidis, architect based in Australia; Professor Anastasios Kotsiopoulos, Professor of Architecture at the University of Thessaloniki; Professor Paolo Marconi, Professor of Architecture at the University of Rome; Pro-

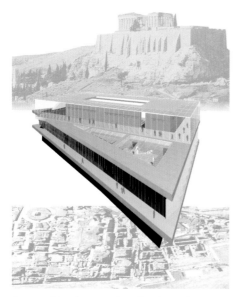

Competition image showing how the building mediates between the Acropolis above and the remains of the ancient city below

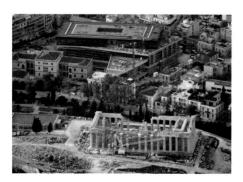

The Parthenon is currently undergoing a comprehensive renovation to ensure that the temple is preserved. Placing the finds from in and around the Acropolis into a new state-of-the-art museum also guarantees that they will be protected and preserved.

Opposite: Aerial view of the Museum under construction showing the street grid of Athens

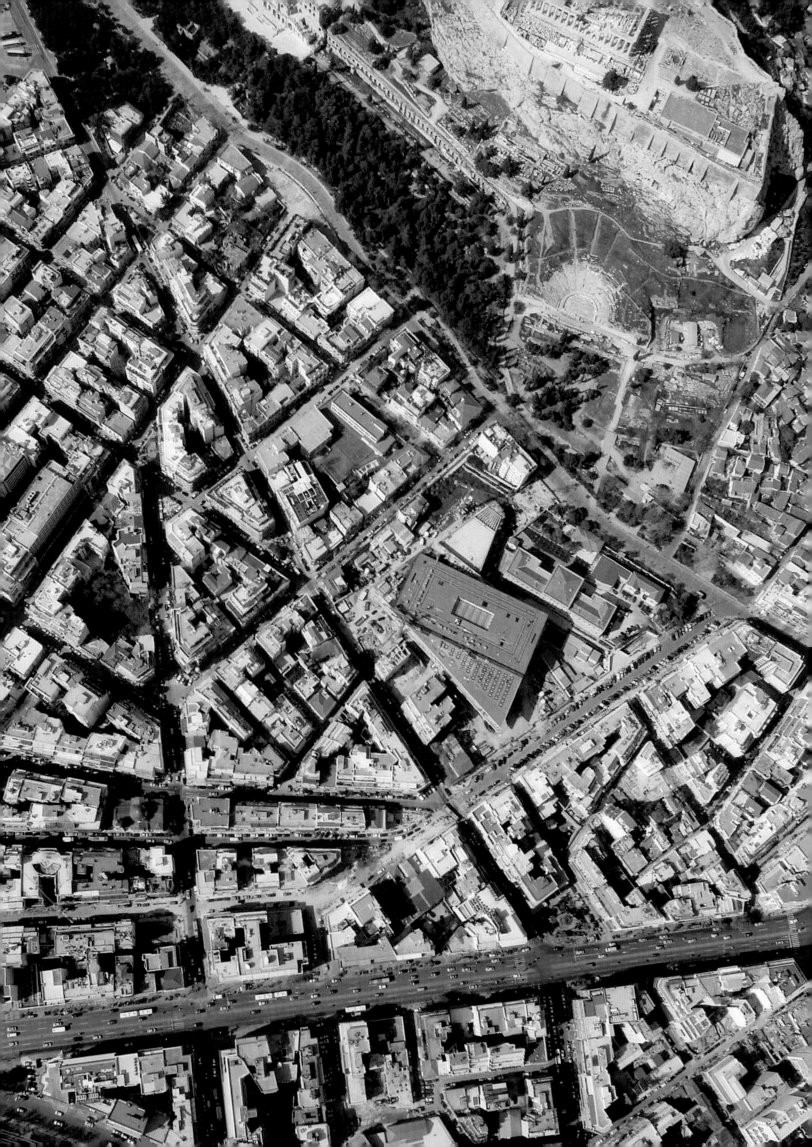

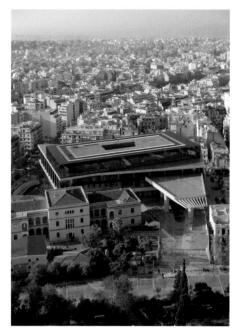

The New Acropolis Museum and the Weiler Building as seen from the Acropolis

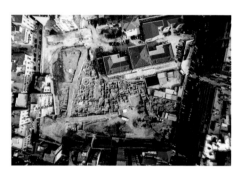

The excavated site before construction revealed a palimpsest of the ancient city.

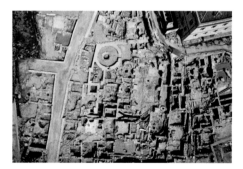

Close-up view of the Makriyianni site showing ancient streets, houses, and gathering places unearthed on the Museum site

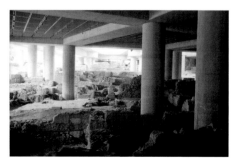

The Museum touches the ground on forty-three distinct columns placed after careful negotiation with engineers and archaeologists.

fessor George Penelis, Professor of Civil Engineering at the University of Thessaloniki; Professor Dennis Sharp, Professor of Architecture in London; and Ersi Philippopoulou, architect, jurist, and Director of the Museum Studies Directorate of the Greek Ministry of Culture.

Judging of the competitors' proposals took place in September 2001. After extensive analysis and exhaustive discussion, the Committee unanimously decided on three awards and two commendations. The first prize was awarded to the French-Swiss architect Bernard Tschumi, then dean of the Graduate School of Architecture, Planning and Preservation at Columbia University in New York, in association with Michael Photiadis, an Athens-based architect. The winning proposal placed the museum building on a grid system of foundation columns, with large expanses of glass flooring above the excavation enabling panoramic views onto the historical environment below. Generous interior spaces with a simple layout allowed a comfortable display of the exhibits and located the Parthenon sculptures in an almost open-air space.

The Weiler Building

As early as 1989, the heritage-listed building of the Center for Acropolis Studies, more commonly known as the Weiler Building, was intended to be part of the new Museum. In the ministerial decision of May 2001 that endorsed the building program for the 2000 competition, the Weiler Building is identified as housing the administrative spaces for the Museum.

The Neoclassical building was built as a military hospital in 1836 by the German engineer Wilhelm Weiler. Nineteenth-century engravings show it to have been the sole building in the area for many years. Its architectural style was simple—a central three-story core flanked symmetrically by two-story wings. The ground floor and the first floor cover an area of 1,235 square meters each, while the central section encompasses 450 square meters. The external walls are made out of stone blocks framed with bricks. The building was fully renovated in 1889 and, years later, became the military barracks for the Gendarme; on December 4, 1944, it was the site of a battle between left-wing forces and the city police.

In 1977 ownership of the Weiler Building was transferred to the Ministry of Culture, which began work to remove add-on structures and to improve the building's interior and facades. The Center for Acropolis Studies soon moved into the building, followed by the First Ephorate for Prehistoric and Classical Antiquities and the Organization for the Construction of the New Acropolis Museum.

During the design and construction of the Museum, care was taken so that the ground floor of the Museum ran level with the ground floor of the Weiler Building, resulting in a harmonious coexistence between the entirely different architectures of the two buildings.

The Archaeological Excavation of the Makriyianni Site

With the Presidential Decree of September 4, 1996, the Makriyianni block was identified as the site for the construction of the New Acropolis Museum. The years between 1997 and 2002 saw an extensive excavation to uncover all of the antiquities on the site. This excavation would also enable final determination of the construction plan for the Museum.

The excavations revealed rich finds in the north and west in contrast to the rest of the site, where the former military barracks had commissioned various police installations such as basement refuges and fuel tanks. The excavations brought to light a densely built area of ancient

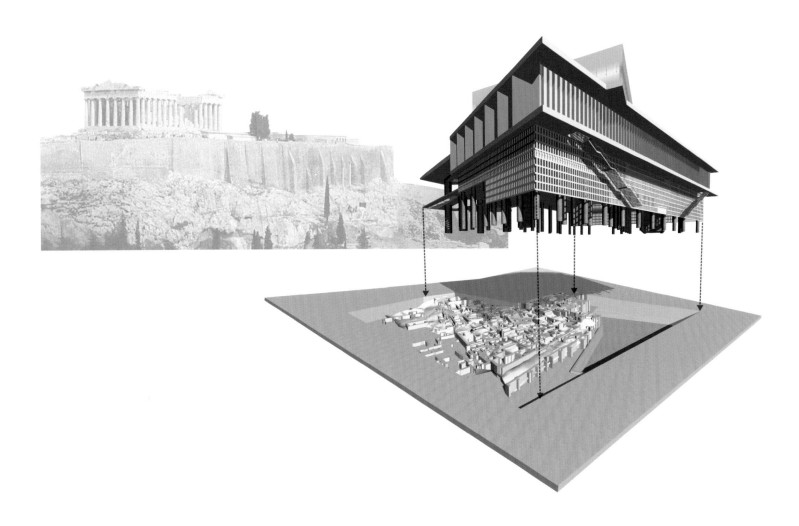

The strategy to accommodate the site meant that the Museum would not have a conventional basement and foundation. The Museum hovers over the excavations, allowing natural light to penetrate the remains despite the bulk of the building.

Athens with continuous layers of construction, the best preserved of which date from late antiquity.

The layout of the ancient roads determined the orientation of the Museum at its lower levels, linking the building to the excavation. This contrasts with the crown of the building, where the Parthenon Gallery parallels the ancient temple located at the top of the Rock, symbolically altering the building's axis.

The oldest archaeological evidence on the Makriyianni site dates from the end of the Neolithic Period. The remains of a few houses from the Mycenean Period and tombs from the Geometric years followed these finds. In 479 B.C. the area was surrounded by city walls and was integrated into the urban area. Roads were developed, houses built, and workshops constructed for the duration of antiquity. The rich underground water level with its seventy wells and fifty water reservoirs provided for the day-to-day needs of residents. However, it appears that the area did not escape the destruction by the Heruli and the Huns, although it recovered quickly and witnessed a peak in development in the fifth century A.D. and a final peak in the seventh century A.D. Tens of thousands of portable finds from the excavation convey unique evidence of the daily lives of the individuals who lived in the shadow of the Acropolis.

The Exhibition Program of the New Acropolis Museum: The Visitor's Experience

The New Acropolis Museum is the museum of a specific archaeological site with certain unique characteristics. It houses the most famous

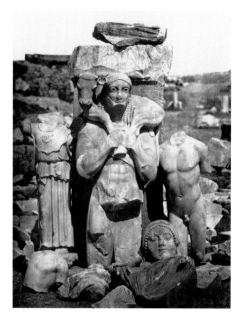

Archaic sculpture found in pits in 1865 during foundation work for construction of the first museum on the Acropolis

works of classical antiquity. These works are also artistic expressions of a deep political change that transformed the ancient city of Athens during the fifth century B.C., subsequently marking entire eras from antiquity to modernity.

The Museum also presents representative works with distinctive characteristics from the Archaic Period. Its collection includes significant works by famous artists that ceased to be visible after the Persian invasion of 480 B.C., which destroyed the Acropolis. On return, the Athenians buried these votives in pits on the Sacred Rock. The works represent the Athens of Solon, Peisistratos, and Kleisthenes—the Athens of the sixth century B.C., with the economic developments and social realignments that led to the birth of democracy.

Naturally, the exhibition program also includes archaeological evidence from the first human settlement on the site. The museum visitor is provided with a complete picture of human life and activities on the Sacred Rock from the Neolithic Era to the decline of antiquity during the Byzantine Period. An exhibition in the old Acropolis Museum titled *From Fortress to Monument* will cover the subsequent periods up to the transformation of the Acropolis into an archaeological site.

Finally, the exhibition program includes the authentic ancient urban environment located in the lower levels of the Museum. Extensive archaeological excavations conducted during preparations for the Museum's construction revealed private houses, bathhouses, shops, workshops, and roads. Many thousands of portable finds will be exhibited on the same level as the excavation in a specially designed exhibition area.

The aim of the exhibition program is to provide all of the significant information gleaned from the archaeological artifacts of the Acropolis, covering themes of worship, mythology, politics, the economy, the arts, and society. The exhibits are not presented solely as works of art, but also as evidence of the historical and social context of the period from which they developed. With the topographic, chronological, and thematic organization of the collections, it is hoped that the Museum will attract

Section through the Museum core showing arrangement of levels in section. Voids allow light from above to penetrate through many levels to illuminate the excavations below.

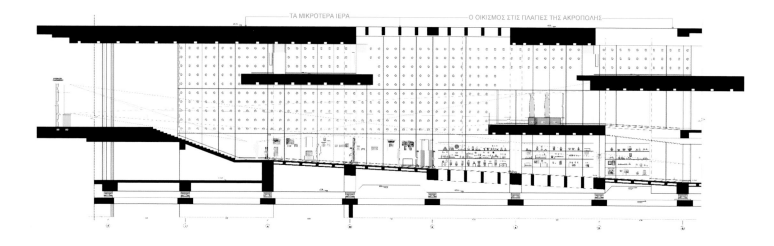

a broad range of visitors, since visitors are the central focus of the New Acropolis Museum. The visitor will become familiar with the sanctuaries and monuments of the Athenian Acropolis through their sculptural adornments and assorted votives and, assisted by the Museum narrative, achieve a comprehensive understanding of the whole.

There are four exhibition levels in the Museum:

1. The archaeological excavation at ground level (Level -1), which includes an exhibition space for its portable finds.

2. The sloping ramp at the ground floor, which links this floor to the first floor, which contains the exhibits from the slopes of the Acropolis.

3. The first floor (Level +1), which is divided into two sections by the building core and by its large central atrium: one for the exhibits from the Archaic Period and one for works from the Propylaia, the Sanctuary of Nike, the Erectheum, and objects dating from the classical period to the end of antiquity.

4. The third floor (Level +3), which displays the architectural sculptures from the Parthenon.

When conservation work is completed and ramps are installed above the excavation, visitors will have the option of beginning their tour from the excavation, the *genius loci* of the Museum. Visitors will then be able to walk among the ruins of the ancient neighborhood and, assisted by comprehensive information available at selected vantage points, gain an understanding of the ancient buildings. Along with the exhibition of selected artifacts found on the site, the excavation offers an opportunity to appreciate the connection between the masterpieces of the Acropolis and the remains of the day-to-day life of the people who lived in the area over many distinct periods of time.

For the time being, visitors can gain a sense of the excavation environment from the views available through the huge opening at the Museum entrance and through the glass-paneled floors, looking down

The glass ramps allow natural light to reflect off the floor.

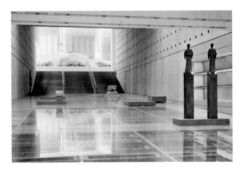

The Gallery of the Slopes

An axonometric view of the Archaic and Post-Parthenon Galleries. Services are confined to two parallel cores, which are also structural.

32: The horses of a chariot, probably from a metope on the early Archaic temple of Athena on the Acropolis

32–33: Athena fighting the giants. The famous figures from the late Archaic temple are displayed for the first time as they stood in their original location.

33: The statue of a giant from the pediment of the Archaic temple

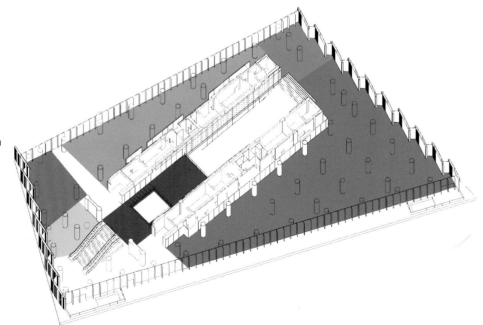

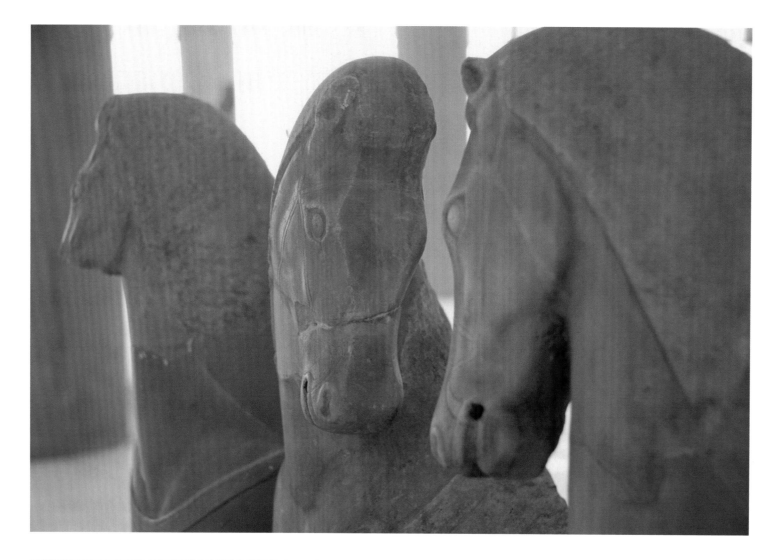

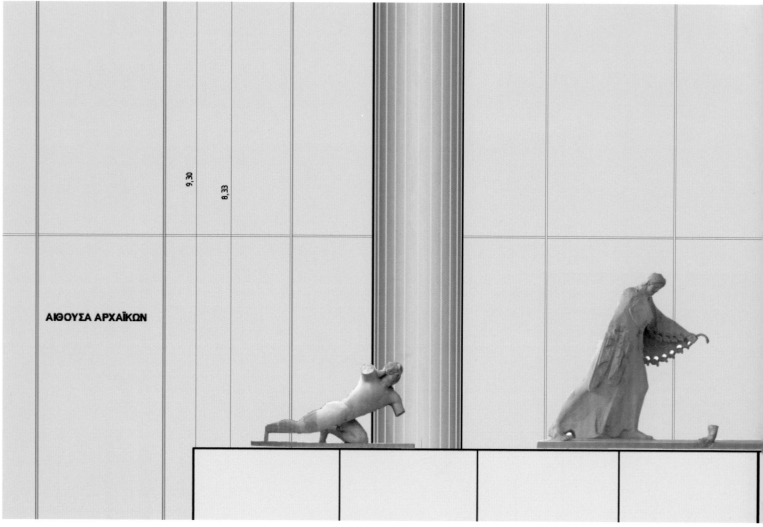

ΑΙΘΟΥΣΑ ΑΡΧΑΪΚΩΝ

9,30

8,33

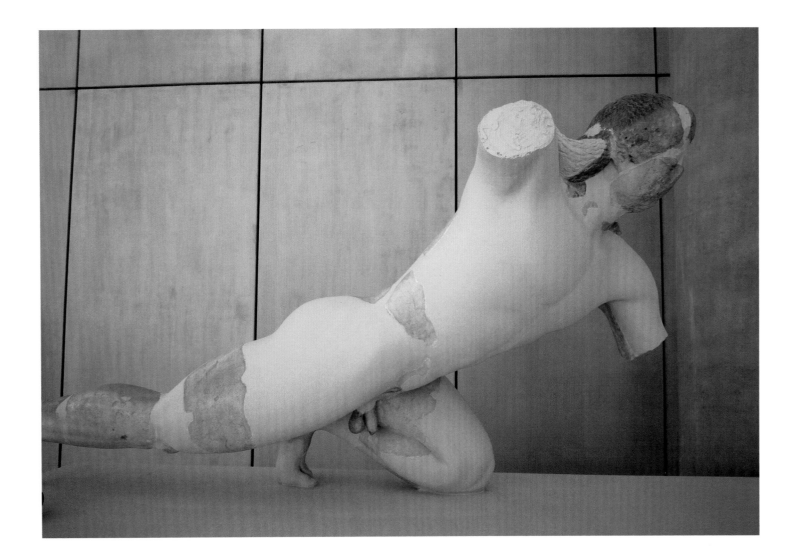

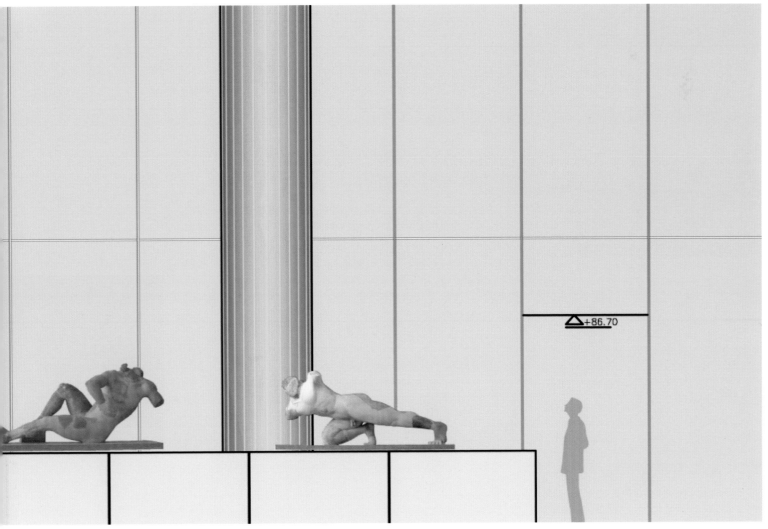

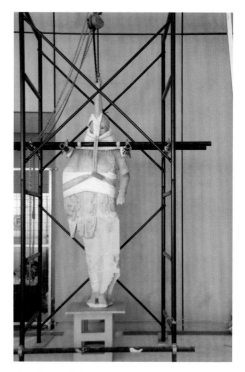

The *Kore of Antenor*, the largest of the Acropolis kores, is prepared for installation.

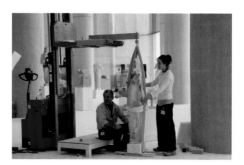

Conservators at work

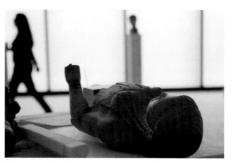

Statue of a kore readied for placement on its pedestal

The so-called *Blond Boy* against the glass facade

onto the key roadways through the ancient neighborhood, its buildings from late antiquity, two baths, and a house with an *andron* dating from the classical period.

The Gallery of the Slopes of the Acropolis is the Museum's first exhibition area. Its walls have display cases for small finds, primarily ceramic vases. Reliefs and inscriptions are attached directly to prefabricated concrete panels, while other sculptures are placed freestanding on marble bases.

The south side of the Gallery exhibits finds from the houses and tombs of people who lived on the Acropolis slopes, re-used sculptures from the House of Proklos, votives from the small sanctuaries of the Fountain House, the Sanctuary of Aphrodite and Eros, Apollon under Acropolis, Pan, Ourania Aphrodite, and Aglauros. On the north side, ceramic vases, votive panels, and other dedications from the Sanctuary of Nymphe are presented, along with votive reliefs from the Sanctuary of Asklepios and the Sanctuary of Dionysus.

The unique vases from the Sanctuary of Nymphe, the relief of Telemachos, theatrical masks, and the treasure of Aphrodite, among other exhibits in this gallery, provide a fascinating introduction and a real sense of the various activities that occurred on the Acropolis slopes. Significant places of worship and domestic residences comprise a colorful zone between the urban areas below and the famous sanctuary above.

A monumental staircase and an elevator located at the end of this ground-floor gallery lead to the first floor.

The Archaic Gallery occupies the east and south section of Level +1. The visit begins in the northeast corner, where archaeological finds and a scale model make clear the significance of the Acropolis in the Mycenaean Period as a residential area and the seat of the local ruler. In the northeast corner, four display cases present significant exhibits from the Mycenaean Acropolis such as the so-called *Treasure of the Coppersmith*. Located opposite them in a prominent position, the large copper depiction of Gorgo, a decorative element from a temple roof and singular evidence of the existence of an important sanctuary dating from the Late Geometric Period, signals the Acropolis's shift in status to an important religious center. These exhibits provide an introduction to the Archaic Acropolis.

The changing role of the Acropolis is evidenced by the monumental pediment of the Hecatompedon, the first large temple on the Acropolis dedicated to the Goddess Athena and the first peripteral temple of Athens. Displayed at the top of the large staircase in a central position, visible from afar as one approaches the sloping ramp, it is presented for the first time in its original form with three sections: Heracles and Triton, two lions killing a bull, and a three-bodied sea monster, reconstituted according to the proposal of W.-H. Schuchhardt.

The visitor subsequently moves to the south side of the gallery where the richness and range of architectural sculptures, freestanding votives, and minor objects provide a vibrant picture of the Acropolis of the Archaic Period, while the beautiful decoration of the statues invites and attracts the visitor's attention.

Works from the Archaic Period are exhibited in thematic groups consisting of:

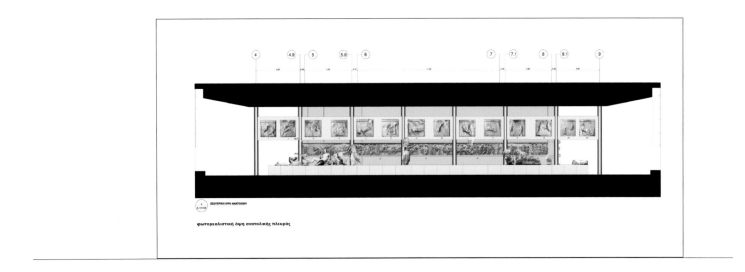

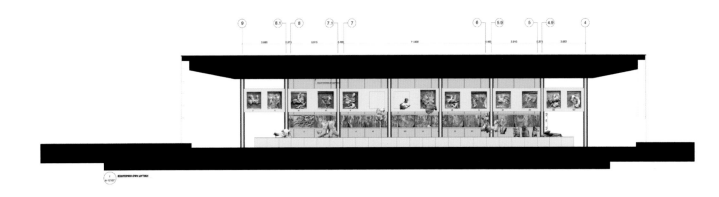

Diagrams of the east and west sides of the Parthenon Gallery showing the Frieze and metopes

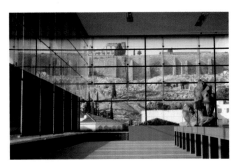

Experimental installation of the west pediment figures. The proximity of the Parthenon Gallery to the temple allows a better understanding of the original context of the sculptures, restoring them to the exact orientation as when they adorned the Parthenon.

The Parthenon Gallery affords views out to the city, relating the ancient sculptures to the world at large.

(a) architectural sculptures and members from Archaic structures, including the *Hecatompedon*, the Ancient Temple with the Gigantomachy pediment, and smaller sacred buildings;

(b) prominent votive statues and early works from island workshops (Naxian and Parian);

(c) sculptural works of the early Attic workshops with *The Calf-Bearer* at the center;

(d) significant Attic works from the Middle Archaic Period with the central exhibit *The Peplophoros*;

(e) the horse riders of the Acropolis with *Rampin* as the central exhibit;

(f) monumental Attic works, including the *Kore of Antenor*;

(g) korai and other works from the Late Archaic Period that evidence the destruction by the Persians, as well as the treasure of sixty-three silver Athenian coins that was deposited with them. Symbolically, the Archaic collection closes with the votive of Nike of Kallimachos, the General of the Athenian troops in the Battle of Marathon in 490 B.C.

The dramatic close of this collection with its archaeological narrative about the Persian disaster of the Acropolis prepares the visitor for the next installation of works from the so-called Severe Period. At the end of the Archaic Gallery and before the ascent to the gallery displaying the sculptures of the Parthenon, the works of the Severe Style and the early classical period are exhibited, with the *Kritios Boy*, the *Kore of Euthidikos*, the head of the *Blond Boy*, and the relief of the *Mourning Athena* key among them.

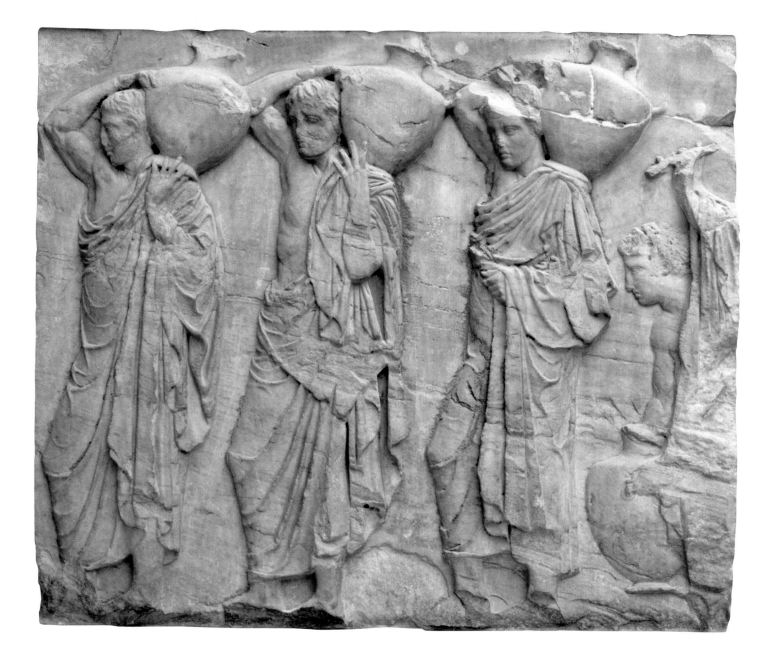

A block from the Parthenon Frieze showing young men carrying water jars

Fragments of limestone and marble sculpture, ceramic votives, architectural members, and small bronze figurines are exhibited in the display cases in the east fins. The display cases located in the west fins contain small objects, fragments of sculptures, and characteristic black-and-red figured ceramics from the Acropolis excavation.

The organization of the exhibits according to thematic criteria and the exhibition of certain votive statues with their original bases and inscriptions help visitors understand the objects and the environment from which they evolved.

The recommended tour for visitors in the Archaic Gallery takes into account their diversity of interest and available time. The hurried visitor can view key exhibits by quickly traversing the spacious gallery, while the visitor who wishes to become more familiar with the archaic world will easily identify the central exhibits and their related thematic groups.

For the first time, visitors with the desire to view each object from a 360-degree perspective can do so. With the benefit of changing natural light, the visitor can discover the delicate surface variations of the statues and choose the most interesting vantage points from which to observe the works of art. In this way, viewing the exhibition and its objects becomes an entirely personal experience.

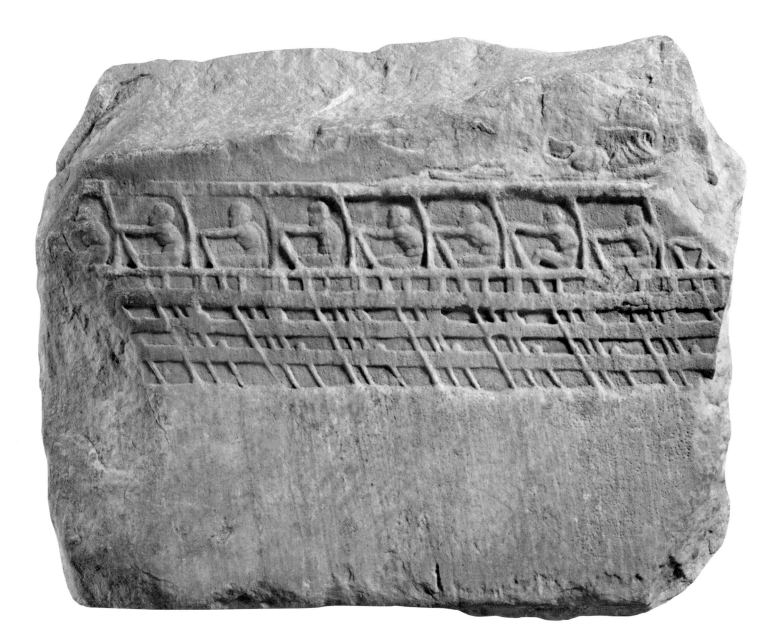

Fragment of a votive relief
showing a sacred Athenian
trireme

The visitor can take the stairs, escalator, or elevators to reach the second
level of the Museum. This level affords panoramic views of the Archaic
Gallery and the Gallery of the Slopes.

Visitors can reach the internal atrium of the third-level Parthenon Gallery
in the same way. The Parthenon Gallery occupies the entire third floor of
the Museum. Its glass-floored atrium provides a wealth of information
about the sculptures and the architecture of the temple. Original inscrip-
tions documenting the construction of the Parthenon and accounts of
ongoing expenses for building the chryselephantine statue of Athena
introduce the architectural sculptures and offer insight into the ways in
which democratic authorities managed construction in the fifth century
B.C. From this point on, the visitor enters the main hall of the Gallery
where he or she encounters both the sculptures and panoramic views of
the Acropolis monument.

The installation of the Parthenon sculptures in the Gallery leads to a
circumambulatory walk that enables a comprehensive view of the
sculptures' details, an awareness of the narrative behind the composi-
tion, and an understanding of their artistic value. The Frieze is mounted
according to specifications that place it recessed into the rectangular
concrete core of the building with the same dimensions as the cella of
the Parthenon. The Frieze is inlaid and fixed at a height between 1.5 and

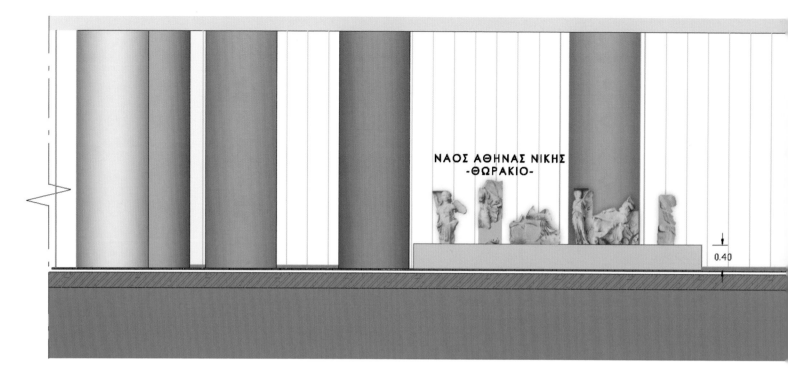

ΝΑΟΣ ΑΘΗΝΑΣ ΝΙΚΗΣ
-ΘΩΡΑΚΙΟ-

0.40

The architectural sculptures from the
Sanctuary of Athena Nike

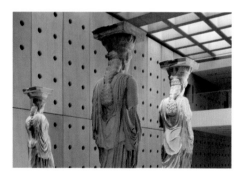

Caryatids are architectural columns
sculpted with a female form. The
Caryatids (shown here with scaffolding) at
the Acropolis Museum are from the
Erechtheum.

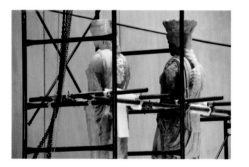

The placement of the Caryatids allows for
views from multiple vantage points.

2.5 meters from the ground. Ideal lighting conditions are assured by the
skylights above it and by side lighting from the glass walls of the Gallery.

The metopes are located at a height of 2.5 meters above ground
between the stainless-steel columns of the Gallery. In this way, the
Frieze is not obscured, the angled natural light infiltrates unimpeded
between the columns, and simultaneous views of the sculptures in the
Museum and the buildings on the Sacred Rock are assured.

The pediment sculptures occupy a large, continuous base 80 cm high
located at the east and west wings of the Gallery. In their original loca-
tion in the Parthenon, the sculptures were fixed to the pediment wall so
that their backs were invisible to the viewer. After extensive experimen-
tation over a period of months it was concluded that the pediment sculp-
tures, as three-dimensional objects, should be freestanding so that their
well-sculpted backs are displayed for all to see.

The question of exhibiting the original Parthenon sculptures next to cast
copies of original pieces currently in the British Museum was con-
fronted. After considerable discussion, it was agreed that cast copies be
presented next to the originals and, in many cases, that originals and
casts be joined together in order to restore dismembered sculptures.
The difference in color between the warm patina of the originals and the
neutral surface of the white casts assures the immediate recognition of
original and copy by the viewer. On the other hand, the arrangement of
restored pieces enables a better understanding of the monument, while
simultaneously presenting the real issue underlying the divided
Parthenon sculptures in an objective manner.

The descent of the visitor back to the first Museum level affords views
of the unique works that became prototypes for the periods from antiq-
uity to today. Visitors are afforded a complete and close-up view of the
Caryatids of the Erechtheum, the coffered ceiling of the Propylaia, and
the sculptures from the parapet of the Temple of Athena Nike.

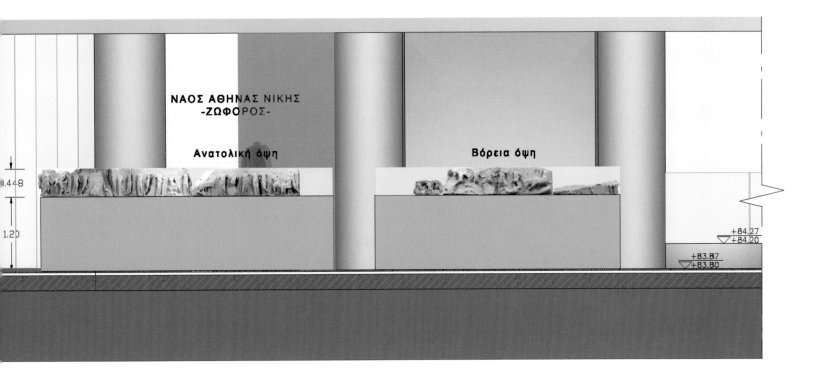

ΝΑΟΣ ΑΘΗΝΑΣ ΝΙΚΗΣ
-ΖΩΦΟΡΟΣ-

Ανατολική όψη Βόρεια όψη

+84.27
+84.20

+83.87
+83.80

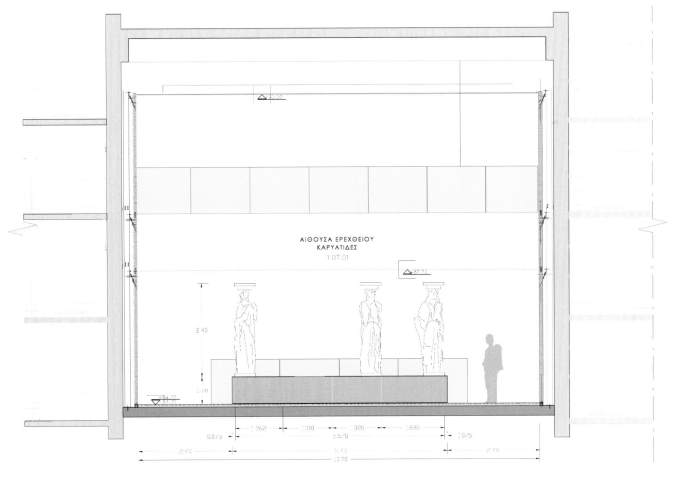

ΑΙΘΟΥΣΑ ΕΡΕΧΘΕΙΟΥ
ΚΑΡΥΑΤΙΔΕΣ
1.07.01

Ερέχθειο

Καρυάτιδες Ερεχθείου

The Caryatids stand overlooking the
entrance ramp, echoing their placement
on the Erechtheum.

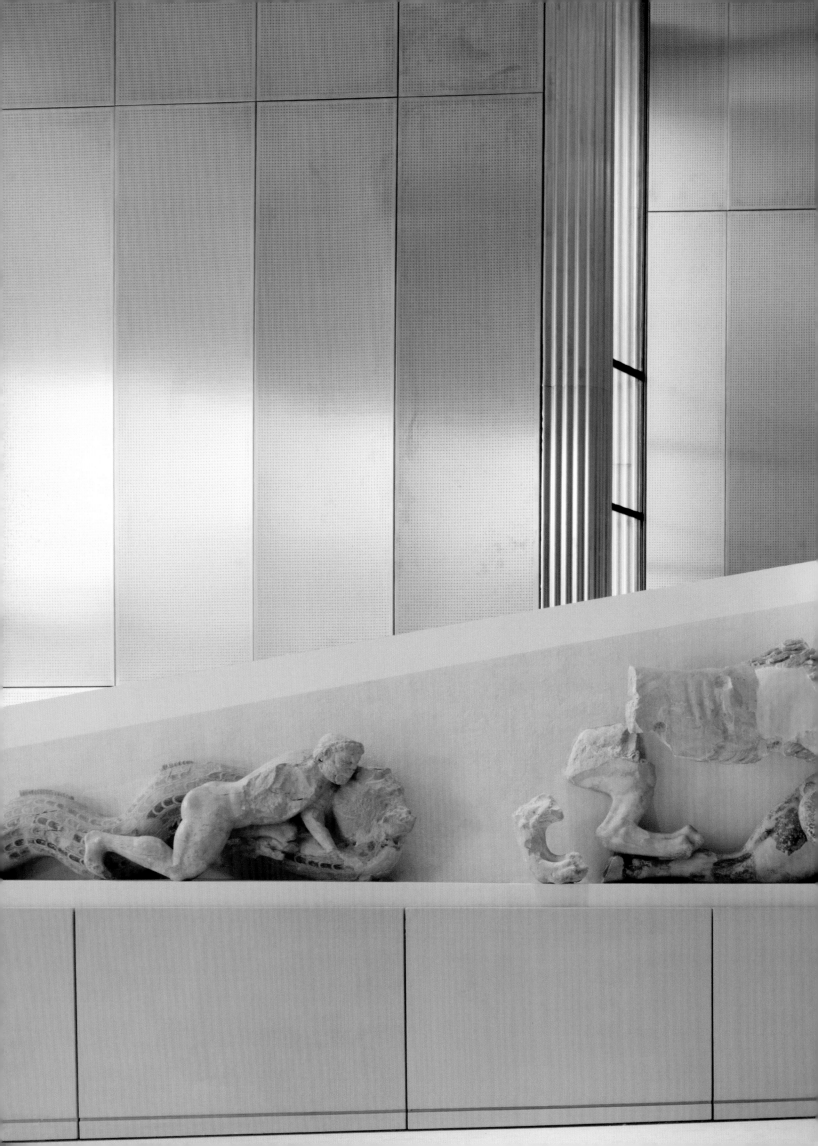

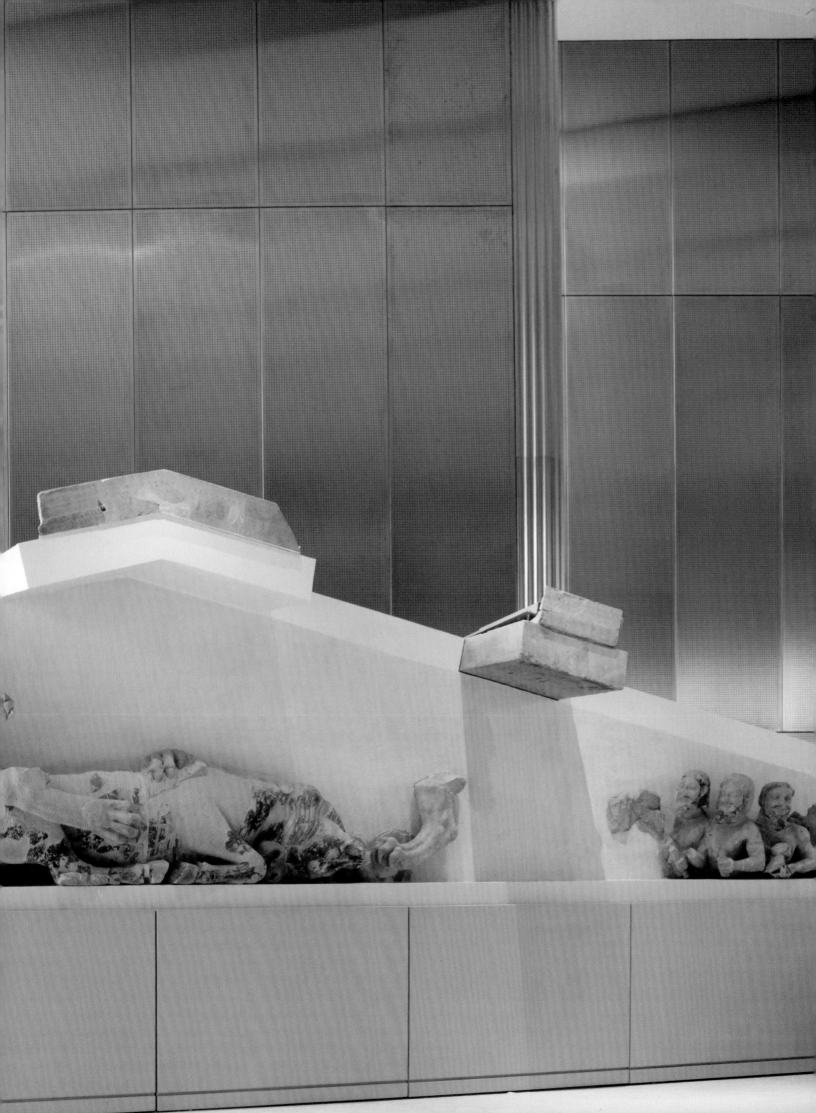

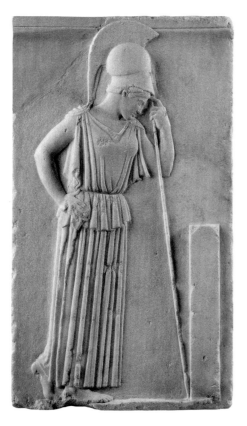

The Mourning Athena

Immediately following the descent from the Parthenon Gallery and the return to the west wing of Level +1, the visitor encounters exhibits from the Propylaia on the right-hand side: a section of its coffered ceiling, fragments of the Ionic capitals, and a section of an epigraphy with construction records from the building.

The sculptures from the Sanctuary of Athena Nike are installed in the northwest of the gallery. The original blocks of the frieze are placed on a base 1.5 meters high, along with slabs from the Sanctuary parapet, with its representations of Athena and winged Nike figures. Other significant fragments of the parapet and pediment figures are exhibited in seven built-in display cases in the west fins of the Gallery.

The Caryatids from the Erechtheum are mounted on a low base. The Museum architect designed a special porch so that they are visible not only in close proximity, but also from many vantage points and levels of the Museum. The Caryatids are mounted in the same formation as when installed on the ancient building.

Figures from the Erechtheum frieze are secured to a grey marble backdrop and divided into two groups, depending on their scale and original position on the temple. The base is approximately 1.5 meters tall. The figures are the recipients of both gentle north light and the stronger south light, which is moderated and filtered thanks to protective coatings on the Gallery's glass windows.

The building inscription from the Erechtheum is mounted on a concrete panel opposite the frieze.

Famous sculptures of the classical period and copies of classical sculptures from the Roman Imperial Era are exhibited in the central part of the north wing. Selected works from late antiquity and the beginning of the Byzantine Period are installed as an epilogue.

Key exhibits at the beginning of this collection include sculptures of the tragic *Prokne* and her son *Itys*, and the colossal head of *Artemis of Brauron*, a masterpiece by Praxiteles. Athena is presented in six varying styles of sculpture, and a large collection of decrees from the fifth and fourth centuries records the diplomatic actions of Athenian foreign policy. Votive sculptures, monuments related to athletes and competitions, and original fragments of post-Phidias works are among other exhibited objects. In the collection of portraits, the head of Alexander the Great dominates other portraits of historical figures, including Roman emperors, priests, and philosophers, and one large marble "magic" ball that make reference to mystical practices of late antiquity. Finally, the visitor crosses the Gallery of the Slopes once again toward the Museum exit.

The exhibition program concludes at this point. Extensive digital information will be available for the visitor interested in the Acropolis of more recent times, along with the exhibitions in the old Acropolis Museum on the Sacred Rock.

Methods for Supporting and Securing Exhibits
Statue Bases
Freestanding exhibits are installed on bases made out of white Helicon marble similar to the floor surface so that the bases are discreet and do not distract the visitor. Specially designed seismic bearings have been made for large exhibits and particularly for those of great height. The sculptures are secured to their bases so as to allow their removal for conservation.

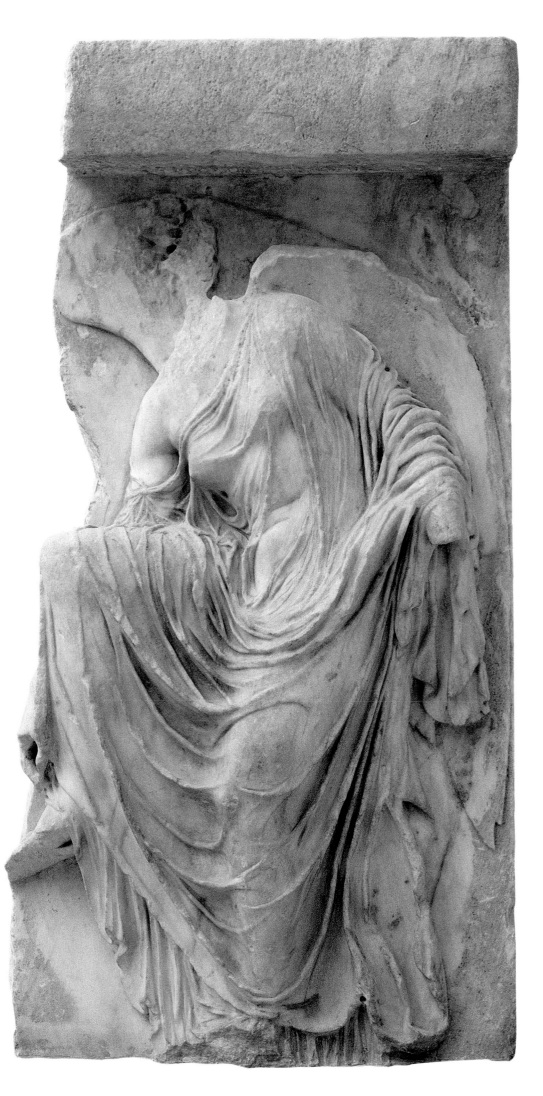

Nike Tying her Sandal, from the
temple of Athena Nike

Architectural sculptures are erected on bases made out of precast concrete slabs that wrap around a strong metal core.

The installation of works on bases is in keeping with specific criteria about presentation and the viewing comfort of the Museum visitors. Insofar as possible, certain sculptures are displayed similarly as to how they were presented in antiquity.

Several reliefs in the Gallery of the Slopes are mounted on the precast concrete panels that revet the walls, using metal attachments.

Display Cases
Three types of display cases are used in the Museum:

1. Those located in the Gallery of the Slopes occupy exactly half of the wall surface reserved for exhibits, and follow the grid system of the wall revetment. These display cases are lined with stainless-steel mesh, selected after exhaustive research and tests, to soften shadows. The lighting employs an LED system with a combination of warm and cool light.

2. Display cases incorporated into the stainless-steel fins on the east and west side of the first floor galleries. In total, there are forty-two display cases lined with stainless steel mesh with LED lighting.

3. Freestanding showcases made out of glass and marble with humidity control systems.

Lighting

The natural light in the galleries contributes to the optimum presentation of the exhibits, revealing their surface variations and enhancing their three-dimensionality. Controlled and filtered natural light enters the galleries through screen-printed windows, skylights, and side blinds that are operated by remote control from a central regulator. UV electric bulbs also support the natural light.

Security Measures

The exhibits are protected from atmospheric pollution by a quality-management program for internal air regulation that incorporates mechanical and chemical filters while also controlling sulphur oxide. An additional sensor system ensures effective air monitoring. Special filters on large glass panels prevent elevated external air temperature from entering the interior spaces. In the Parthenon Gallery, a specially designed air conditioning system cools the glass panels.

The seismic isolation of the Museum is assured by friction pendulum isolators. Special bearing mechanisms have been constructed to reduce vertical distress to large exhibits.

All of the exhibition galleries are equipped with a highly developed security monitoring system to protect the artworks against the risk of vandalism.

Visitor Information

Information is offered to Museum visitors on a multilayered basis. Electronic screens located on the ground floor provide general information on the Museum and its range of services and programs. Information about the exhibits is provided in Greek and English on glass and metal panels. Individual exhibit labels provide summary identifying information, while texts that provide contextual information for groups or themes in the collections, supported by illustrations and other visual aids, are

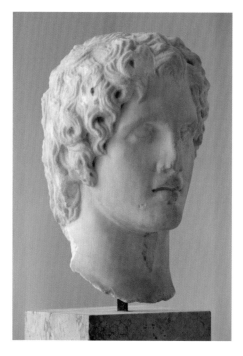

Marble portrait of Alexander the Great from the late fourth century B.C.

located throughout the Museum galleries.

In the future, detailed information on the exhibits and the Acropolis will be provided in a range of languages in the multimedia center. Information on the Parthenon and its sculptural ornamentation is available in the large anteroom in front of the entrance to the Parthenon Gallery. Additionally, models, among them scale models of the slopes of the Acropolis, the Mycenaean Acropolis, the Acropolis of the Archaic Period, the Parthenon, Propylaia, Erectheum, and the Temple of Athena Nike, offer the visitor help in understanding both the topography and the monuments of the Acropolis.

Visitor Management

The Museum's visitor reception areas are designed on the basis of visitation data from the Acropolis and the old Acropolis Museum. Up to ten thousand visitors a day are expected during the peak visiting months of August and September, necessitating regulated visitor entry to the exhibition galleries.

A range of options is available to the visitor awaiting entry to the Museum galleries. The spacious ground floor with its range of services, the archaeological excavation, and the Museum gardens planted with reference to ancient myths provide alternative activities for the visitor.

The number of visitors entering the exhibition areas will be controlled by an electronic monitoring system located in the entrance turnstiles. Visitor rest points at the first and second levels are provided with seating, while a marble bench around the perimeter of the Parthenon Gallery allows space for up to four hundred people at a time.

The opening of the New Acropolis Museum marks a new era in the presentation of classical art. Visitors to the Museum will have a unique opportunity to enjoy the highpoints of ancient Greek sculpture and the rare experience of observing the continued restoration of significant works at close range in the Museum's exhibition galleries.

Significantly, the New Acropolis Museum presents the original sources of classical inspiration without classicism and provides a means for the world community to obtain a fresh interpretation of ancient Greek art. Last but not least, the Museum invites its visitors to reflect on the issue of the divided Parthenon Marbles.

Translated by Niki Dollis

Conservators at work installing exhibits in the Parthenon Gallery

Visitors on the glass ramp over the excavations

46–47: View of the Parthenon Gallery from the northeast corner

48–49: The Archaic Gallery as seen from the west in daylight

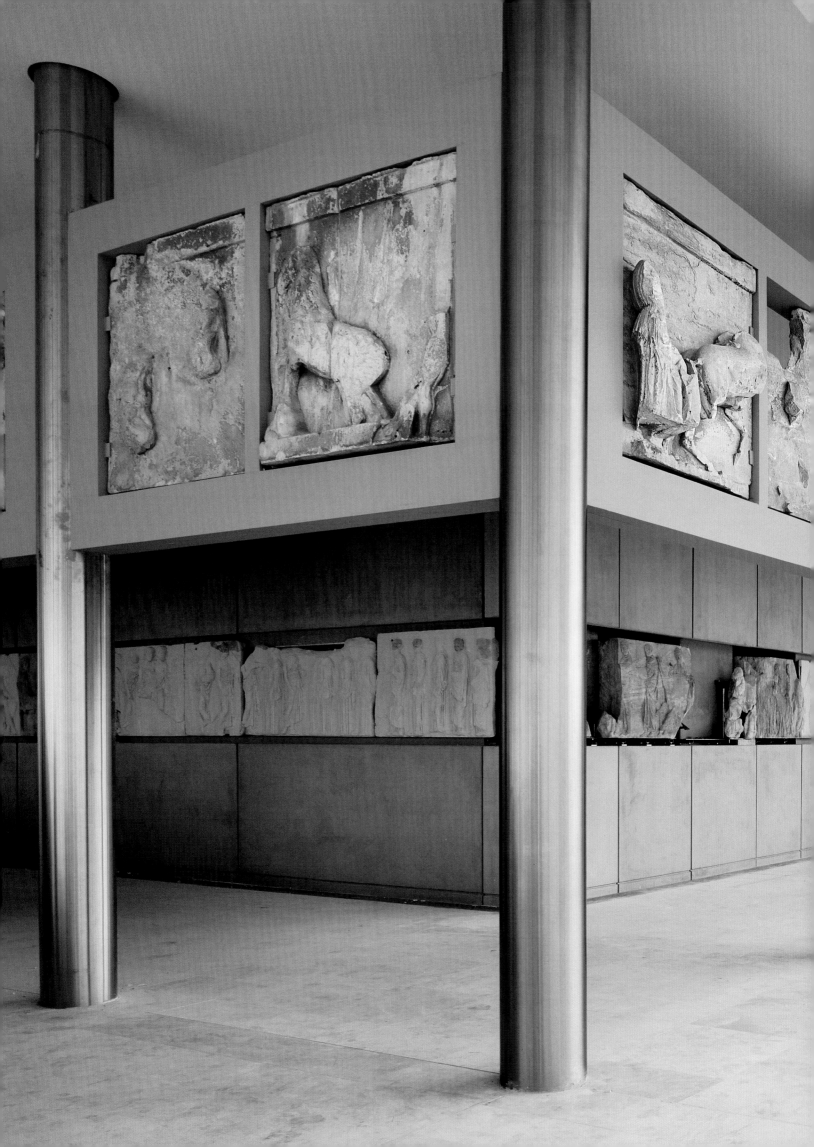

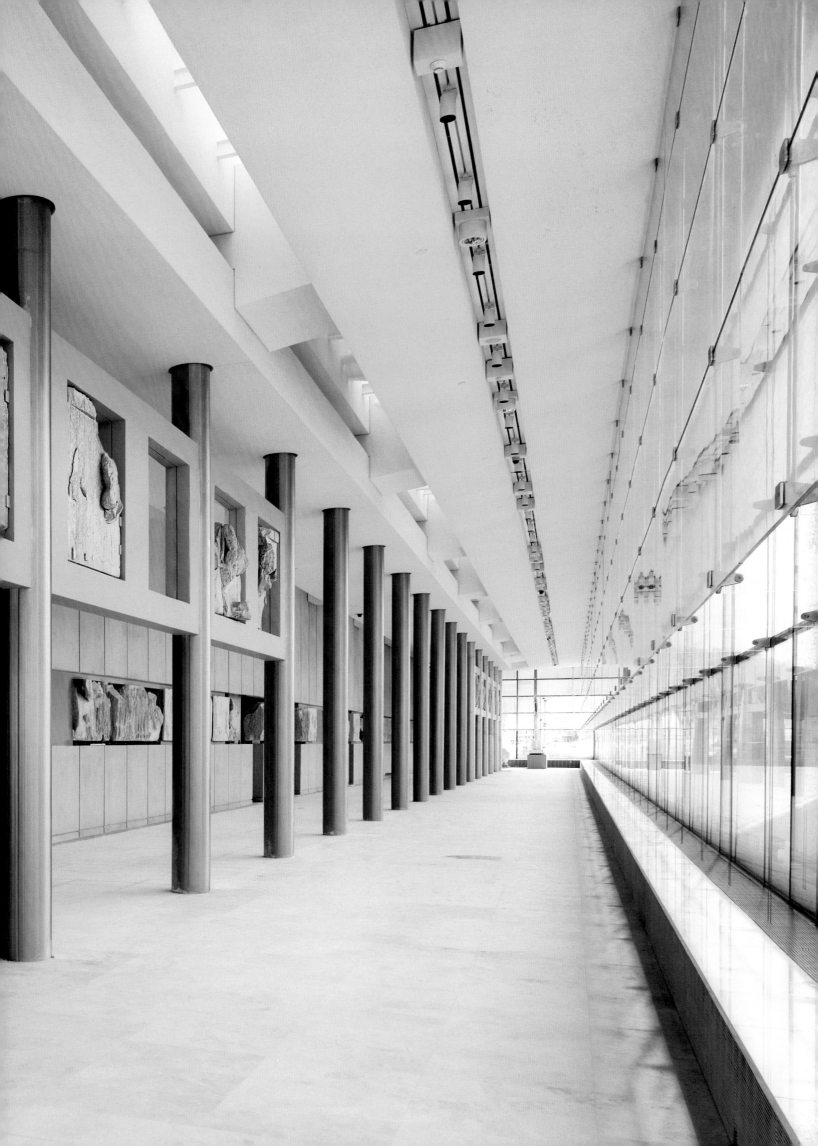

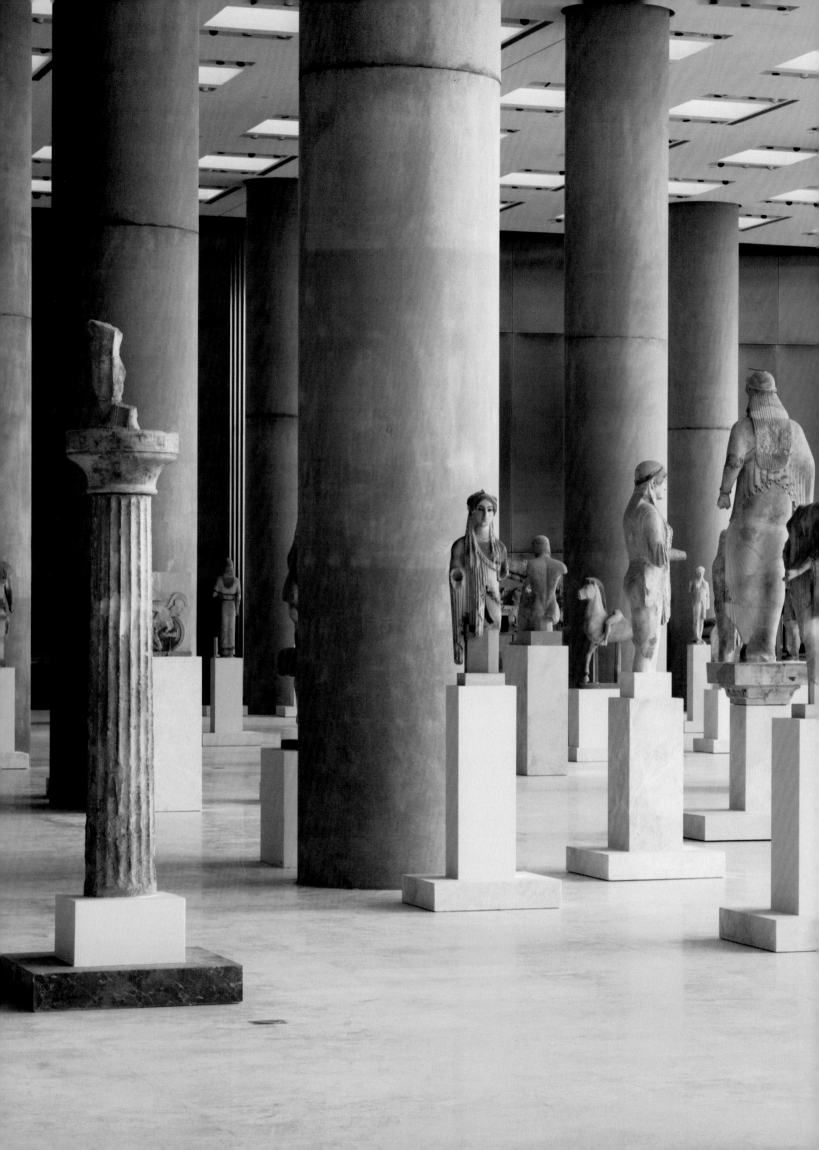

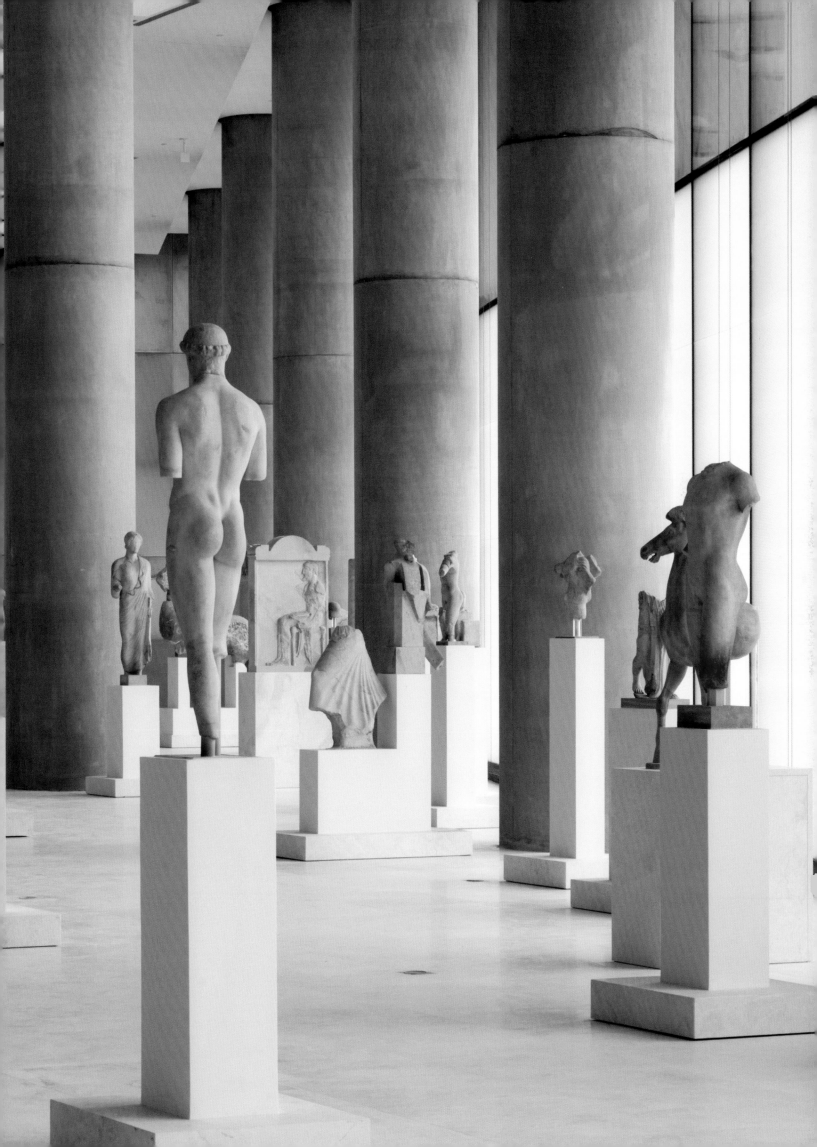

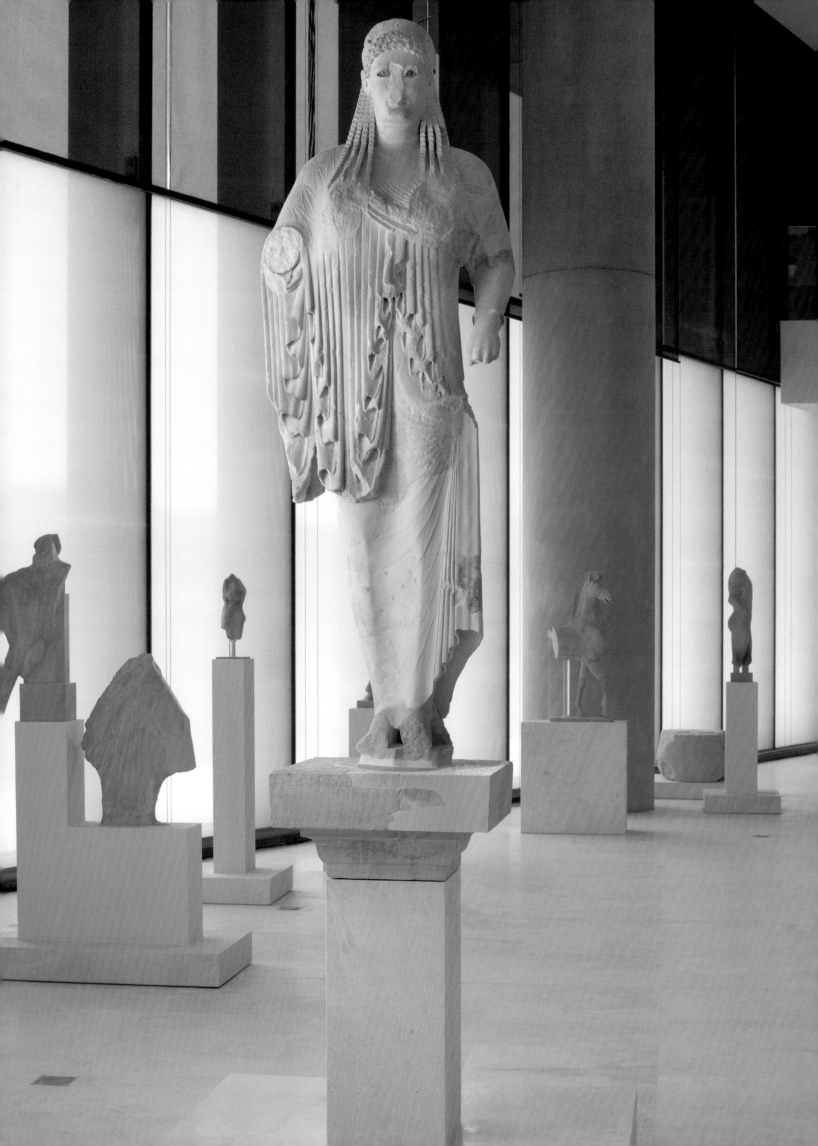

Opposite: The *Kore of Antenor*

The Parthenon as seen from the northeast of the Parthenon Gallery

52–53: The Caryatids. In the background, fragments from the frieze of the Erechtheum

54–55: The Archaic Gallery as seen from the east at dusk

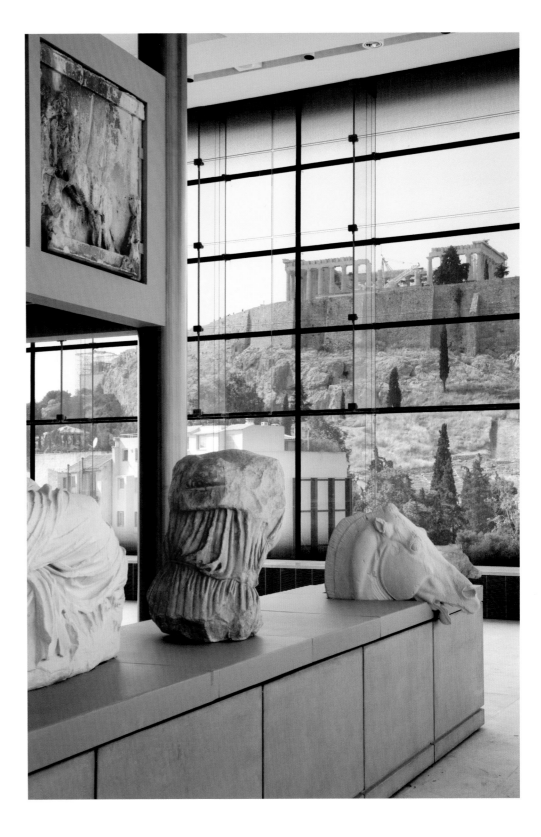

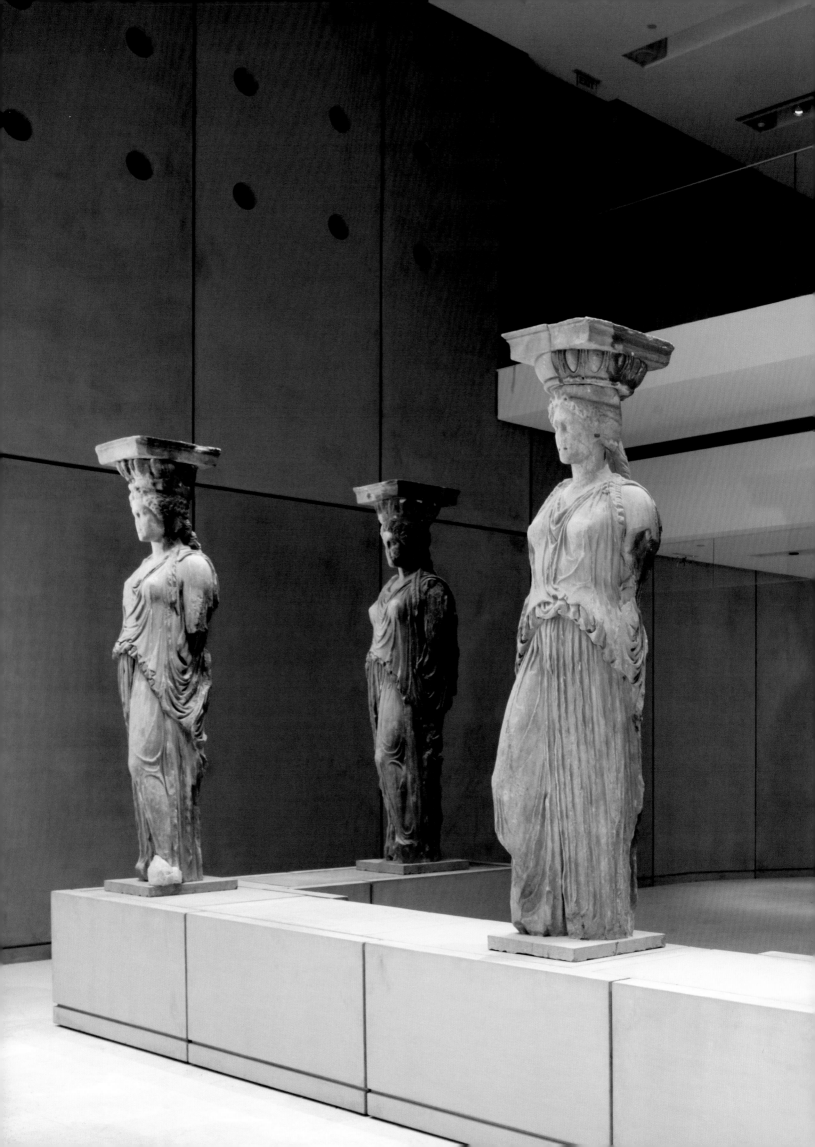

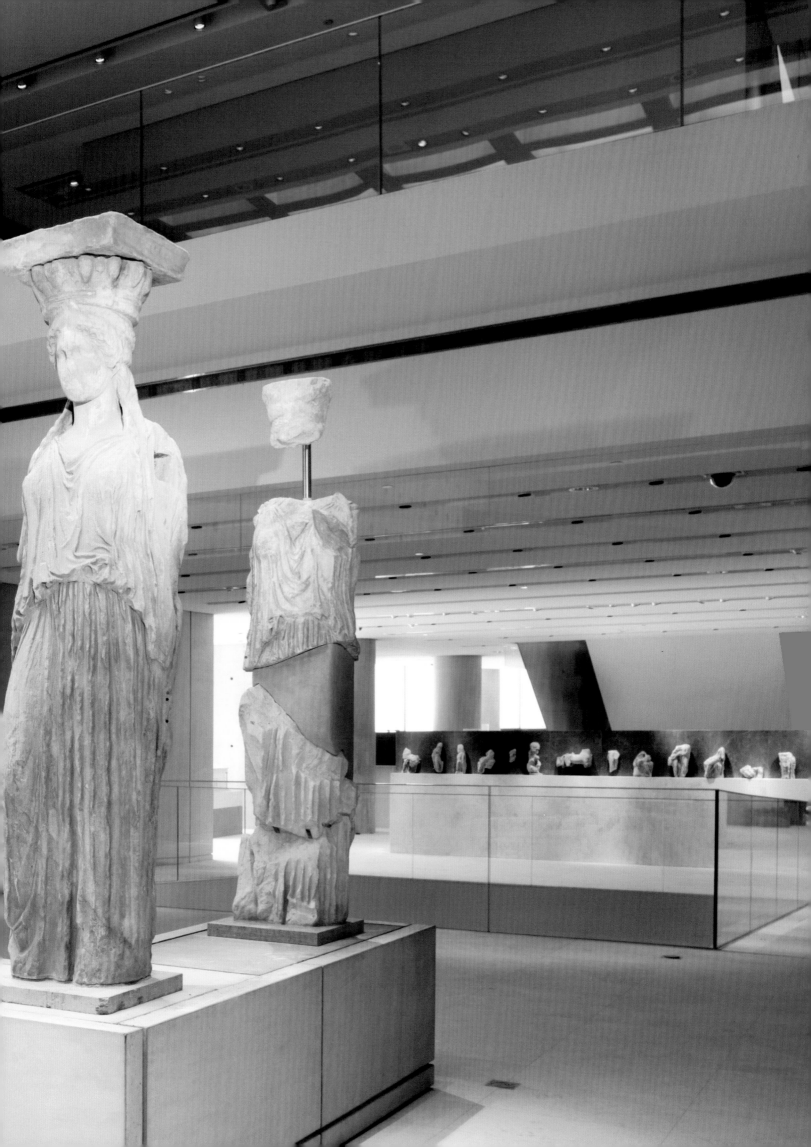

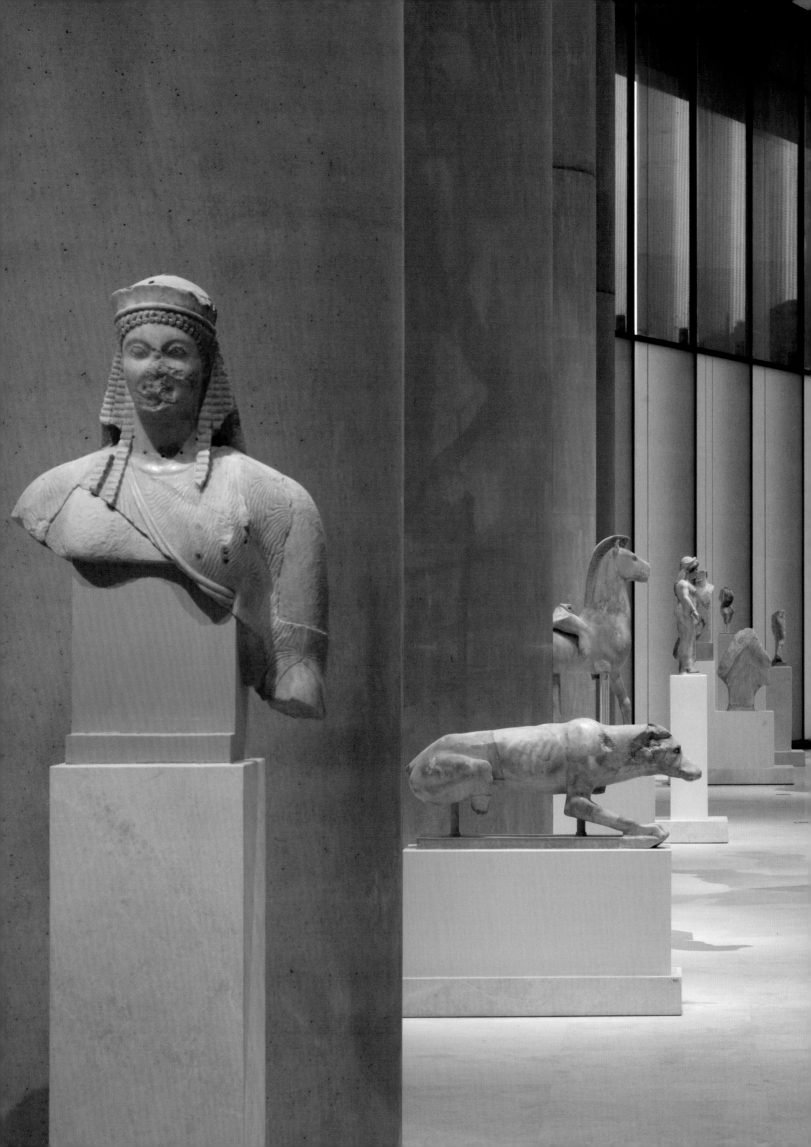

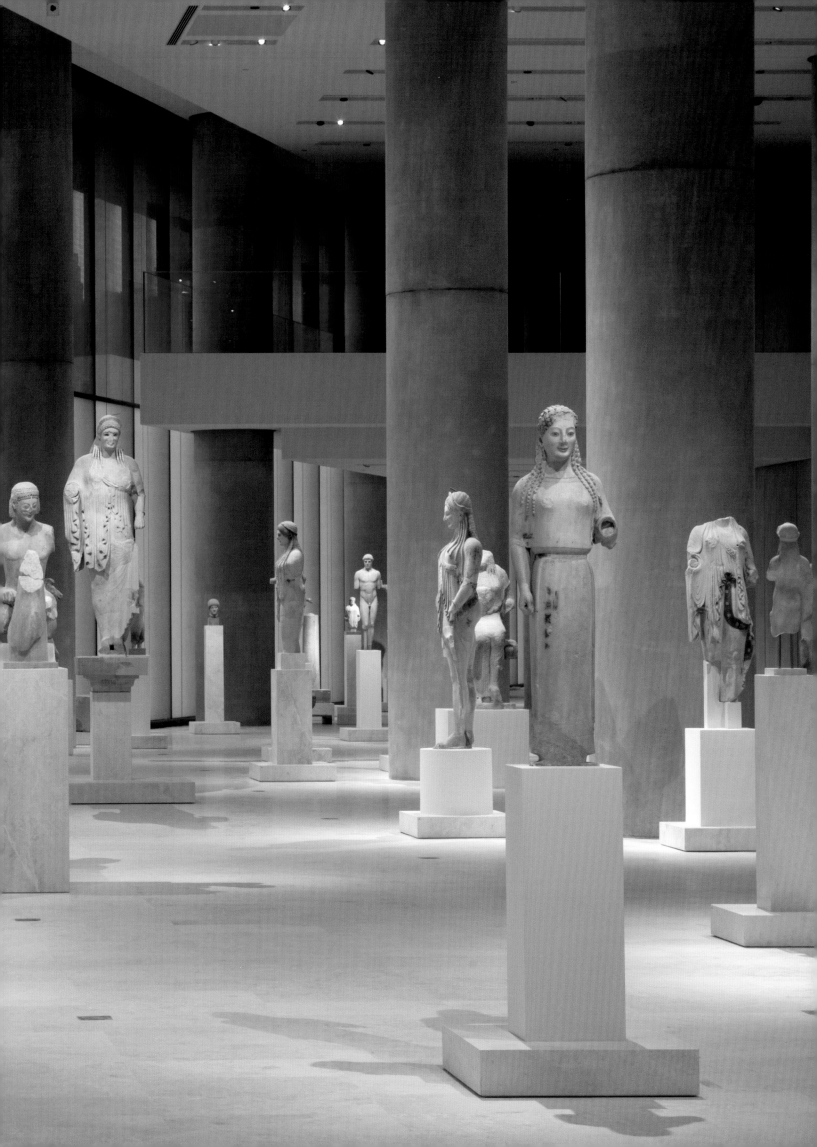

The New Acropolis Museum: Re-making the Collective

Yannis Aesopos

The Parthenon Marbles as
exhibited in the British Museum

Opposite: Detail of the Parthenon
Frieze

The new museum to house the sculptures of the Acropolis is finally
ready to welcome its visitors. Designed by Bernard Tschumi Archi-
tects,[1] the project was selected out of twelve entries in an interna-
tional architectural competition held in 2001, the fourth in a series of
unsuccessful attempts to realize a building to replace the small under-
ground museum located alongside the Parthenon.[2] The new mu-
seum's 21,000-square-meter surface makes it more than twenty times
larger than its predecessor and a significant public building for the city
of Athens. The building's extra-large size and architectural prominence
could also provide a strong card in Greece's case for the repatriation of
the so-called Elgin Marbles, a collection of sculptures from the Acropo-
lis that were seized between 1801 and 1810 by Lord Elgin, then British
ambassador to the Ottoman Empire in Istanbul, and sold to the British
Museum in London in 1816. Currently on exhibition in London, the
Elgin Marbles comprise half of the Ionic Frieze, fifteen metopes of the
Doric Frieze, and parts of the east and west pediment sculptures of
the Parthenon, as well as one of the six Caryatids from the
Erechtheum. Decades-long diplomatic efforts having failed, contempo-
rary architecture now seems to represent the last chance for a "reuni-
fication" of the Parthenon sculptures so as to exhibit them in their
entirety.

Beyond the clearly political dimension of the Museum lie its important
architectural and urban dimensions. I will argue here that, in keeping
with Tschumi's other work, developed in the forms of buildings, proj-
ects, and texts, the Museum brings together concept and experience
and succeeds in becoming part of the city on both physical and mental
levels. By doing so, it simultaneously allows for the unexpected and pro-
motes a new sense of the collective.

Textual Data
In 1978, as part of an exhibition titled *Architectural Manifestoes*[3] at
Artists Space in New York, Tschumi displayed a series of images called
"Advertisements for Architecture" that he had completed several years
earlier. Similar to commercial advertisements that combine images with
captioned texts, the works were aimed at triggering desire for what lies
behind the page—in this case, desire for architecture. One of the adver-
tisements was titled "Ropes and Rules." Its lower caption read: "The
most excessive passion always involves a set of rules. Why not enjoy
them?" The upper caption elaborated on this proposition: "The game of
architecture is an intricate play with rules that you may break or accept.
These rules, like so many knots that cannot be untied, have the erotic
significance of bondage: the more numerous and sophisticated the re-
straints, the greater the pleasure." The pleasurable dimension of restric-

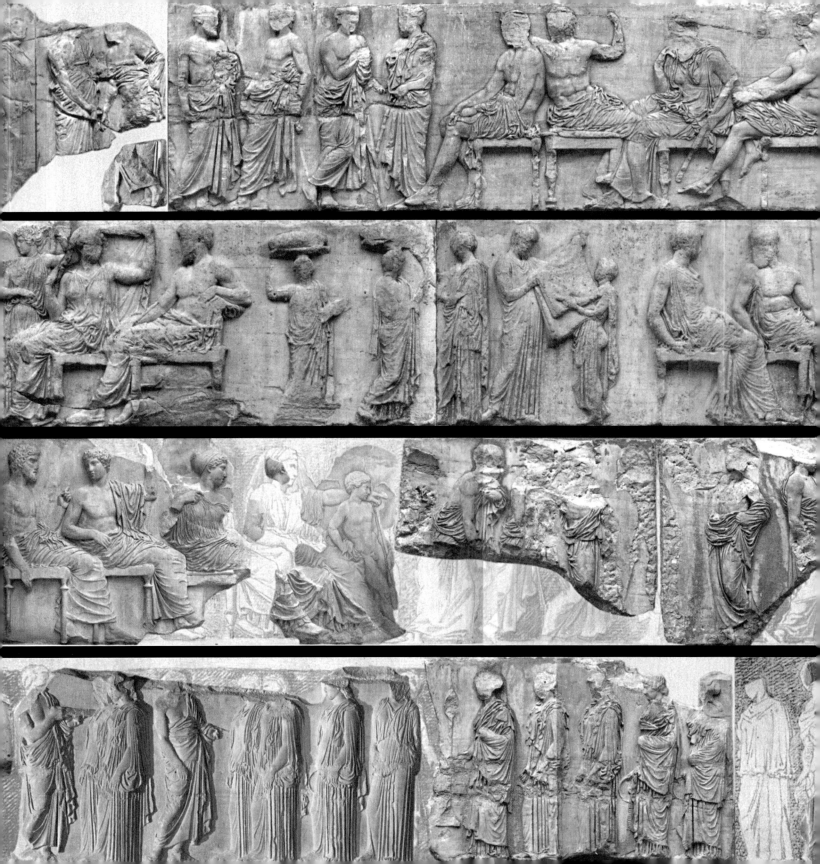

Sequence from *The Manhattan Transcripts*, Tschumi's project using architectural notation to describe events, space, and movement simultaneously

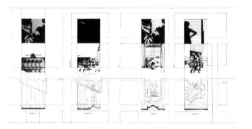

Detail of *The Street*, a linear drawing from *The Manhattan Transcripts* that narrates an imaginary sequential path along 42nd Street

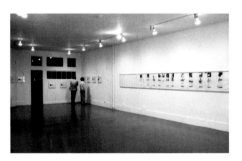

The Street as installed at Artists Space in 1978

tions and regulations—could we call them "context"?—was elliptically and suggestively invoked.

Tschumi developed the concept of "pleasure" in an article, "The Pleasure of Architecture,"[4] first published in 1977. According to him, pleasure could resolve the binary opposition between the conceptual and experiential aspects of architecture, the mental and bodily dimensions of space. "Concept" is presented as an ideal space, a product of mental processes; "experience," in contrast, is about "real" space, the result of social praxis. The tension between the two is indeed paradoxical; it is the pleasure produced at the point where abstract rules and sensuality coexist that revokes the paradox, since pleasure "may lie both inside and outside such oppositions—both in the dialectic and the disintegration of the dialectic."[5]

Four years later, in 1981, Tschumi published *The Manhattan Transcripts*, a book that attempted to "transcribe an architectural interpretation of reality"[6] as well as "things normally removed from conventional architectural representation, namely the complex relationship between spaces and their use; between the set and the script; between 'type' and 'program'; between objects and events." The "implicit purpose" of the architectural drawings, he observed, "ha[d] to do with the twentieth-century city."[7] Here architecture was broken down into three constituent elements—space, movement, and event—that are always present and coexist without any one prevailing over another. These three elements describe the architecture of the contemporary city; space, movement, and event operate in a state of disjunction, in which none of the three can exist without the others nor can it be reduced to one of the other two. The three elements were also represented through different means: plans, sections, and axonometrics; diagrams; and images, respectively. The fragmented condition of the contemporary city and the representational structure adopted in the *Transcripts*' layout find clear analogies in cinematography and its use of temporality, the frame-by-frame technique of narrative development, and the isolation of frozen bits of action. As in film, an organizing sequence becomes visible through the successive frames of the tripartite structure of spaces/objects, movements, and events. The *Transcripts* are about the metropolitan condition as a creator of situations in the urban field. The use of an "architectural stage set" (in which photographs "witness" or record events that occur in architectural spaces, which are defined by traditional disciplinary methods [plans, sections, and axonometrics] as well as by "protagonists" who leave traces of their movements) both deconstructs the metropolitan reality and subsequently transforms it, producing an alternative reality that can be interpreted through the subjective experiences of the viewer who joins together the parts. This is why, for Tschumi, "looking at the *Transcripts* also means constructing them,"[8] disrupting and challenging the conventional linear deterministic approach to the city by suggesting multiple readings. The erotic or pleasurable dimension of the city is revealed and a subjective, metaphorical chain of interpretations released in a never-ending process that brings together architecture and "life."

A decade later, in a lecture titled "Six Concepts,"[9] Tschumi elaborated on the notion of "event" that he had introduced in the *Transcripts*' tripartite structure. He associated the "event" with Situationist discourse and its idea of the "*événement*" as both an event "in action" and "in thought," suggesting a psychosomatic experience. Further references to events as products of unstable and ever-changing combinations of spaces and programs could be established in the programmatically dense conditions of the contemporary metropolis. These unpredictable

associations of spaces and events take on subversive qualities since they reject the linear relationship between function and form. An event thus becomes an "action-in-space," a "turning point," a rethinking of space and the program that "takes place" in it—in short, a dislocation.

Finally, in a recent text published in 2004 under the title "Concept, Context, Content,"[10] Tschumi approached the architectural project using the three respective analytical elements. "There is no architecture," he wrote, "without a concept—an overarching idea, diagram, or *parti* that gives coherence and identity to a building. Concept, not form, is what distinguishes architecture from mere building." At the same time, however, architecture is always attached to a "context," since "a work of architecture is always *in situ*, or 'in situation,' located on a site and within a setting." Clearly, context can be multifaceted: it can be political, cultural, or "other," and does not necessarily prescribe visual boundaries that dictate its effortless reproduction as form. The third element, "content," concerns the program of any architecture: "There is no architectural space without something that happens in it." Given that concept, context, and content all contribute to the final architectural product, it is the definition of their relationship that will determine the project's character. Is this relationship one of "indifference, reciprocity, or conflict," Tschumi asks?

The architectural project of the New Acropolis Museum can be approached through the three analytical elements of content, context, and concept, in that precise chronological order, since the sculptural collection (content) preceded any physical or mental site conditions (context) which, in turn, preceded the architectural idea (concept).

Content: The Collective

The Museum's content represents, without a doubt, the apogee of classical art—but let art historians and archaeologists expand on that. Instead, what interests me here is to consider the many exquisite statues of boys and girls, heroes, gods, and demigods, athletes and warriors, equestrians and chariot soldiers, animals, mythical beasts, and monsters as a representation of the collective—as a group of differing people, young and old, male or female, surrounded by deities and mythical creatures and horses and cattle, who live in Athens and share common binding principles or ideals about life. Some of these statues and sculptures present a welcome smile, a serene look, or evident signs of struggle; others mourn as if for an unfortunate event; still others reveal slight traces of color or geometric patterns on their clothing. All of them visibly transform in the changing shadow and light, and they ask for our help in imaginatively filling in their missing parts. Placed together in a single space—the galleries of the Museum—they become the citizens of the ancient, former city who have been modeled out of marble. If you look closer, they could actually be alive.

The same applies to the sculptures of the Parthenon's Ionic Frieze. The Frieze was not an applied work of art but rather a structural part of the edifice—a unity of architecture and art—that was sculpted *in situ* from 443 to 438 B.C. by Phidias and a crew of assistants on the blocks of marble that supported the building. The Frieze is made out of a continuous strip of scenes, some 160 meters long and 1.02 meters high, which was located in the upper part of the "pteroma," the corridor surrounding the cella, or enclosed inner volume, of the temple. Since the public was not allowed in any part of the temple, the Frieze could only be seen from the outside and from below, at a rather sharp angle, while walking around the building. It is important to keep in mind that in order to "read" the sequence of actions represented in the Frieze one had to combine vision

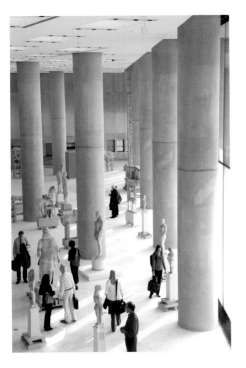

Spectator and art intermingle in early tests of an installation strategy.

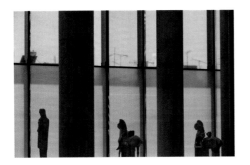

The Archaic Gallery

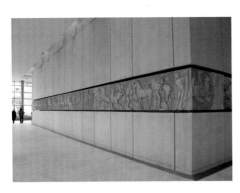

The Frieze as restored in the Parthenon Gallery

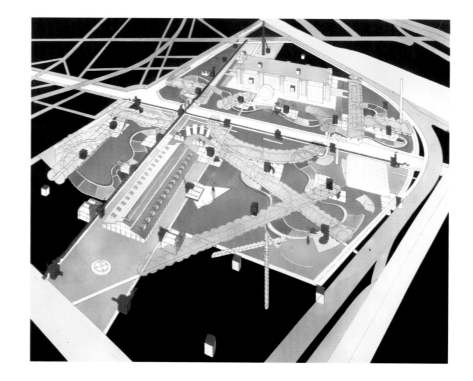

The Parc de la Villette is organized around a grid of red steel *folies*, small buildings containing a range of programs such as a café, an information center, a jazz club, and a first-aid station as well as lookouts, bridges, and passages.

The park also includes gardens, canals, playing fields, and promenades set off by the *folies*.

Folie detail

and movement. Indeed, the Frieze is a sculptural narrative that depicts the Panathenaic Procession, a ceremonial march of the Athenian people during the Great Panathenaia, a festival organized every four years to honor the goddess Athena, the founder and protector of Athens. The procession began at the northwestern Gate of Dipylon, then crossed the Kerameikos Cemetery and the Agora, climbing up the Acropolis Rock to end with the offering of the "peplos," or sacred cloth, to the statue of Athena inside the Parthenon. The Parthenon takes its name from its identity as the temple of Athena Parthenos, the Virgin goddess.

The Frieze sets up a continuous narrative of actions and social practices common to the citizens of Athens. Its sequence blends together humans and gods, men and women, elders and youths, political representatives and musicians from all ten tribes of the city, all engaged in different rituals—preparations for horseback riding, holding vessels and offerings, chariot or track-and-field races, to name just a few. The sequence encompasses 360 human figures, the twelve Olympian gods, and more than 250 animals, mainly horses and bulls. The unfolding of the scenes of the Frieze resembles the unfolding of frames in a cinematographic film. However, Phidias was not interested in producing a documentary recording specific details of the march, but rather in creating an ideal city that combined its mythology, history, and extraordinary present into a single, glorifying whole. This fact of intention may explain the problems faced by contemporary archaeologists when dealing with the place and time of several depictions. Ideal Athens, as celebrated through democratic collectivity, is simultaneously a propagation of its democratic ideals—a project shared equally by all the Acropolis monuments that were constructed during the Periclean Golden Age. The anaglyphs, which emerge from their marble backgrounds to acquire volume from the shadows cast by the surrounding light, are a call to a psychosomatic experience, part of an abstract and ideal society that seems more alive today than ever.

Context: Visual, Mental, and Physical
For an architect with conceptual origins, Tschumi has proven to practice excellent contextual architecture. Not "contextual" in the sense of reproducing the iconography or formal data of a context, but rather of ob-

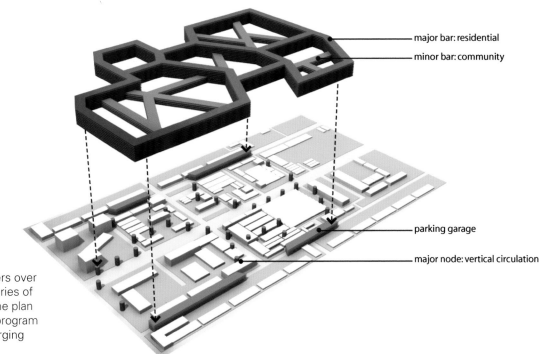

major bar: residential

minor bar: community

parking garage

major node: vertical circulation

Tschumi's Factory 798 project hovers over a vibrant arts neighborhood on a series of columns that contain circulation. The plan accommodated a major multi-use program without destroying a dynamic emerging neighborhood.

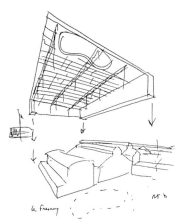

A sketch for Le Fresnoy, where a large electronic roof is superimposed on a building complex that once housed a 1920s leisure center

The in-between space generated by the electronic roof

taining from that context, through a process that I would call a "revealing of intelligence," the data necessary to inform or even determine the design of a project. Since we are dealing with the Acropolis Museum, a museum designed to exhibit archaeological treasures, the process of "revealing" might be compared to that of unearthing, or discovery, in an archaeological excavation.

In the same way, the Parc de la Villette (1983–98)[11] in Paris applies an external organizing device—the point-grid with red cube *folie* structures at each intersection—but is "contextualized" or, more properly, "territorialized" by recognizing the specificities and restrictions of the site, namely, its bisecting canal, metro station entrances, street accesses, and existing buildings. Similarly, the National Center for Contemporary Arts (Le Fresnoy, 1991–97)[12] in Tourcoing, France, applies an external device—the large horizontal roof—that is subsequently "contextualized" by incorporating the specificities of the adjacent canal and the underlying buildings of an old recreation complex from the 1920s. The latter make up an "archaeological site" that prescribes foundation points, the undulation, folds, and openings in the roof, and the location of horizontal and vertical circulation, ramps, pathways, and staircases. In a third example, the Factory 798 project (2003)[13] in Beijing, the volumetric lattice that makes up the building complex is produced by connecting the points available for foundation structures in the voids of the underlying manufacturing facility from the 1950s. It too can be seen as the remains of a twentieth-century industrial archaeological site.

The context of the New Acropolis Museum is manifested primarily through the presence of the Acropolis and particularly the Parthenon, the place of origin of the Museum's exhibits. This is simultaneously a visual and a mental or conceptual context. Tschumi's project, as opposed to other entries in the 2001 international competition, is in this sense extremely "contextual." It had a clear idea: to establish a continuous visual relationship between the new building (as the space for safeguarding and exhibiting the Acropolis sculptures) and the ancient monument (as the place where the sculptures came from). In an expanded reading, this relationship between old and new, based on vision and mental associa-

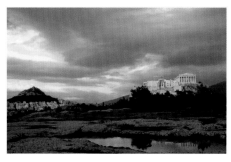

The Acropolis with Mount Lycabettus in the background

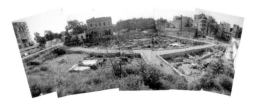

The Makriyianni site before construction

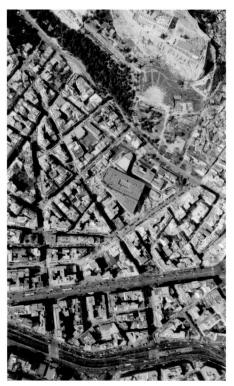

Aerial view of the Acropolis and the New Acropolis Museum

Sound-dampening holes in precast concrete panels

tion, would act as a continuous reminder of the Marbles' place of origin. "Contextuality" reaches its pinnacle in the decision to locate the most precious part of the collection, the Parthenon Frieze and pediment sculptures, in a top-floor prism, a glass gallery whose geometry is freed from the geometry of the city grid to take up the geometry of the Parthenon itself. The Parthenon Gallery is placed parallel to the ancient temple, with the Frieze organized around an indoor court so as to recreate the orientation of its original setting: because all sides have the original orientation, they are lit by the same natural light and receive the same shadow in an installation that approximates its antique predecessor. This is context reconstructed. As opposed to the exhibition logic of the previous underground Acropolis Museum adjacent to the Parthenon and the British Museum, where the visitor moves through a large, secluded, and introverted hall surrounded by sculptures that are visible simultaneously in a near-total view, here the sculptures are seen only partially and in sequence. In order to view the Frieze, one has to walk along it; as in antiquity, movement becomes an indispensable part of the experience. Moreover, the viewer/visitor can simultaneously observe the Frieze and glimpse the Parthenon, from which the Frieze originated: the Museum is just a diaphragm—a transparency or pane of glass—that separates the two conditions.

An additional if unexpected layer of contextual complexity came from the Museum's very site. Selected by the Organization for the Construction of the New Acropolis Museum, the site is located in the Makriyianni neighborhood just below the Acropolis rock. A tight and largely vacant lot, it originally included several buildings from the Bavarian, Neoclassical, Art Deco, and modern periods, some of which were demolished before and during construction. Although the suitability of the site for housing a large museum was repeatedly questioned and other, less congested sites were offered to participants as alternatives in the international competition of 1990, the State's insistence on the chosen site had to do with the direct visual connection it offered with the Parthenon. When foundation work began, digging revealed an entire part of the ancient city, including the ruins of buildings and urban infrastructure in the form of an historical palimpsest extending from the sixth century B.C. to the fifth century A.D. These finds turned the lot into an archaeological site, thereby slowing down construction and forcing the repositioning of foundation columns. The building would have to float above the ground, elevated on pilotis, and touch the earth only at specific points determined carefully so as not to destroy the ruins. Special triple columns had to be designed, longer spans needed to be dealt with, and openings and glass floors had to be introduced in the ground-level slab to allow light and views into the ancient city ruins. It is as if the new Museum rises from the findings it houses.

One last layer of context should not be neglected. The Museum is located in a dense part of contemporary Athens characterized by the presence of a number of Neoclassical buildings but by far more modern *polykatoikias*, the postwar apartment buildings that epitomized architecture of the 1950s and '60s and produced the vivid urban ambiance that gives Athens a unique character. The Museum rises up through the modern city—its extra-large volumes seem almost squeezed inside the small- to medium-scale urban mass—and then manages to free itself above the surrounding cityscape. It does not close itself off from the amorphous city that encircles it, but instead allows for horizontal views through large glass surfaces. These views over the city blend the ancient sculpted figures with the contemporary built environment: fragments of gods, heroes, humans, animals, and mythical creatures from classical antiquity interact with fragmented, abstract modern architec-

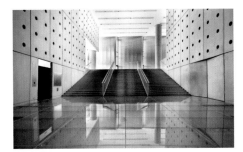

The glass ramp to the Archaic Gallery

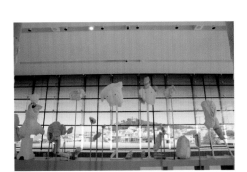

The fragmented sculptures that once adorned the west pediment. Trial installation with casts

Floors in the building core are made out of glass, allowing light to filter through the building.

ture in an unprecedented way, negating the expectation of a conventional and sterile museum environment.

Concept

To be strong and convincing, concepts have to be concise. The Museum consists of the stacking and rotation of two gallery prisms that are contextualized through vision and light.

Architecture: The Museum as an Urban Fragment

The three organizing elements of the Museum's architecture are about to be established:

Movement: Circulation within the Museum is organized in the form of a spiral rising vertically from bottom to top. It can be described as an architectural promenade that follows a chronological order: ground-level excavations, museum entrance hall and amphitheatre, Archaic sculpture gallery, top-floor Parthenon sculpture gallery, Roman collections. Parts of the floors and ramps are made out of transparent or translucent glass that further interconnects the different spaces of the Museum, establishing vertical unity.

Space: As opposed to earlier work by Tschumi, the New Acropolis Museum is a rather sober project based on stacking and rotating two prisms—a large trapezoidal prism on the bottom and a smaller orthogonal glass prism on top that is shifted in plan so as to assume the same orientation as the Parthenon. The materials selected are basic, modest, and simple: precast and cast-in-place exposed concrete; glass; undulating stainless-steel panels (which act as sun-protectors); and local black and beige marble (for flooring). The use of a minimalist formal language, basic orthogonal geometry, and local materials common to Greek construction, as opposed to elaborate, expressionistic forms and imported materials (all characteristic of much current museum design) shifts attention away from the Museum's volumes, forms, and materials to its priceless collection. The Museum's architecture acknowledges that the collection is the a priori protagonist and avoids competing for dominance. This is why Tschumi calls his project an "anti-Bilbao," referring to the Guggenheim Bilbao Museum (1997), designed by Frank Gehry for the Spanish city of Bilbao, which ignited a trend of cultural buildings whose architecture often outshines the art works they house. Their forms are so particular that they are more successful in creating iconic landmarks for their cities.

The exhibition spaces in the New Museum are parts of the two orthogonal prisms that make up the whole and are placed along the path of movement, incorporating different envelope conditions. On the first above ground level one finds the large Archaic sculpture gallery, a double-height hypostyle hall where statues are freely placed in the space so as to intermingle with the moving figures of visitors. The result is a contemporary or "relived" Agora, transformed by everchanging natural light. On the second level, a small store and a café offer views of the ancient Acropolis Rock as well as the surrounding city. The Parthenon Gallery, located on the third and topmost level, aims to reconstruct the original viewing experience: the white marble artworks are lit with fluid natural light that enters the space from the exact same angle as in antiquity, and they are placed in the center of the space around an inner volume so as to encourage visitors to move around them. The Frieze's ideal narrative thus unfolds through time in a 360-degree circuit. To paraphrase Tschumi when referring to the (fragmented) narrative of the *Transcripts*: Looking at the Frieze also means constructing it.

Here, for the first time since the early nineteenth century, when all the sculptures were part of the Parthenon, the visitor can enjoy the Frieze in its entirety; both the parts in Athens and the parts in London are represented. The latter, of course, are plaster copies that are whiter than the originals (which exhibit the patina of time), making the originals stand out in contrast. The recreation is both didactic (offering a perception of the entire sequence or complete narrative) and polemical (posing a constant reminder of the missing pieces and a claim for their return). When one turns away from the Frieze to look out through the glass, the image of the Parthenon is waiting. This simultaneous view of the sculptures and their place of origin offers a total experience.

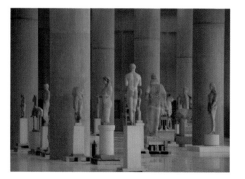

Every effort was made to ensure that visitors and sculptures are not separated by partition walls or barriers in the Archaic Gallery.

Event: How can one instigate architecture's third element, the event, which by definition cannot be designed? We must remember that the event is simultaneously spatial and mental and that the unlikely association of spaces and events can disrupt normalcy; as a result, it can be subversive. As already implied in more than one instance, visiting the Parthenon sculptures is an "eventful" experience because they not only offer visual fulfillment (based on their formal plasticity and craftsmanship) but also represent something broader—a society or shared set of ideals that goes beyond the associations triggered by the depicted figures or scenes. Moreover, the fact that the design of the Museum does not confront the space of the museum as a static, self-referential environment for storing and exhibiting art (an enclave within the city), but instead profits from its loaded context, promoting exteriority and inclusion, makes the project disrupt expectations; the experience becomes pleasurably subversive. The act of opening itself up to the city establishes a continuous interaction based on vision and conceptual relationships. The references invoked are both eponymous and anonymous: the Parthenon (the *raison d'être* of the museum), the geomorphology of the Acropolis Rock (fortifications designed through orthogonal geometry combined with curvaceous slopes, soil, greenery, and fragments of ancient columns), the Theater of Dionysus (lingering traces of a glorious construction, the birthplace of tragedy), the Roman Odeon of Herodus Atticus (a reconstruction of antique atmosphere), and the constant flow of citizens and tourists (always in motion, the latter always photographing) along the pedestrian street of Dionysiou Areopagitou, which defines the perimeter of the Acropolis archaeological site. To them should be added the common, inglorious, and tactile qualities of the Museum's ground-level urban palimpsest (chthonic associations unleashed), the surrounding modern city of the *polykatoikias* (a *répétition différente*), and the bustling streets of the Makriyianni neighborhood (intermingled people, scooters, and cars). And still beyond, the skyline of the surrounding mountains of the Athenian Basin (the grey profile of Ymmitos, a protective embrace), the green density of Philopappos Hill, and the horizon to the south (serene blue sea, an exodus).

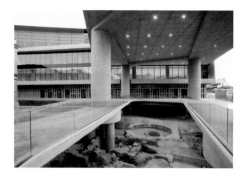

The museum entrance has voids that look down over the excavations.

The new Museum provides a stage for the varied sculptures to relive by interacting with citizens and visitors in the city that produced them, convoking an ephemeral version of Athenian community. Although the city has changed in the passing years, they are still grateful to be part of it.

Afterword

Like all significant contemporary work, the New Acropolis Museum has stimulated intense interest. The airlifting of the sculptures down from the Acropolis to the Museum via three large cranes and the arrival of the first sculpture in its new home were broadcast live on national television. The official opening in summer 2009 is generating publicity unprecedented for a public building. The international press has welcomed the building as an important architectural work. The debate at

The contrasting alignment of the Parthenon Gallery creates interesting moments on the facade.

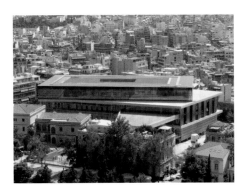

The Museum as seen from the Parthenon

home, as recorded in numerous publications, has acknowledged the Museum's cultural significance but also questioned its abstract forms, its large volume, and its relationship to the surrounding buildings (nostalgia for the long-gone familiarity of small scale, the still-unhealed trauma of the Modern city?). The last issue has triggered a broad discussion on the role, place, and formal expression of contemporary public architecture in Greece.

One thing is for sure: the New Acropolis Museum is at once local and global. It operates on the local scale as a powerful "urban magnet" that draws together the city's public spaces and pedestrian streets. It acts as a catalyst for changing common perceptions about modern public architecture, and no doubt will contribute to a new image for the city. At the same time, it operates globally by confronting current issues on the role and significance of form, spatial organization, movement, transparency, and envelope design. The exhibition strategies it introduces—including the combination of vision and movement, the generous presence of natural light, the loose arrangement of artworks in space, and the treatment of the exhibition gallery as an extension of the city—are innovative and will constitute a foundation for future debate.

As with all of Tschumi's work, the New Acropolis Museum is about the pleasures and struggles of man, the unpredictability of encounters, the coming together of body and mind, and the constant interaction with the dense urban environment as well as the emphatic exploration of its cultural significations. The Museum sculptures, products of artists of exceptional talent and intellect, are also about the meeting of body and mind, the enjoyment and hardships of life, the celebration of the individual, and the individual's role in defining a (contemporary) collective, sharing common ideals. The two meet in the new Museum.

1. The Museum is the product of the New York office of Bernard Tschumi Architects, working with the local associate Michael Photiadis/ARSY of Athens and the engineers Arup (New York) and ADK (Athens).
2. The old Acropolis Museum was built in two consecutive phases, from 1865 to 1874 and from 1946 to 1964.
3. See Bernard Tschumi, *Architectural Manifestoes* (New York: Artists Space, 1978).
4. Bernard Tschumi, "The Pleasure of Architecture," *Architectural Design* 47, no. 3 (March 1977): 214–18, reprinted in Tschumi, *Architecture and Disjunction* (Cambridge, MA and London: The MIT Press, 1993), 81–96.
5. Ibid.
6. Bernard Tschumi, *The Manhattan Transcripts* (London and New York: Academy Editions/St. Martin's Press, 1981), 7.
7. Ibid., 7.
8. Ibid., 9.
9. Tschumi, "Six Concepts," in *Architecture and Disjunction*, 227.
10. Tschumi, "Concept, Context, Content," in *Event-Cities 3* (Cambridge, MA and London: The MIT Press, 2004), 11.
11. See Bernard Tschumi, *Event-Cities 2* (Cambridge, MA and London: The MIT Press, 2000), and Bernard Tschumi, *Cinegramme Folie: Le Parc de la Villette* (New York and Paris: Princeton Architectural Press/Champ Vallon, 1987).
12. See Bernard Tschumi, *Event-Cities* (Cambridge, MA and London: MIT Press, 1994), and Bernard Tschumi, *Le Fresnoy: Architecture In/Between* (New York: The Monacelli Press, 1999).
13. See Tschumi, *Event-Cities 3*.

The Drawings

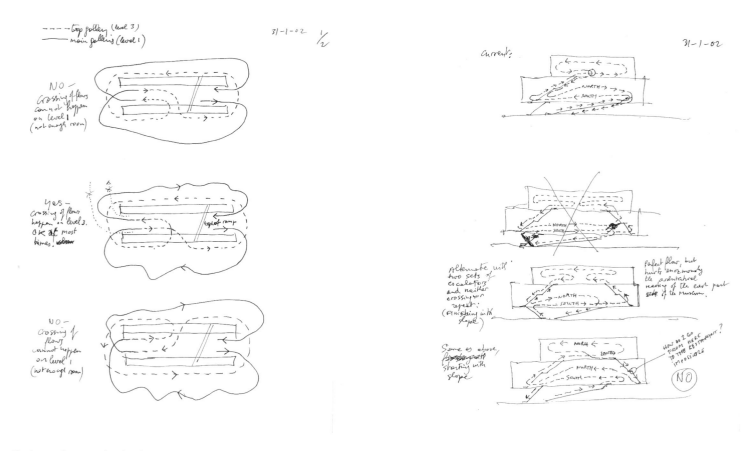

Early studies emphasized
circulation routes throughout
the building.

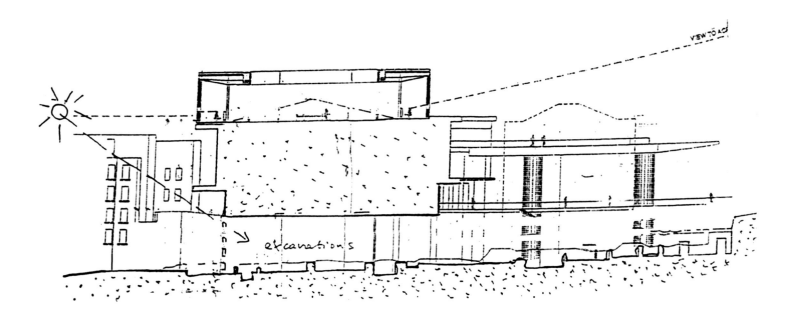

Sketching the relationship
between sunlight, Acropolis
views, and the excavations

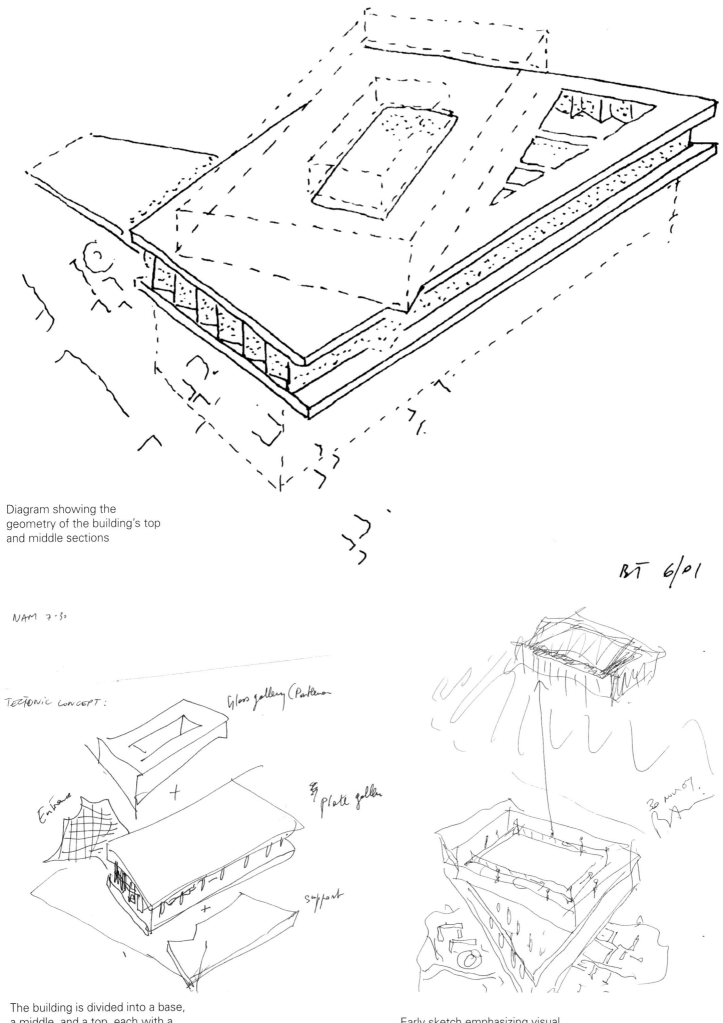

Diagram showing the
geometry of the building's top
and middle sections

BT 6/01

NAM 7-30

TECTONIC CONCEPT:

Glass gallery (Parthenon

Entrance

plate gallery

support

30 NOV 01.
BT

The building is divided into a base,
a middle, and a top, each with a
programmatic specificity.

Early sketch emphasizing visual
connection with the Parthenon

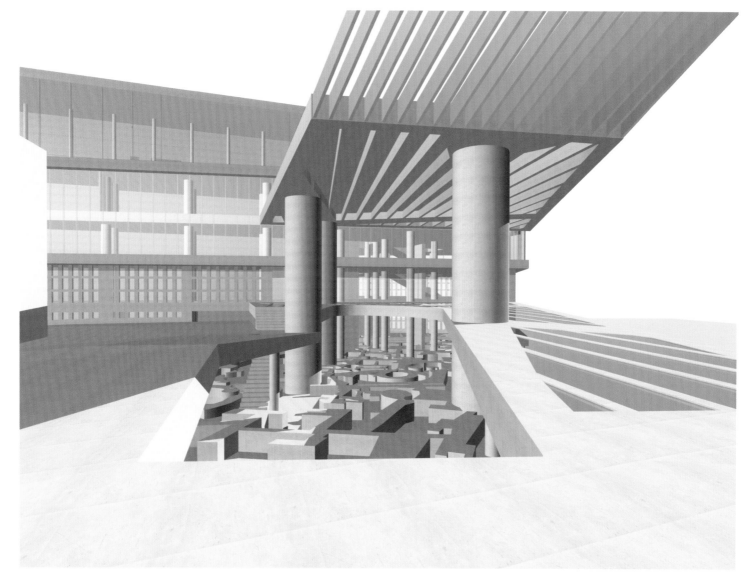

Entrance sequence

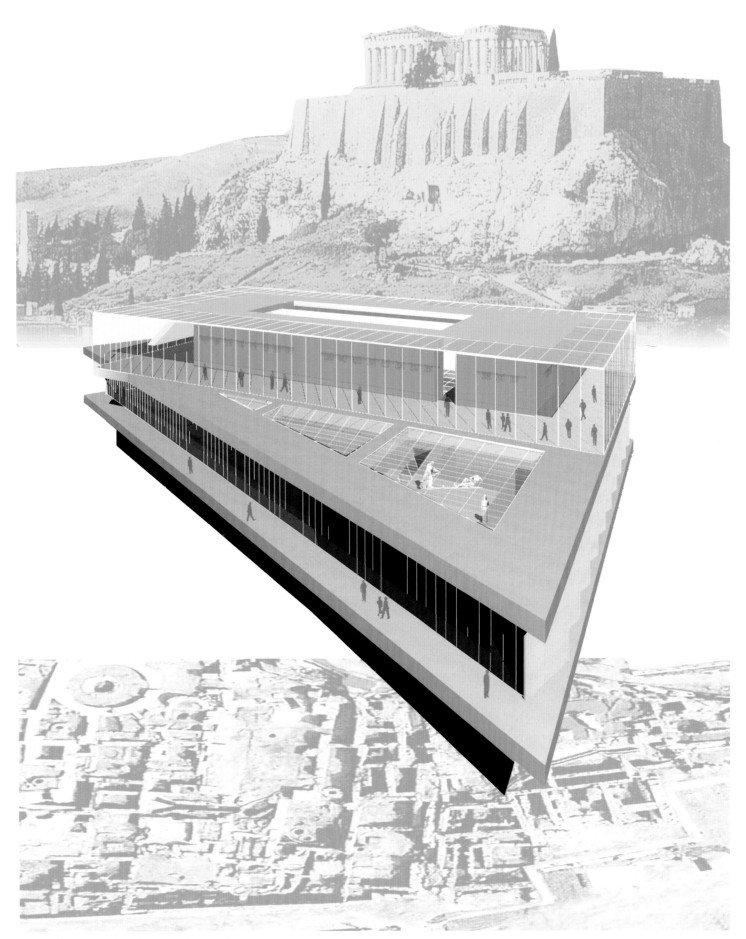

Competition rendering showing the building
mediating between the Acropolis above and
the archaeological remnants below

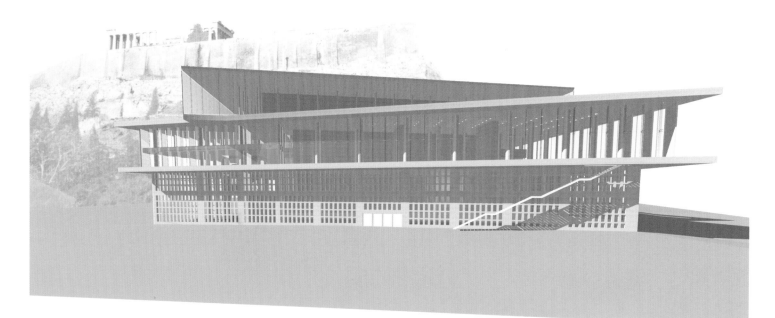

South facade

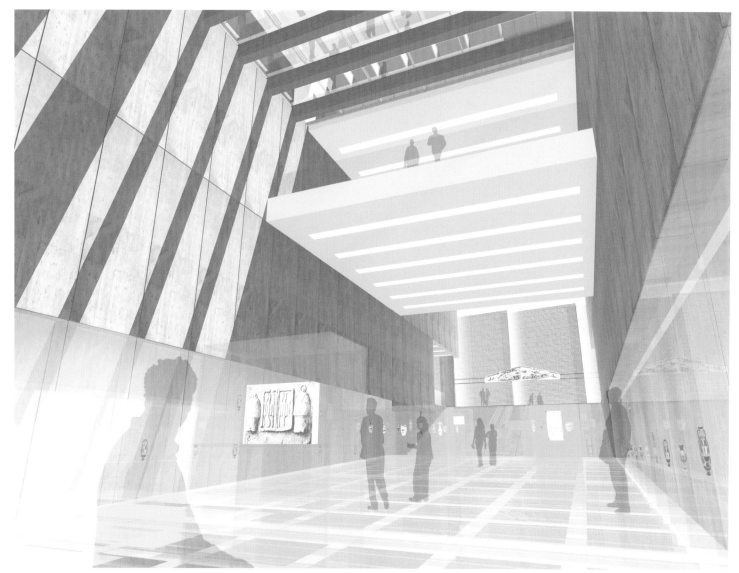

The building core with skylights and glass floors

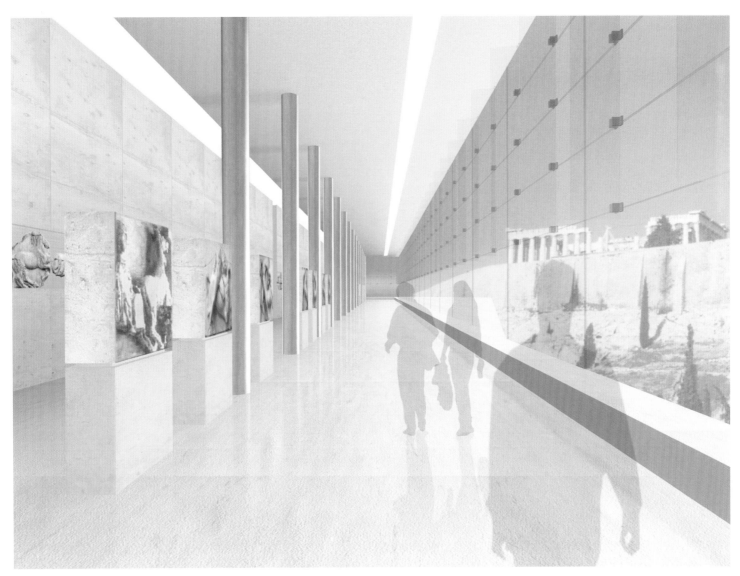

The Parthenon Gallery

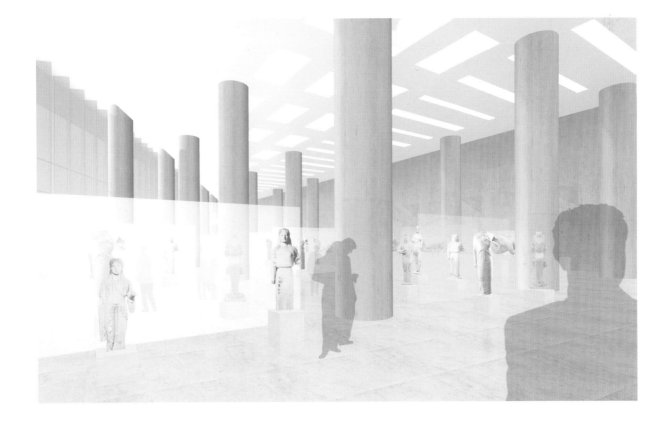

The Archaic Gallery in an early rendering

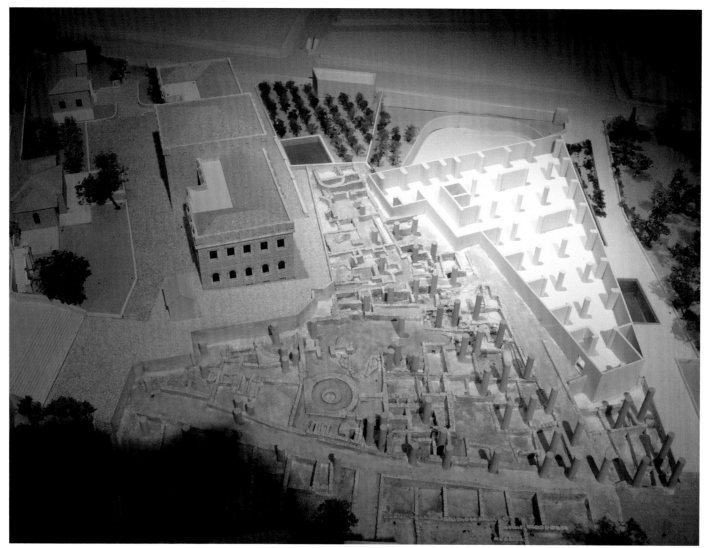

Site model showing points of contact

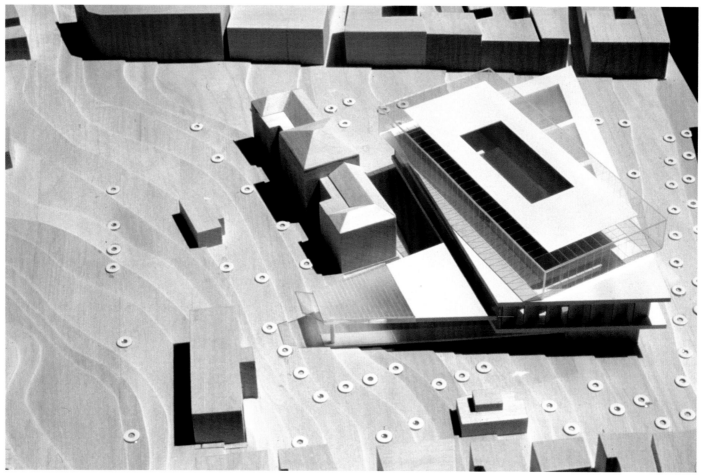

Competition model

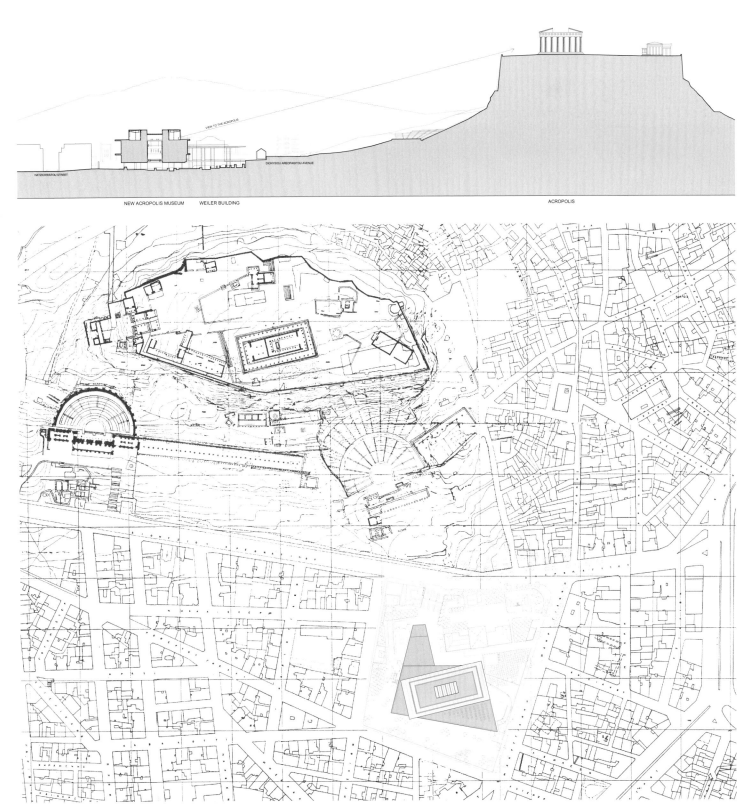

Site plan showing surrounding
neighborhood and the Acropolis

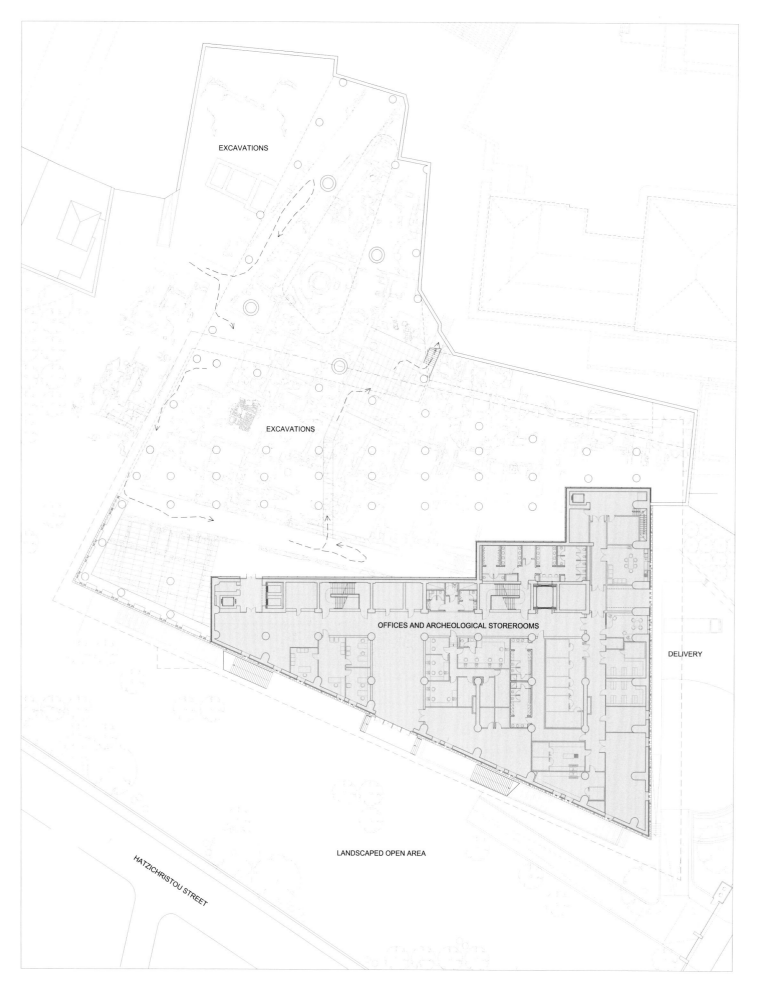

EXCAVATIONS

EXCAVATIONS

OFFICES AND ARCHEOLOGICAL STOREROOMS

DELIVERY

LANDSCAPED OPEN AREA

HATZICHRISTOU STREET

Level -1 plan (Support)

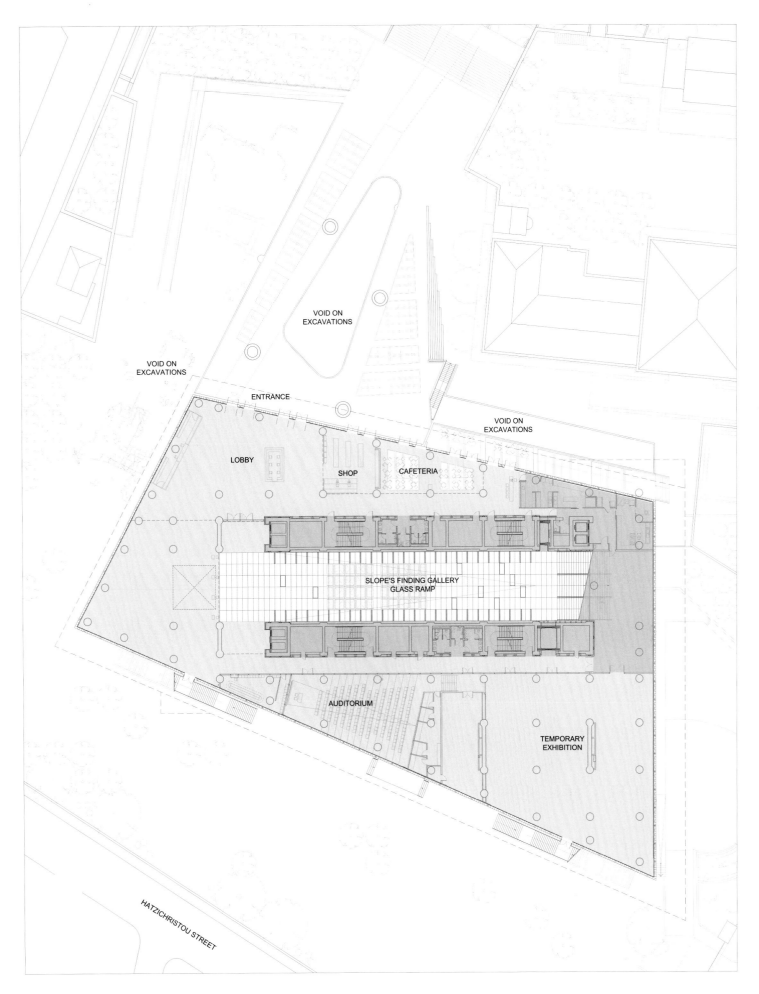

VOID ON
EXCAVATIONS

VOID ON
EXCAVATIONS

ENTRANCE

VOID ON
EXCAVATIONS

LOBBY

SHOP

CAFETERIA

SLOPE'S FINDING GALLERY
GLASS RAMP

AUDITORIUM

TEMPORARY
EXHIBITION

HATZICHRISTOU STREET

Level 0 plan (Entrance and Lobby)

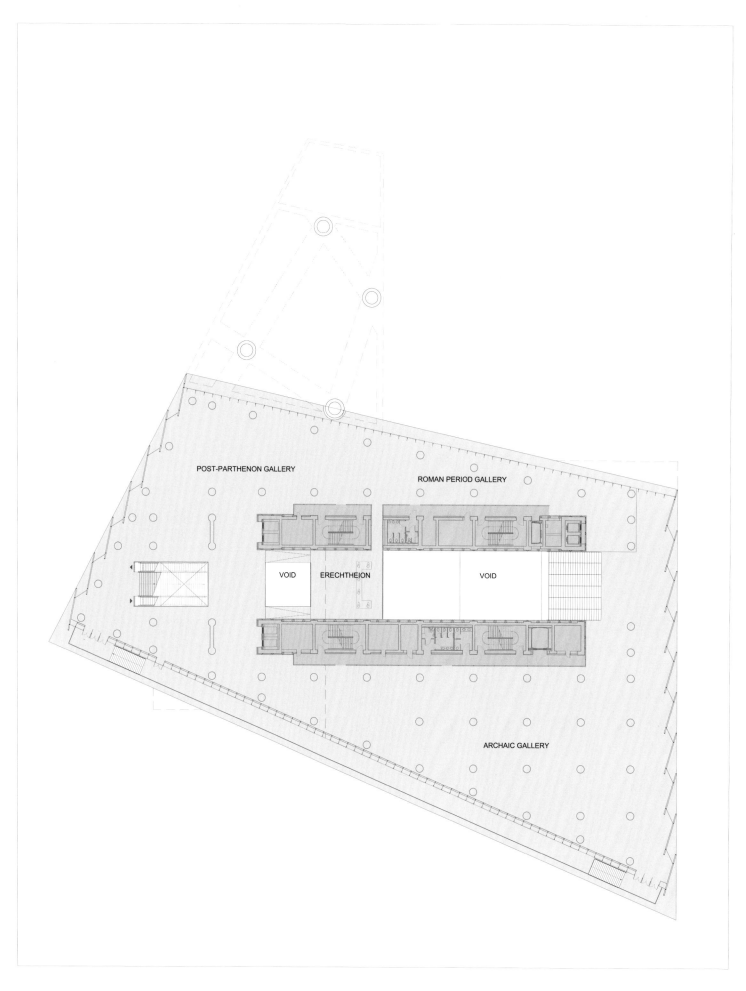

POST-PARTHENON GALLERY

ROMAN PERIOD GALLERY

VOID

ERECHTHEION

VOID

ARCHAIC GALLERY

Level +1 plan (Main Galleries)

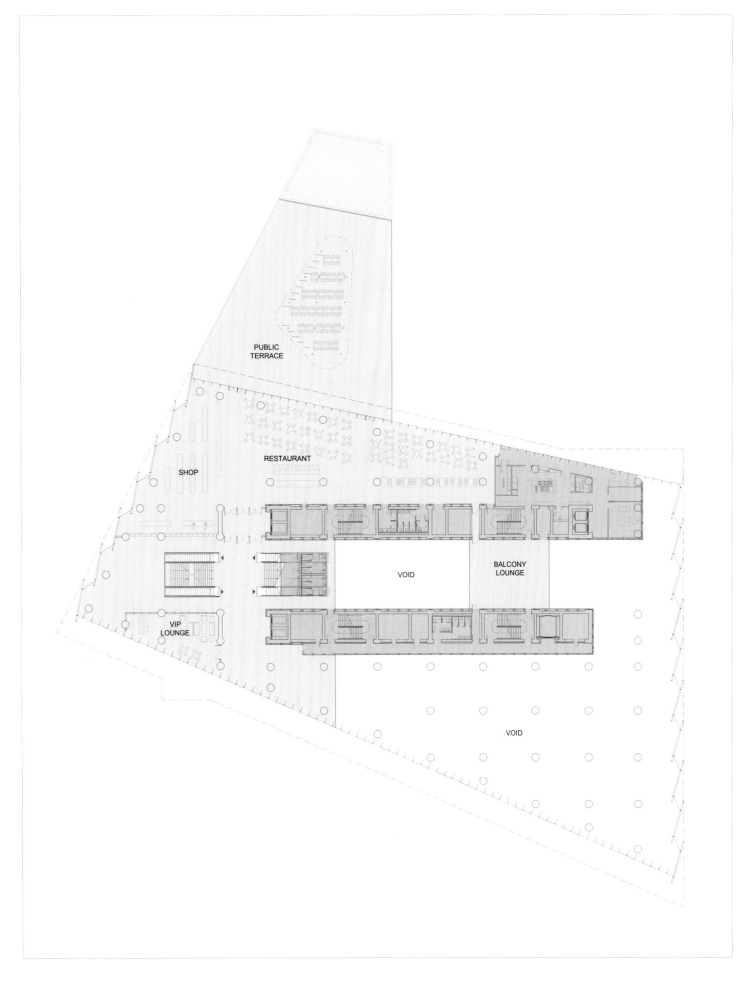

PUBLIC
TERRACE

SHOP

RESTAURANT

VIP
LOUNGE

VOID

BALCONY
LOUNGE

.VOID

Level +2 plan (Mezzanine)

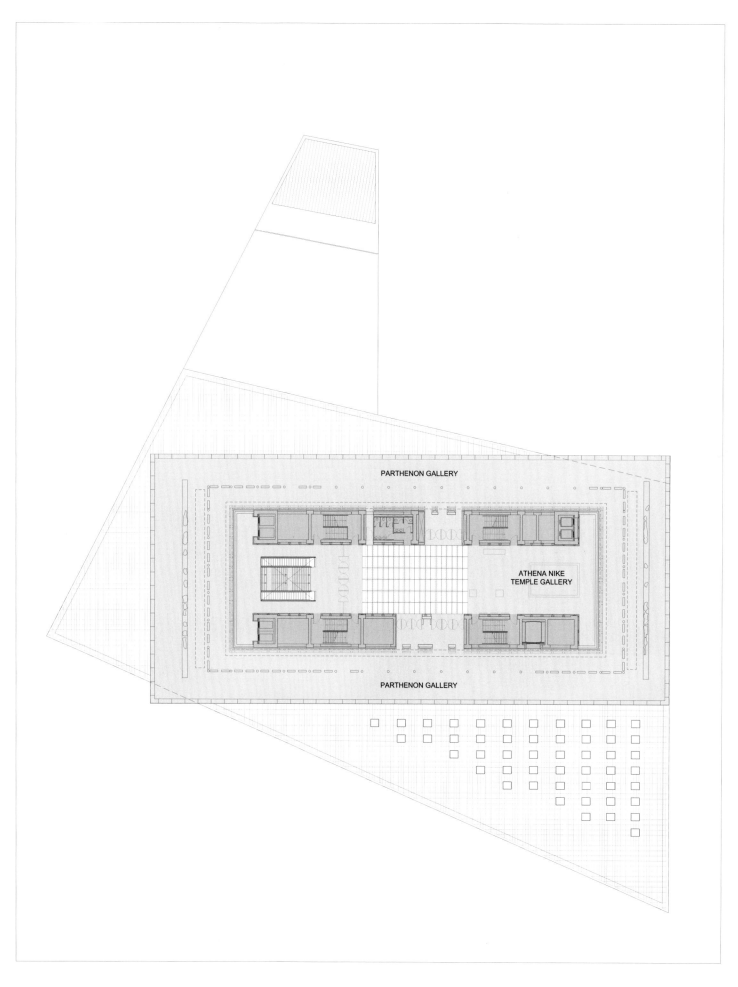

PARTHENON GALLERY

ATHENA NIKE
TEMPLE GALLERY

PARTHENON GALLERY

Level +3 plan of the Parthenon Gallery

TERRACE

Roof plan

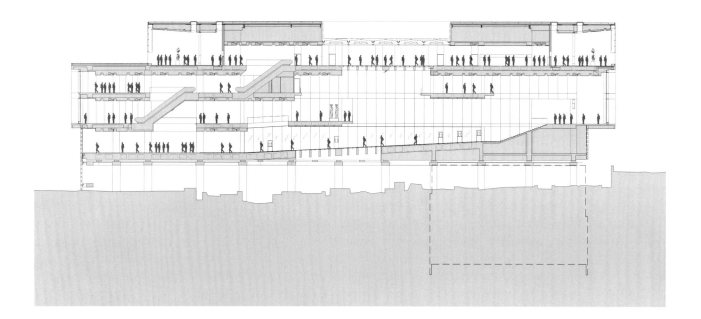

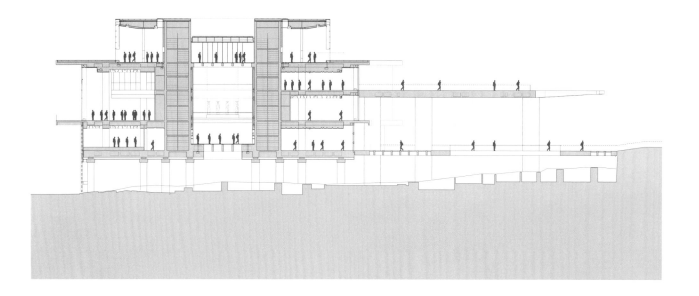

Longitudinal and transverse sections

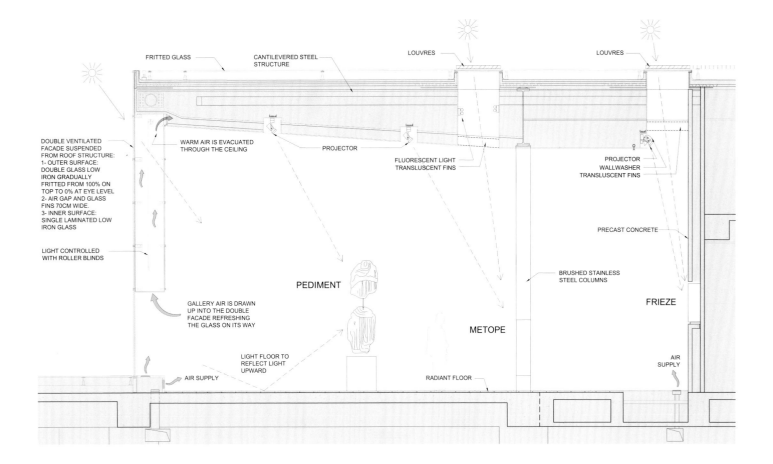

FRITTED GLASS

CANTILEVERED STEEL STRUCTURE

LOUVRES

LOUVRES

DOUBLE VENTILATED FACADE SUSPENDED FROM ROOF STRUCTURE:
1- OUTER SURFACE: DOUBLE GLASS LOW IRON GRADUALLY FRITTED FROM 100% ON TOP TO 0% AT EYE LEVEL
2- AIR GAP AND GLASS FINS 70CM WIDE.
3- INNER SURFACE: SINGLE LAMINATED LOW IRON GLASS

WARM AIR IS EVACUATED THROUGH THE CEILING

PROJECTOR

FLUORESCENT LIGHT TRANSLUSCENT FINS

PROJECTOR WALLWASHER TRANSLUSCENT FINS

LIGHT CONTROLLED WITH ROLLER BLINDS

PRECAST CONCRETE

PEDIMENT

GALLERY AIR IS DRAWN UP INTO THE DOUBLE FACADE REFRESHING THE GLASS ON ITS WAY

BRUSHED STAINLESS STEEL COLUMNS

FRIEZE

LIGHT FLOOR TO REFLECT LIGHT UPWARD

METOPE

AIR SUPPLY

RADIANT FLOOR

AIR SUPPLY

Diagram of the Parthenon Gallery

Conceptualizing Context

Bernard Tschumi

Panoramic collage of the site

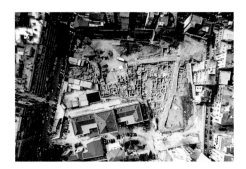

Aerial view of the excavations

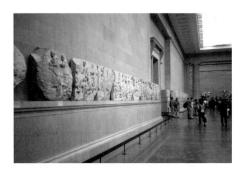

The Parthenon Marbles as exhibited in the British Museum

The design for the New Acropolis Museum began with a simple question made up of three independent parts. How does one design a building located only 300 meters away from the most influential building in Western civilization? Additionally, how does one design a building when its site is an extraordinary archaeological graveyard containing the remains of many centuries of civic life in Athens? Equally insistent was the third query, how to design a structure whose unstated mandate is to facilitate the reunification of the Parthenon Frieze, when half of it is still on display at the British Museum in London? The challenges of the project lay in its starting conditions, its irreducible context.

At such a time, an architect does not think about architectural theory or even architectural form. If he wants to appeal to historical figures or precedents for influence or advice, the appeal does not go out to Phidias, the sculptor behind the Parthenon Marbles, but rather to Pythagoras, the mathematician. In our design for the Museum, we aimed to arrive at the clearest concept possible, the most concise and elegant expression of the set of ideas that embodied the remarkable challenges of the project. Yet those challenges were not abstract, but rather inextricable from the project's specific and extraordinary circumstances: a possibly incomparable civilization dating from 2,500 years ago with beautiful and irreplaceable sculptures that needed to be protected and exhibited in an historical environment located in a climate that is both hot and prone to earthquakes. Floating above these many challenges were the demands of the Attic light, at once serene and implacable, which had to be incorporated both as a defining element and an architectural material.

During the first years of design, the Museum remained an anomaly, a building whose evolving features did not seem to fit within the established contours of my architectural practice. But it gradually came to appear as a work that not only tied together many fragments of my preoccupations but also filled a long-abiding gap or lacuna. Context—that chimera to any conceptually oriented architect or theorist as well as the *raison d'être* of many bland "contextualist" buildings— was the term or field of investigation that the Museum both epitomized and fulfilled.

The New Acropolis Museum is unthinkable outside of the context of the Acropolis "Sacred Rock" and the Parthenon temple located above it, with which the Museum establishes an architectural and cultural dialogue. It is also inconceivable without the ongoing excavations at its base that bring to light both "old" Athens and the teeming contemporary city around it. As its design developed, the Museum became equally about the city that gave rise to the remarkable civilization embodied in the Acropolis artifacts and the needs, demands, and often loudly expressed

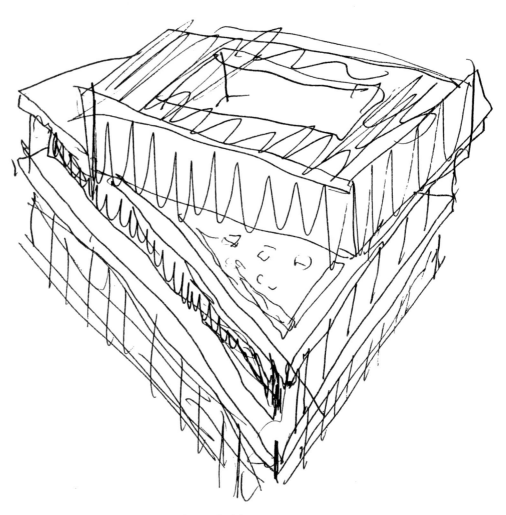

Sketch of the New Acropolis Museum

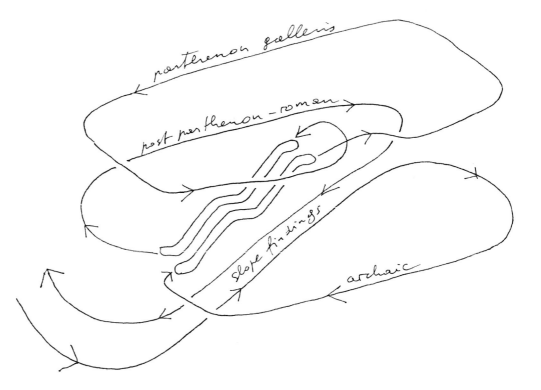

Circulation diagram

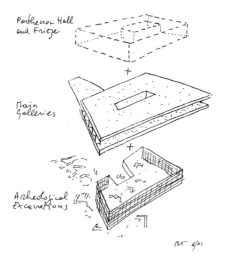

Parthenon Hall and Frieze

Main Galleries

Archeological Excavations

BT 6/01

The base, the middle, and the top

Columns had to be placed with absolute precision; here the steel rebar for a future column is juxtaposed with the walls of an ancient home.

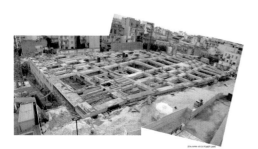

The Museum is built in two independent parts for seismic isolation; it rests on a series of bearings that cushion the Museum and dampen earthquake vibrations.

opinions of the Athenian people today. Indeed, as excavations brought new artifacts to light, determining aspects of the Museum structure and architectural design, and as we explored exhibition strategies to respond to the demands of its collections, the project became inseparable from its circumstances and site. The added challenge of making the ongoing excavations not only visible, but also permeable to the Museum visitor only accentuated the complex dimensions of the Athenian city, past and present, that were both incorporated and represented in the Museum design. As "context" came to play an increasing role in the architectural "concept," so we began to conceptualize the word so as to give it a fuller and more expansive meaning.

To confront the complexity of the Museum context, we arrived at a clear and near–mathematically precise concept, consisting of three superimposed and autonomous parts—a base, a middle, and a top—made out of three materials, marble, concrete, and glass. Light became a fourth material as well as a design requirement, reflecting the specific exhibition needs of sculpture, the demands of making the excavations visible, and the desire to replicate, as far as possible, the outdoor conditions under which the Parthenon Frieze and the Acropolis sculptures were originally seen.

In the design concept, the base is constituted by the archaeological excavations interspersed by pilotis that are carefully located so as not to damage the ruins, with the entrance terrace and lobby partially placed on a glass floor so as to reveal the ruins below them. A glass ramp overlooking the excavations leads up to the middle volume, which encloses the double-height hypostyle Archaic Gallery. This volume is oriented according to the existing street pattern around the Museum. Large expanses of glass are sheltered from acute sunlight on the south side by cantilevered concrete slabs and on the east and west sides by obliquely angled steel fins that open onto the north light and the Acropolis above. The top, or Parthenon Gallery, is made almost entirely out of glass. Its dimensions are slightly larger than the Parthenon so as to accommodate the Parthenon Frieze in its entirety in the exact configuration and viewing conditions of its original temple location. Additionally, its orientation in the identical direction as the Parthenon re-creates comparable lighting conditions over the east and west pediments. This orientation accounts for the slight rotation of the rectangular glass volume in relation to the larger middle section of the building.

This relatively simple and lucid design concept cannot account for the complex layering of chronological times and conditions that the process of construction uncovered. The difficulties of locating "modern" supporting columns only inches away from fragile ancient walls forced us to deal with a multifaceted task: how to protect invaluable archaeological artifacts, support the building and its contents (including in earthquake conditions), and confer visibility over a previously unseen and still-evolving antique world to both general and specialized audiences. The complicated seismic requirements of the area led to the use of a base isolation system, consisting of large elastomeric and sliding bearings made out of polished Teflon steel, interspersed among the ruins in relation to the supporting columns. The bisected division of the system allows the Museum to move as two independent and protected parts, absorbing vibrations, in the event of earthquakes. This seismic system, which reflects the most advanced technological developments, was not only incorporated in, but installed simultaneously with the ongoing archaeological excavations. Archaeologists, engineers, and construction laborers worked side-by-side, establishing a dialogue across different worlds and centuries.

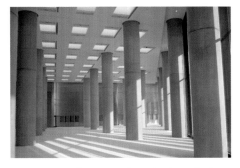

The Archaic Gallery before the installation of the collection

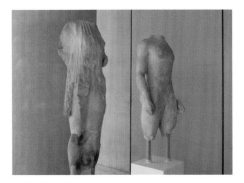

The soft, cool-hued concrete is intended to contrast with the warm tones and hard marble of the sculptures.

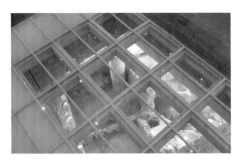

Some floors afford views of the excavations below; a textured dot pattern prevents pedestrian slippage.

The location of the supporting columns was also central to the design of galleries. Because we rejected conventional "white-box" galleries and wanted to approximate the original viewing conditions for the Acropolis sculptures, we decided against partition walls and in favor of using only the concrete vertical core and columns of the structure to articulate the galleries. The results—free and unconstricted spaces that approximate natural outdoor light and air—are most eloquent in the Archaic Gallery on the middle level, where twenty-nine concrete columns articulate an eight-meter-high space. As a result, the marble statues appear to populate this open space in casual arrangements of figures—the first and "original" inhabitants of the Museum.

The choice of concrete walls and columns as the backgrounds for statuary required technical precision: the concrete had to be as unrelieved as possible, with a soft, lightly sandblasted texture that would absorb rather than reflect light. Similarly, the aim of not distracting from the art, but instead focusing the viewer's attention, led to marble bases for the statues that blend with the local Greek marble used for flooring throughout the Museum. However, the greatest material focus may have been directed toward the use of glass. Here, glass is the ally of natural light, which enters the Museum from the atrium of the Parthenon Gallery, penetrating through its glass floor, passing through the Archaic Gallery, and ultimately filtering through the glass paneling in the ground floor onto the archaeological remains below. Throughout the Museum, the most sophisticated and technically advanced glass technology is employed both to approximate the viewing conditions of the ancient Acropolis—the original context of the Museum's contents—and to confront modern climate and seismic insulation needs. For example, in the Parthenon Gallery, the concern for transparency, climate control, independent panel movement, and wind resistance led to the development (by our brilliant glass consultant, Hugh Dutton) of clear glass without greenish tints arrayed so as to provide a cool, comfortable, seismic-insulated environment with unobstructed views to the Acropolis. The silk-screen dot gradient employed on the glass of the Parthenon and Archaic Galleries is among the minimized details used throughout the Museum. This dot pattern emits echoes: a similar point grid is etched into the nonslip surface of the transparent glass ramp overlooking the excavations, and this visual motif is subtly inflected in and on the concrete cores on either side of the atrium, where round holes serve as acoustical "sponges" to minimize the reverberation of sound against hard surfaces.

Most recently, the design of the New Acropolis Museum has provided a context to place aspects of past projects in perspective. Much as it responds to its complex site, it also contains the accretions of other projects and preoccupations. On the most subliminal level, the point-grid matrix through which the excavations are visible echoes the point grid used in an early conceptual project, *Joyce's Garden* (1976–77) to organize the disparate events occurring in and on a given site. In a later built project, the Parc de la Villette (1983–98) in Paris, a point grid of red *folies* serves as a common denominator to mark and structure a 125-acre site. Much like the Museum, the Parc de la Villette is organized in three superimposed layers and, as with the loop or visitor circuit through the Museum, attention is paid to the linear vectors of movement throughout the site. Two concert halls built for different cities in France (Rouen, 1998–2001, and Limoges, 2003–07) similarly use the materials of steel, concrete, wood, and light conceptually, as actual design concepts, as well as ramps that respond to underlying topographical conditions to choreograph the movement of bodies through space. In the National Center for Contemporary Arts (Le Fresnoy, 1991–97) in Tourcoing, France, a technologically sophisticated roof extends over an existing 1920s building

Detail of the textured pattern on glass floors

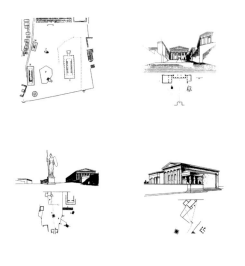

Installation of *The Manhattan Transcripts* at Artists Space in 1978

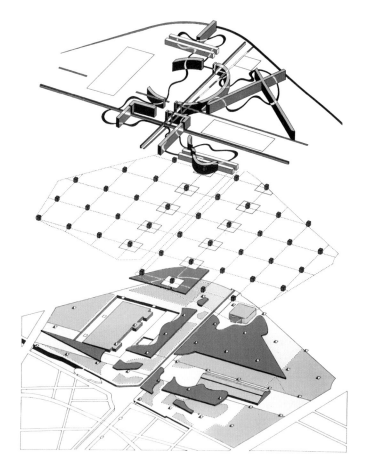

The Parc de la Villette is designed as the superimposition of a series of points (*folies*), lines (promenades and canals), and surfaces (playing fields and gardens).

Drawings of the Acropolis complex from Choisy, reproduced in Sergei Eisenstein's "Montage and Architecture"

Eisenstein's notation from the film *Alexander Nevsky* (1938)

to protect the spaces below and to transform them into exhibition facilities. Here, the parallel to the extension of the Museum over the excavations, and to its dialogue between "old" and "new" elements, is striking and indisputable. An unbuilt project designed for Factory 798 in Beijing (2003) develops spaces for offices, retail, and housing in an elevated multifloored lattice in order to preserve an obsolete industrial site below that is now occupied by artists and galleries..

The most revealing relationship to the design of the New Acropolis Museum may be found in an early drawing, *The Street* (from *The Manhattan Transcripts*, Part II, 1976–81), that invokes the cinematic theory of montage. Eleven meters long and formed out of juxtaposed sequences of drawn and photographed elements, it comprises an architectural narrative that can only be apprehended as the body moves along it, evoking the paradigm of vision-in-motion that is explicit in the Parthenon Frieze. An informing source for this and other early work was the Russian cinematographer Sergei M. Eisenstein, whose great essay from the 1930s, "Montage and Architecture," was inspired by Greek architecture and, in particular, by the buildings of the Acropolis. The famous cavalcade scene in Eisenstein's film *Alexander Nevsky* shows a striking resemblance to the equestrian segments in the Parthenon Frieze. In the essay, rediscovered only in the 1980s,[1] Eisenstein thinks analogically, referring to the Acropolis as "the perfect example of one of the most ancient films," uniquely capable of "fixing the total representation of a phenomenon in its full visual multidimensionality." Once again, the Acropolis appears in all its complexity, as an original "context" for thought.

1. Sergei M. Eisenstein, "Montage and Architecture," reprinted in *Assemblage* 10 (December 1989): 116–31, with an introduction by Yve-Alain Bois.

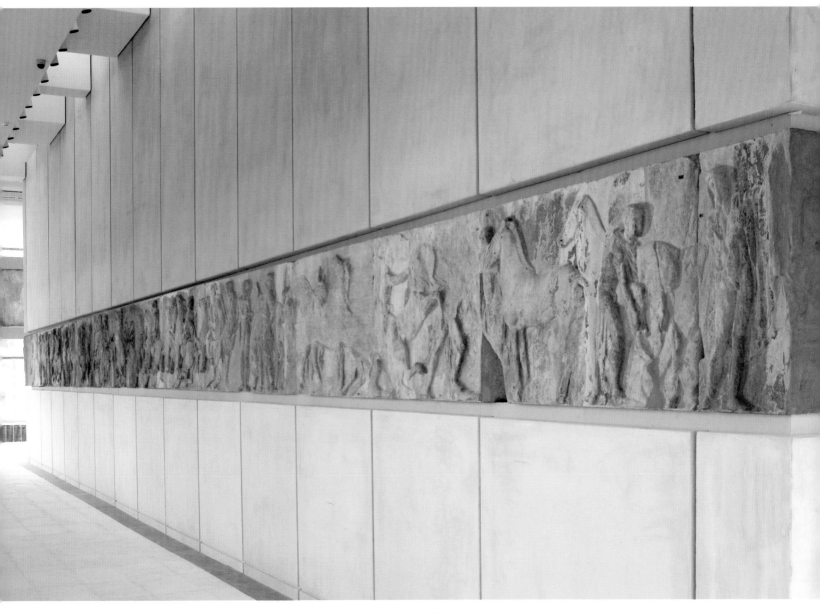

The Parthenon Frieze restored as a
narrative sequence

88–89: Images of the Frieze juxtaposed
with frames from *Alexander Nevsky*

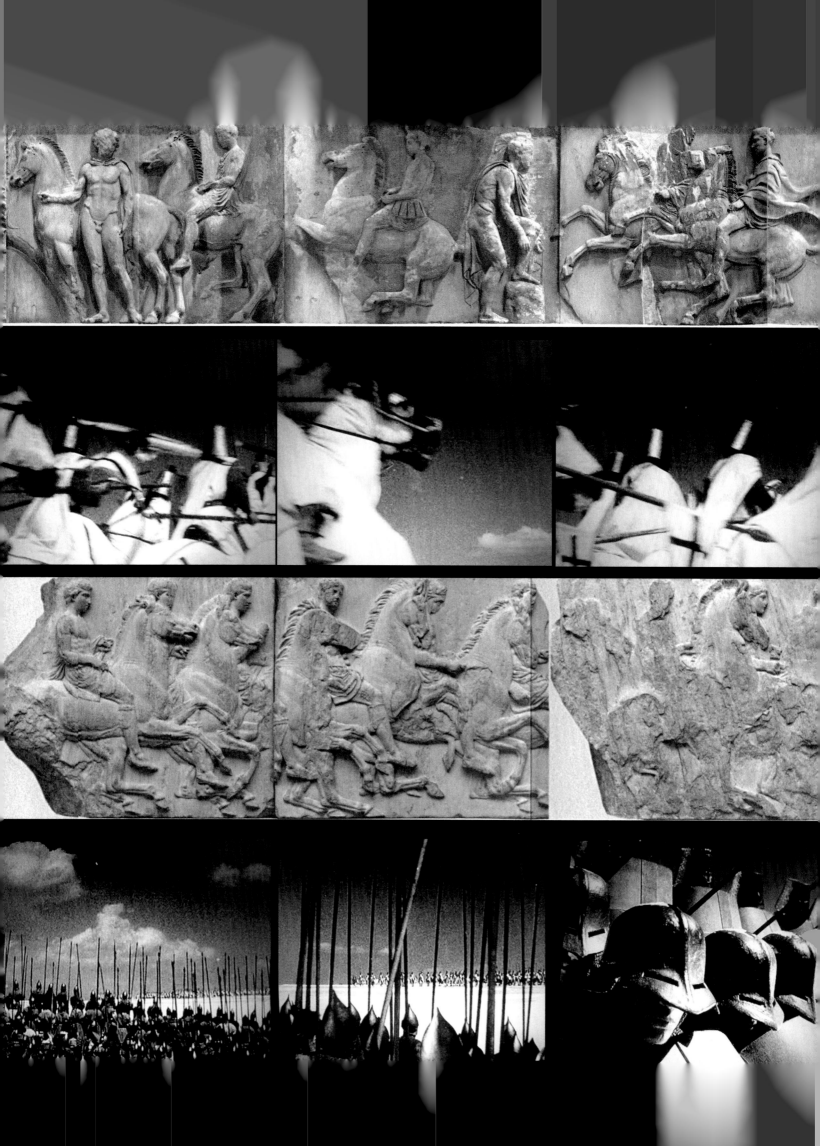

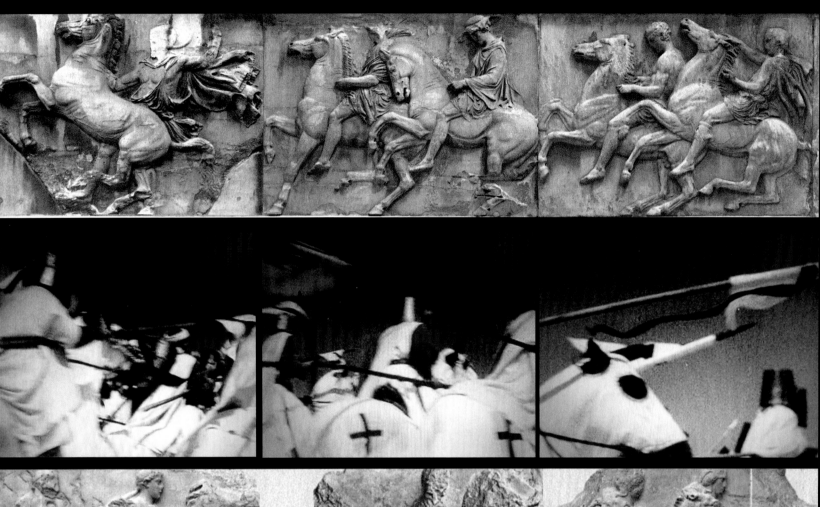

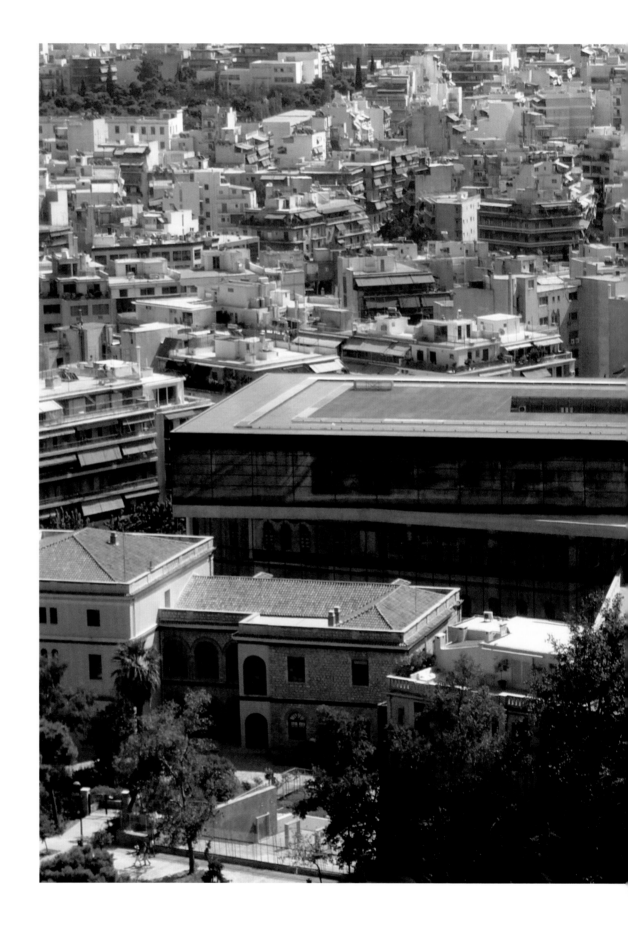

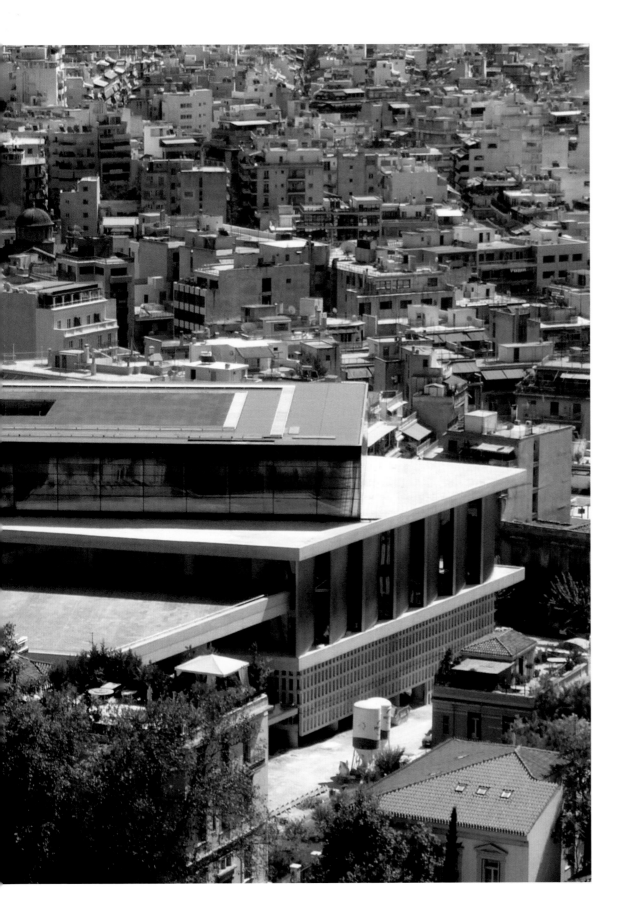

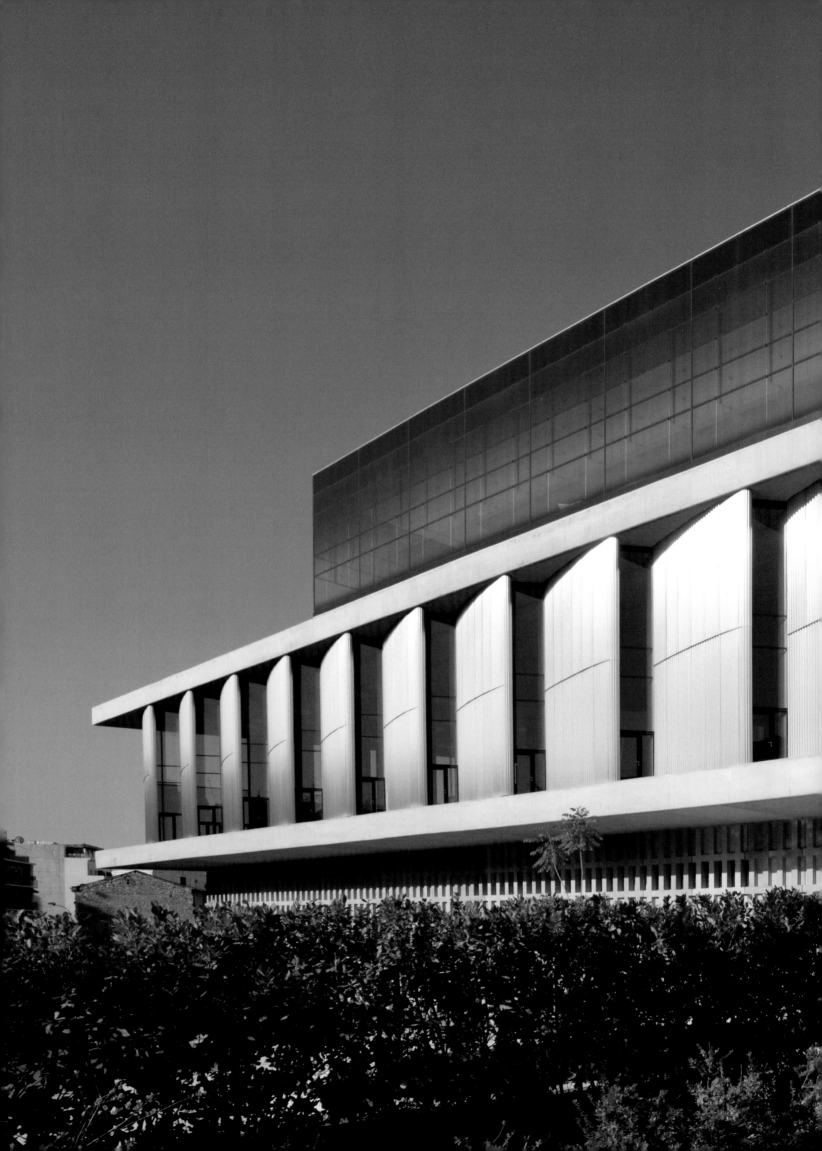

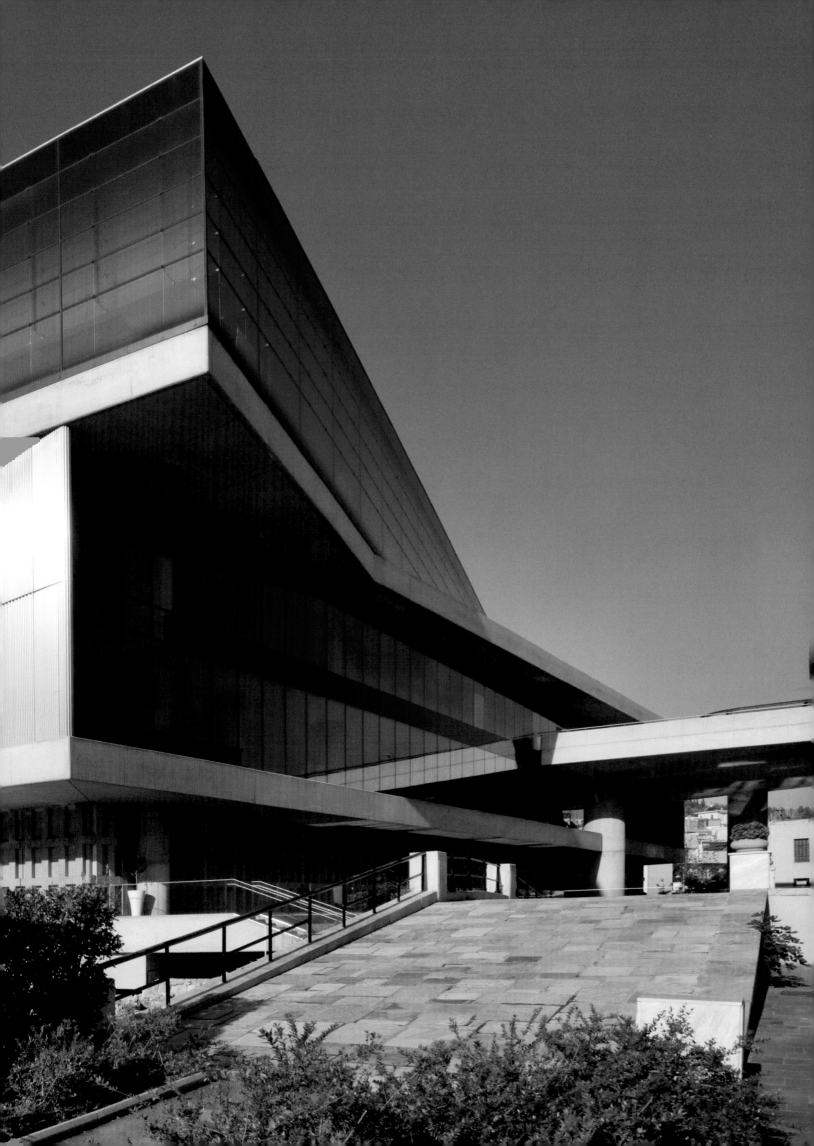

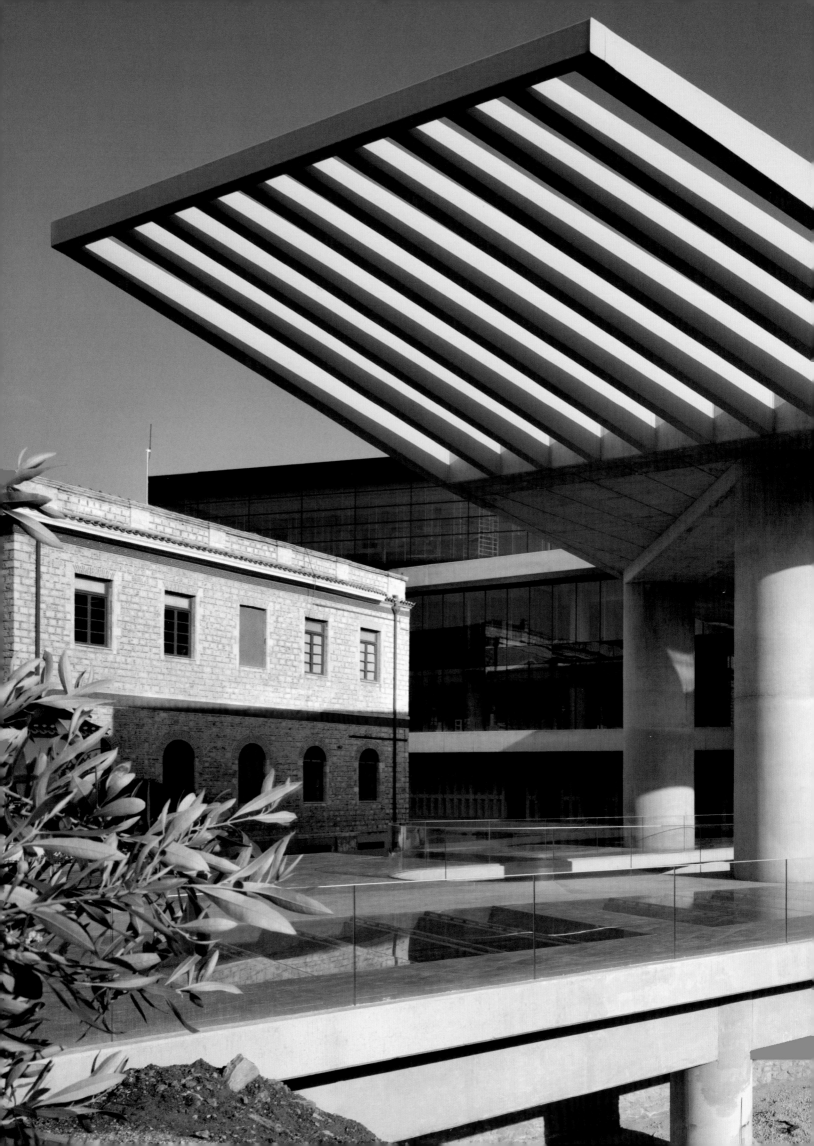

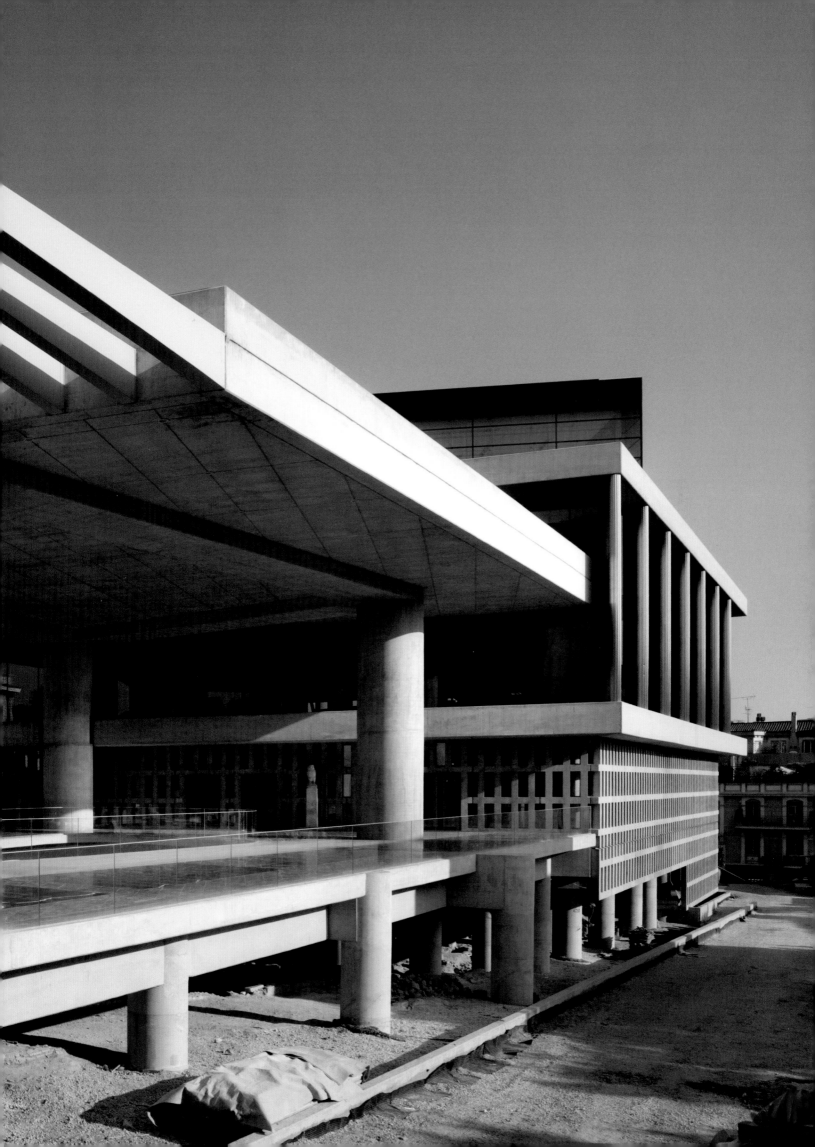

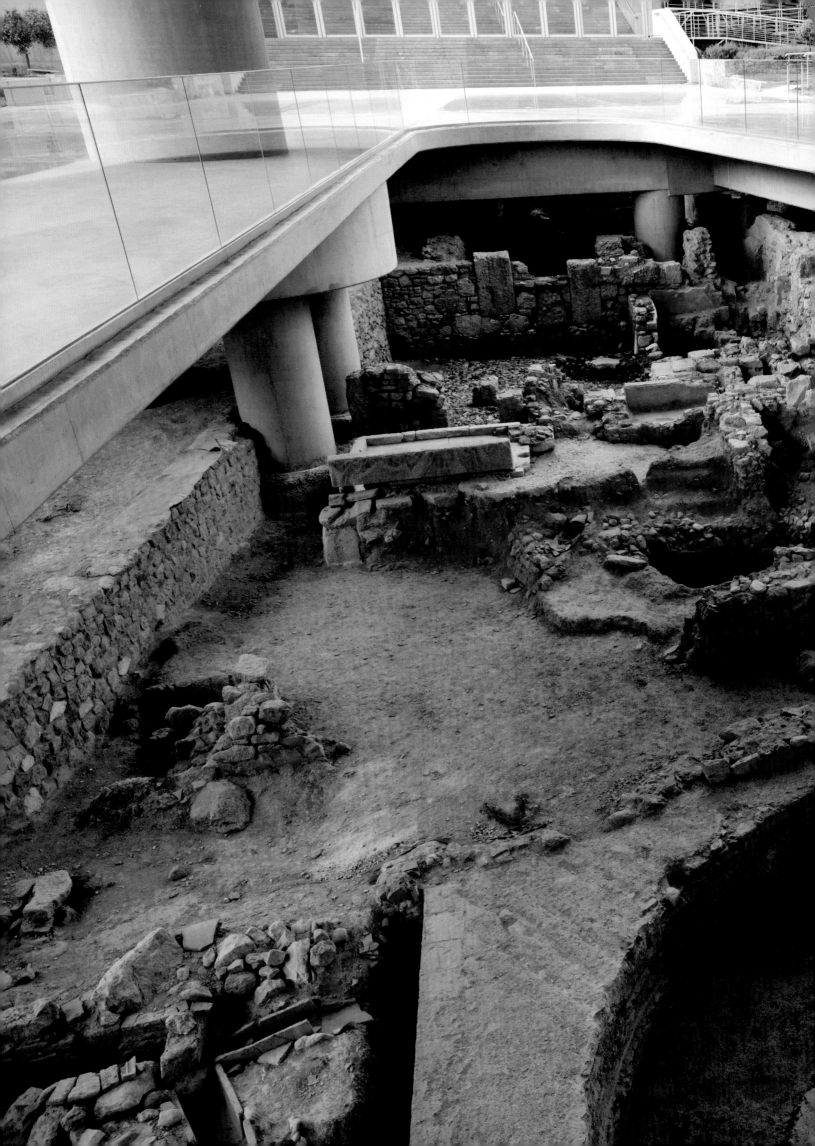

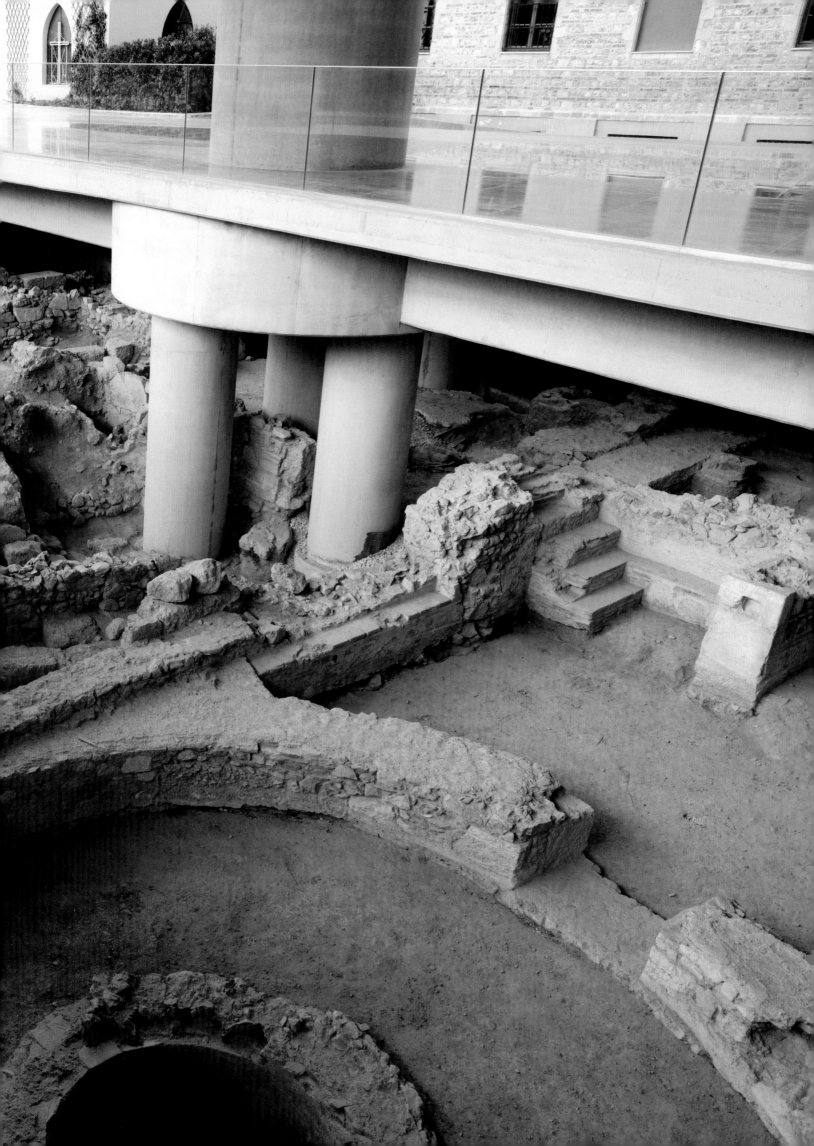

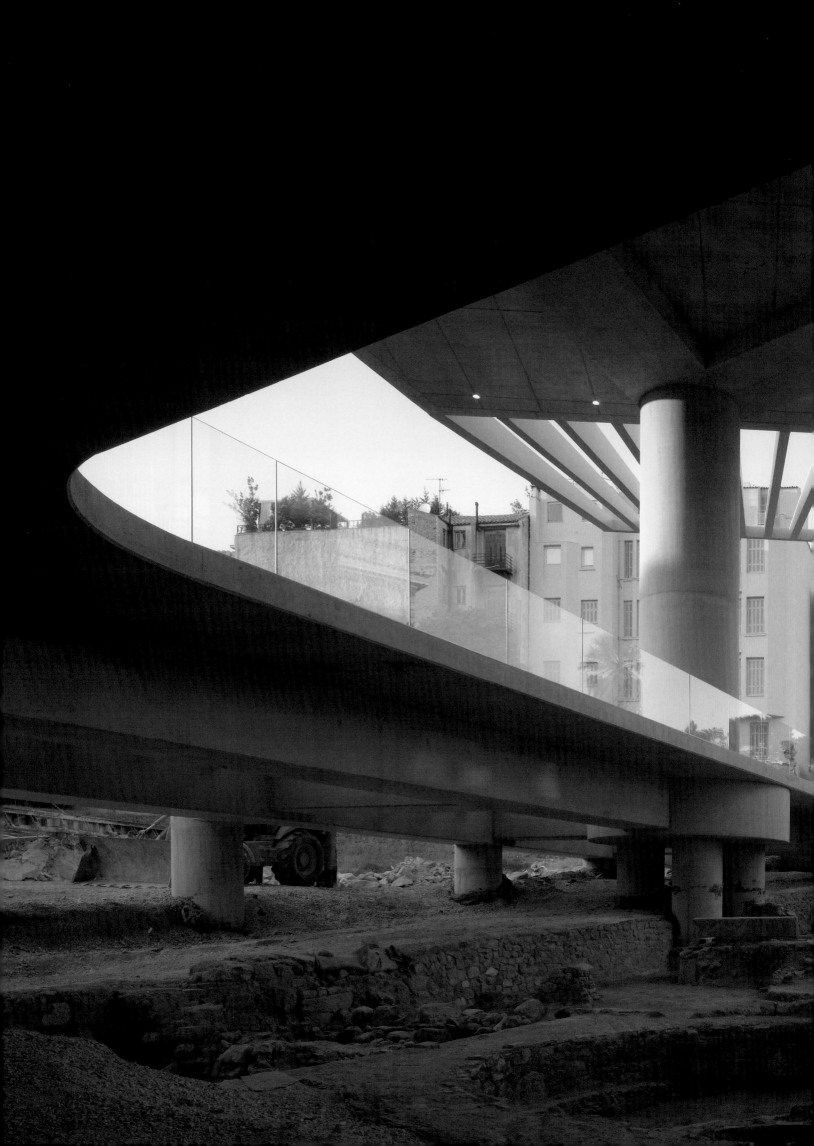

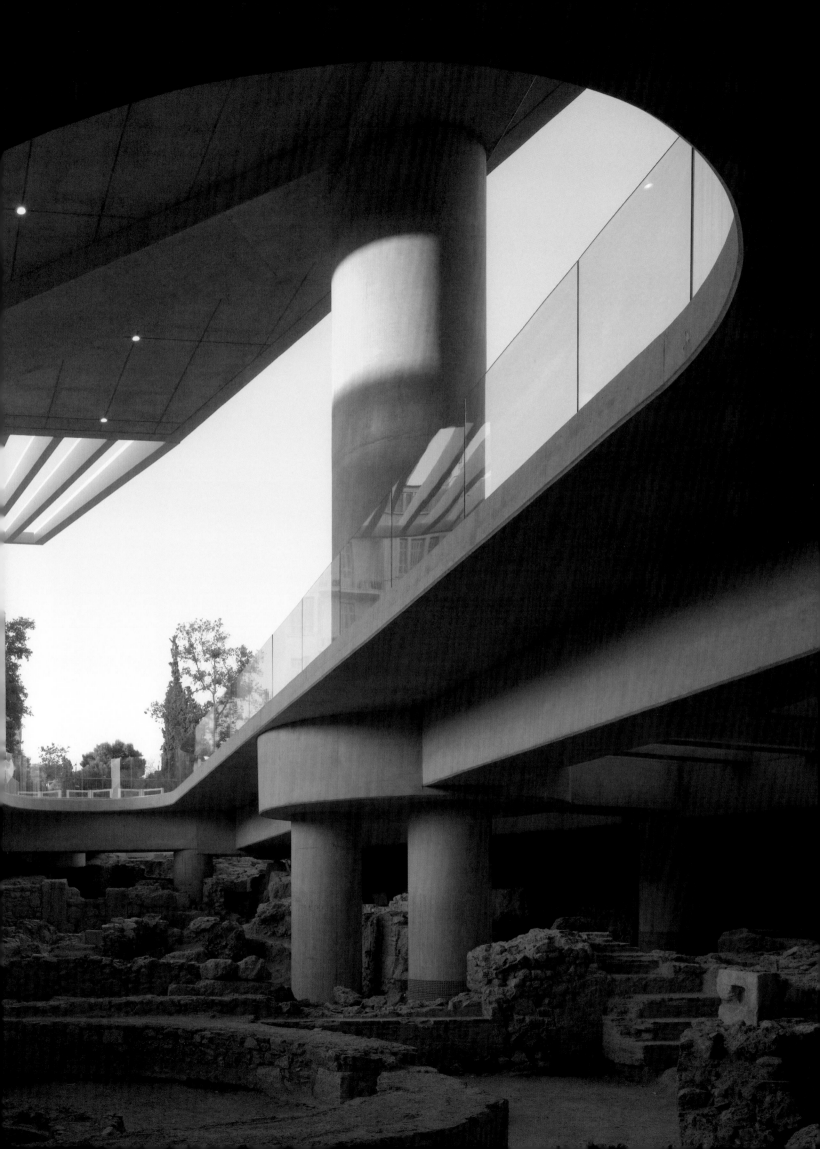

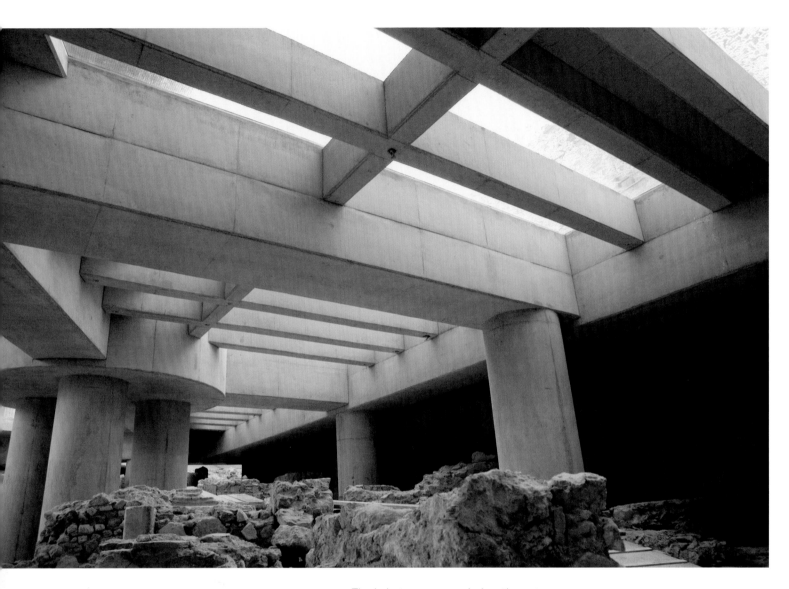

The in-between space below the entry ramp

Opposite: Some parts of the ramp surrounding the Museum entry have glazed surfaces to allow views onto the excavations.

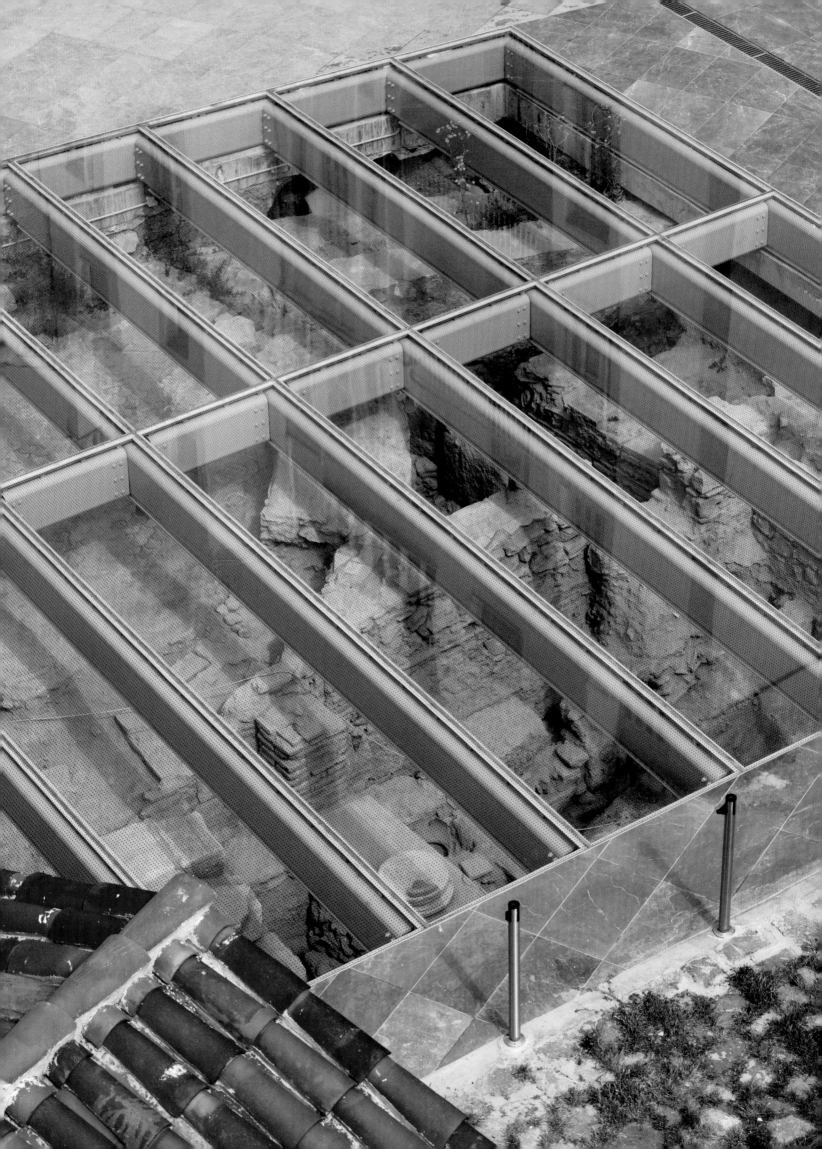

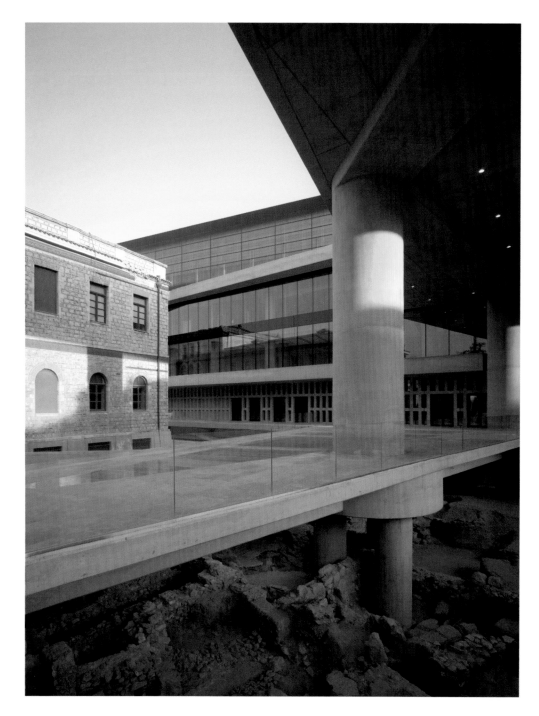

Early morning view of the entrance ramps and the Weiler Building

Opposite: The north facade at dawn

104–05: The entrance lobby is illuminated with perforated precast concrete panels.

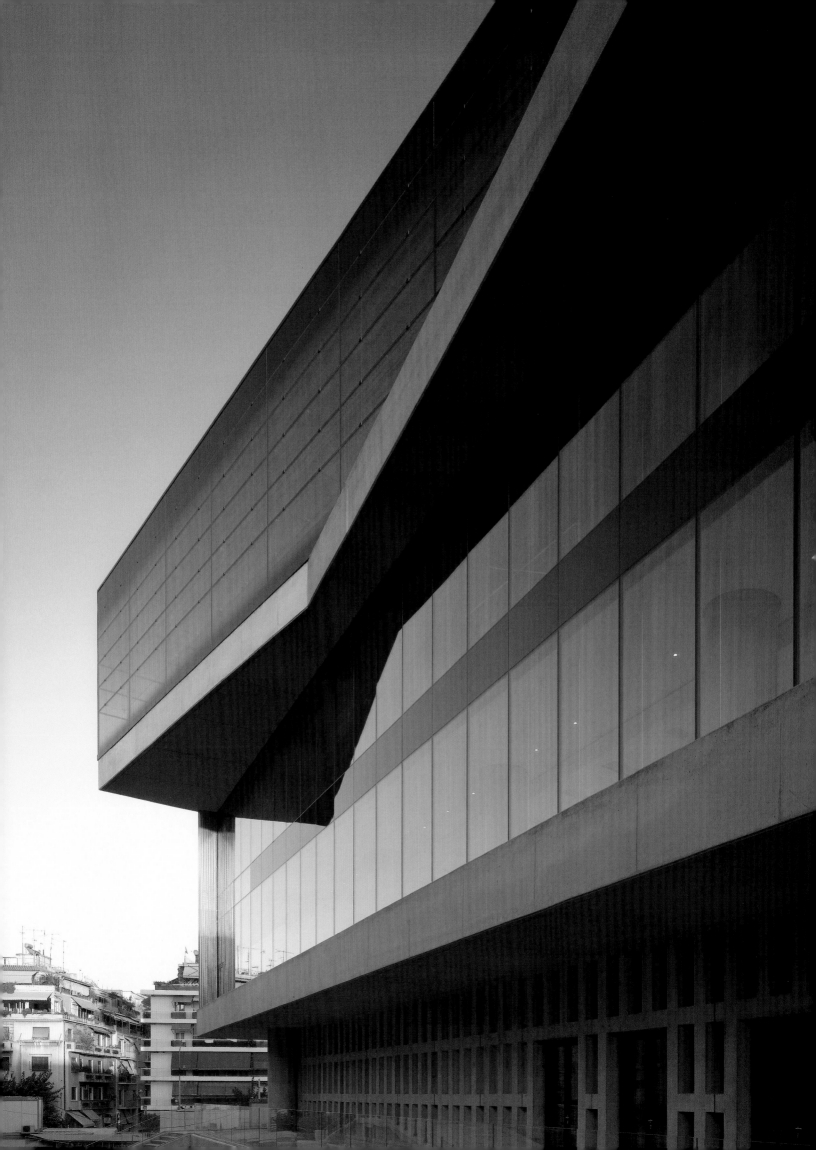

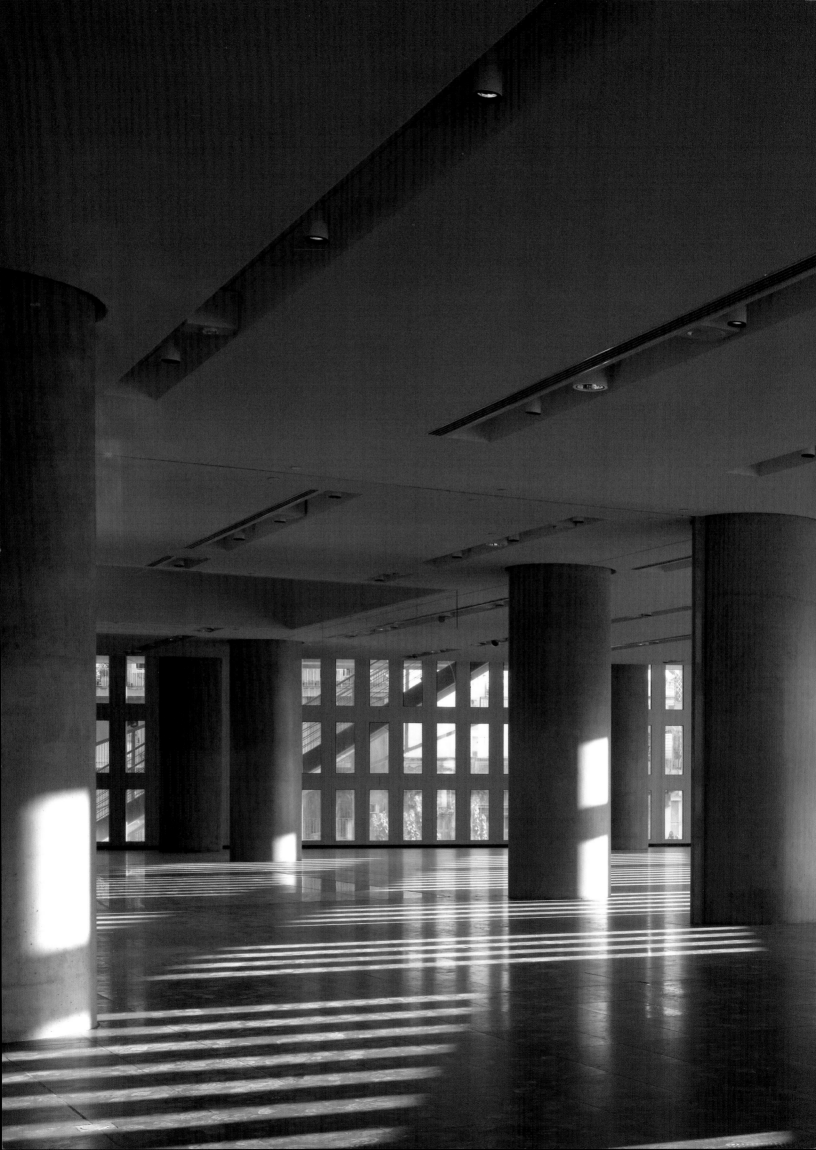

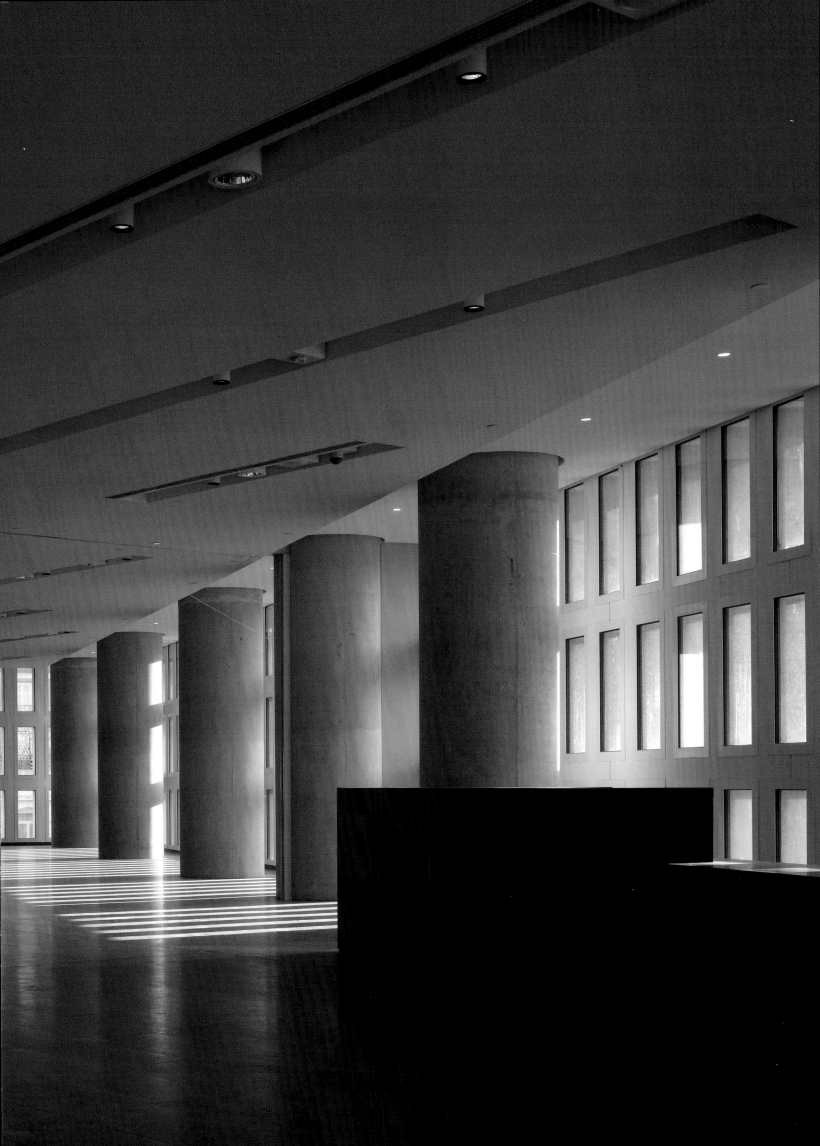

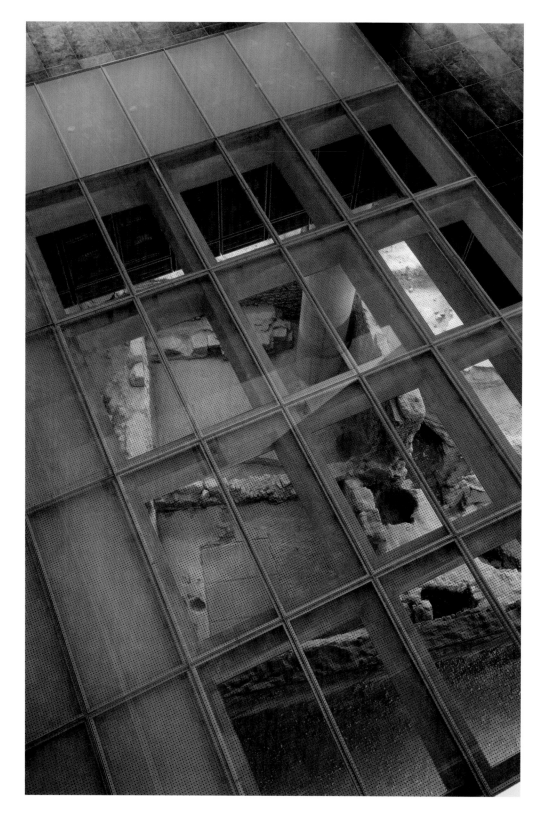

Left and opposite: The lower level of the Museum contains frequent glimpses onto the excavations that help contextualize the artifacts seen elsewhere.

108–09: The Gallery of the Slopes

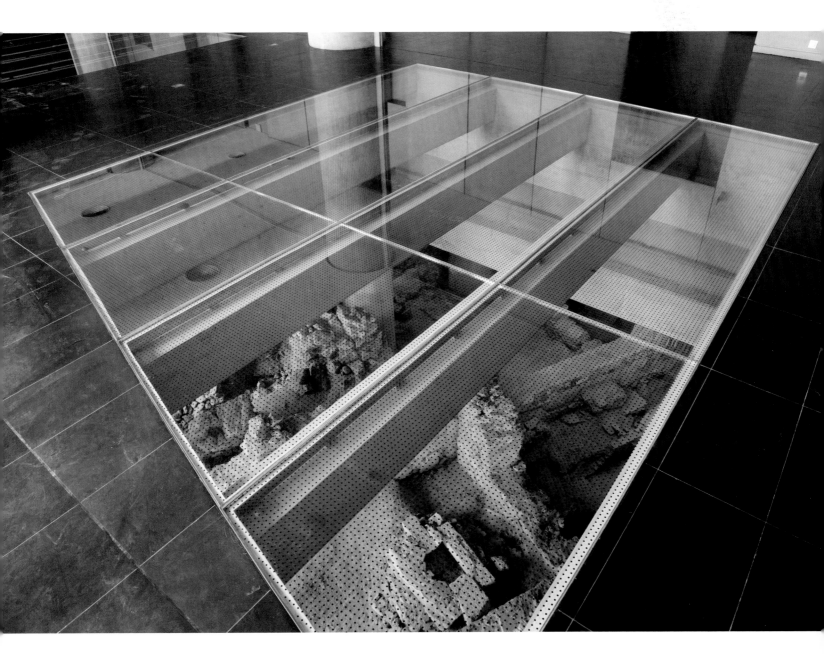

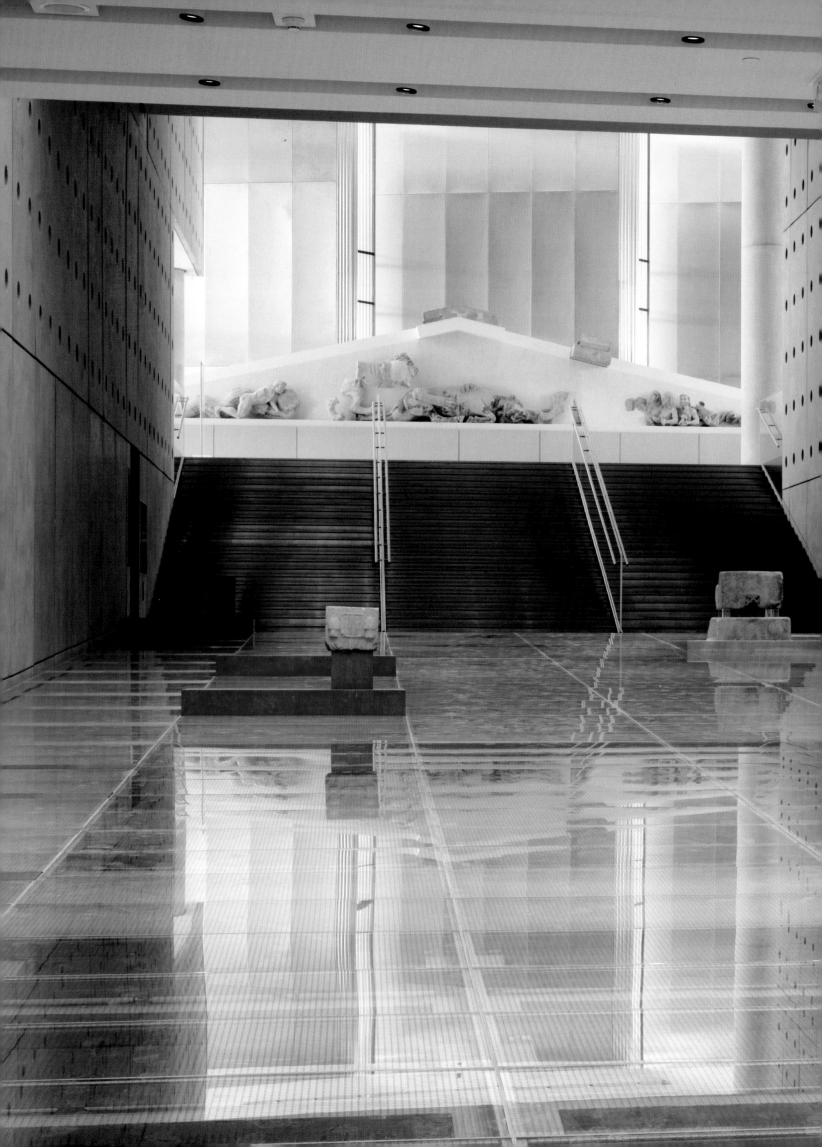

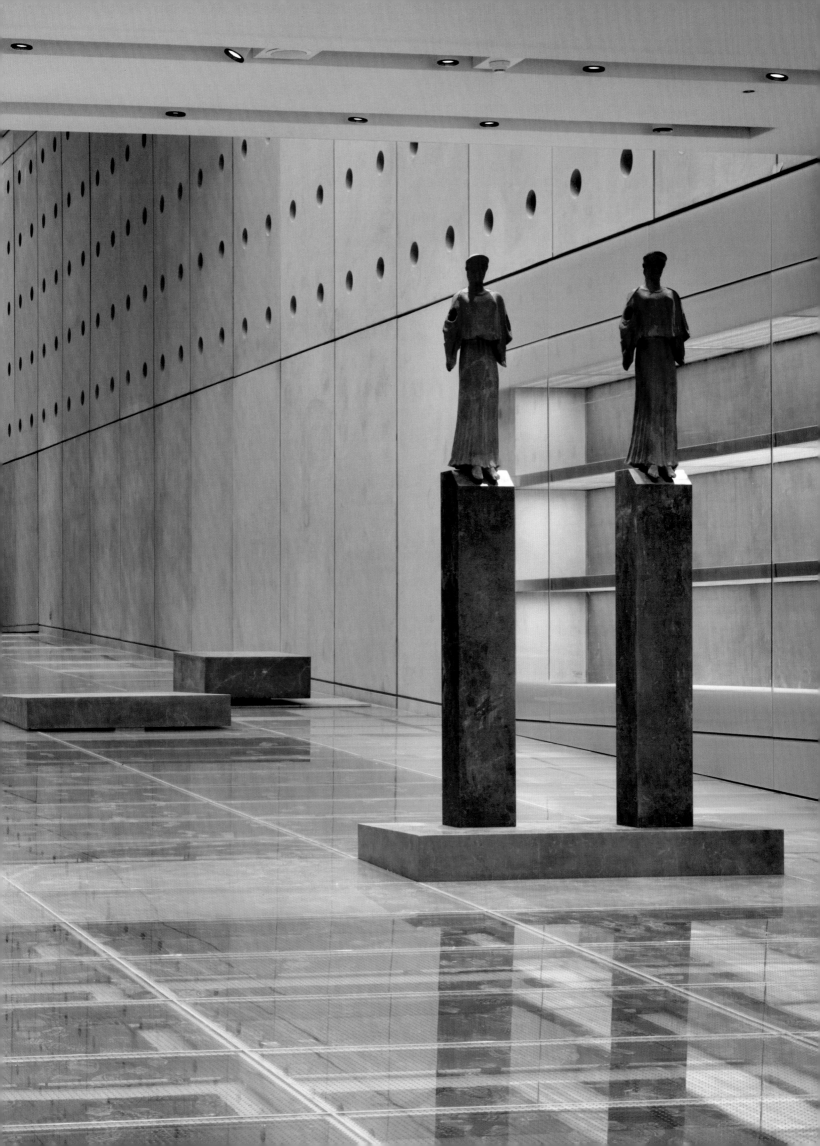

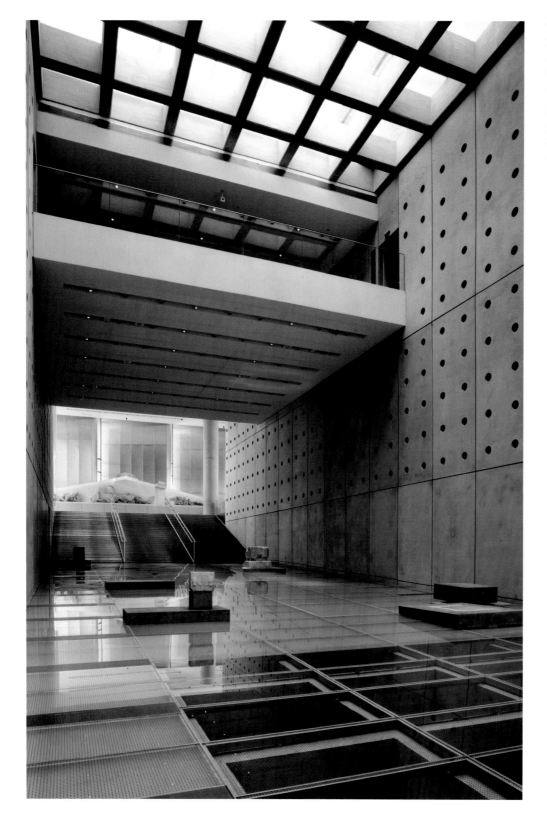

Visitors ascend a glass ramp that leads to a short staircase to the Archaic Gallery. The sequence of circulation echoes the ascent to the Acropolis complex.

Opposite: Filtered light animates the core of the building, which houses the Gallery of the Slopes. The Caryatids can be seen looking into the space.

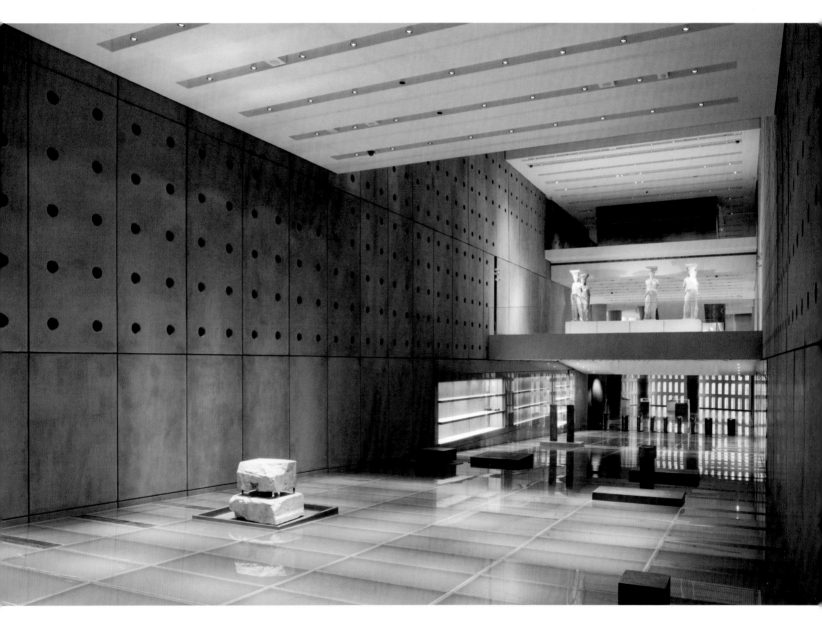

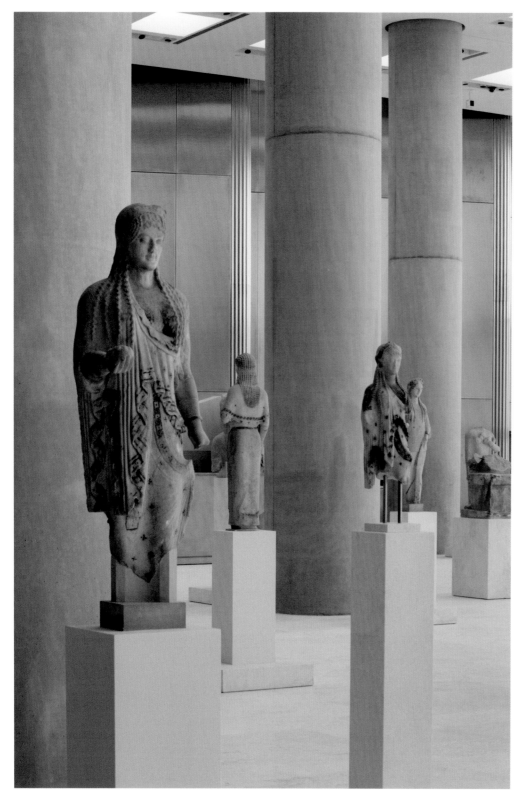

Close-up view of the exhibition strategy in the Archaic Gallery. The columns in the Archaic Gallery create an unpartitioned open space that allows sculptures to be displayed in close proximity to visitors. The double-height space is lit from skylights, which mimic natural lighting conditions on the Acropolis.

Opposite: The statues are exhibited at an optimal height in an open gallery, so as to allow visitors an opportunity to view sculptures from any angle.

114–15: The Archaic Gallery at dusk

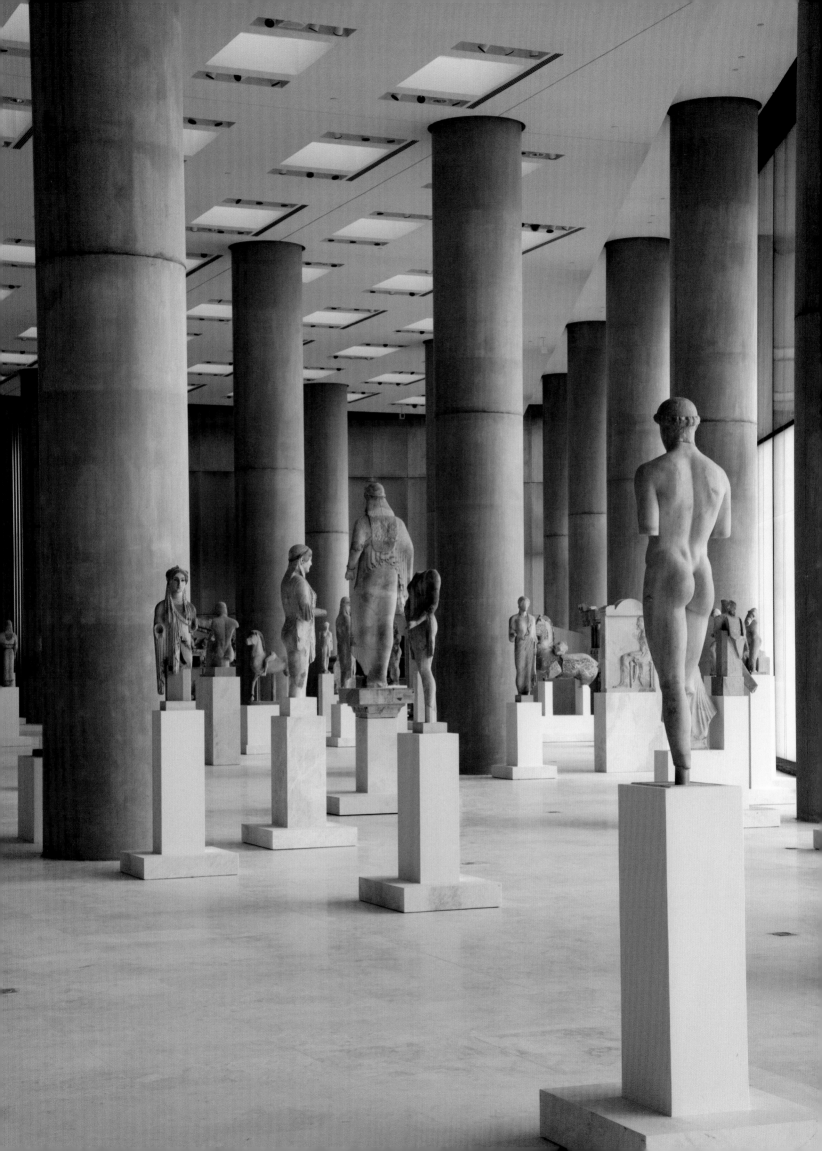

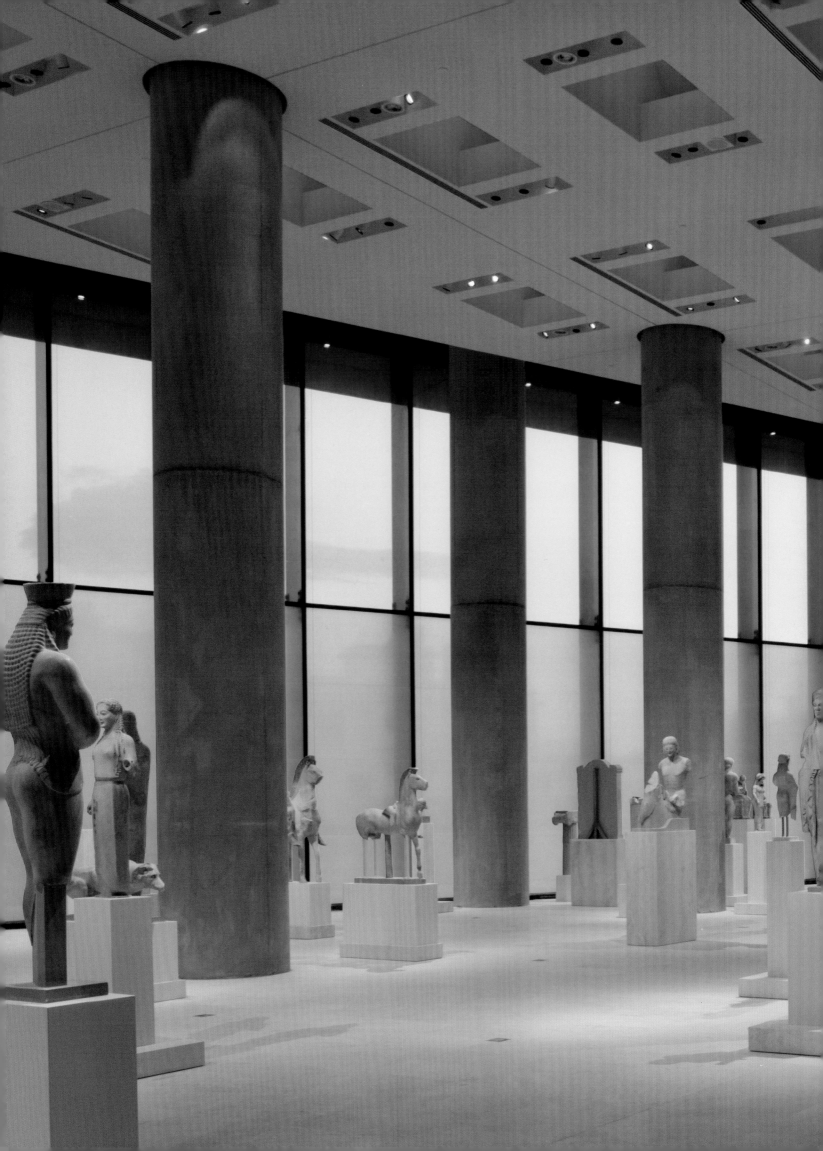

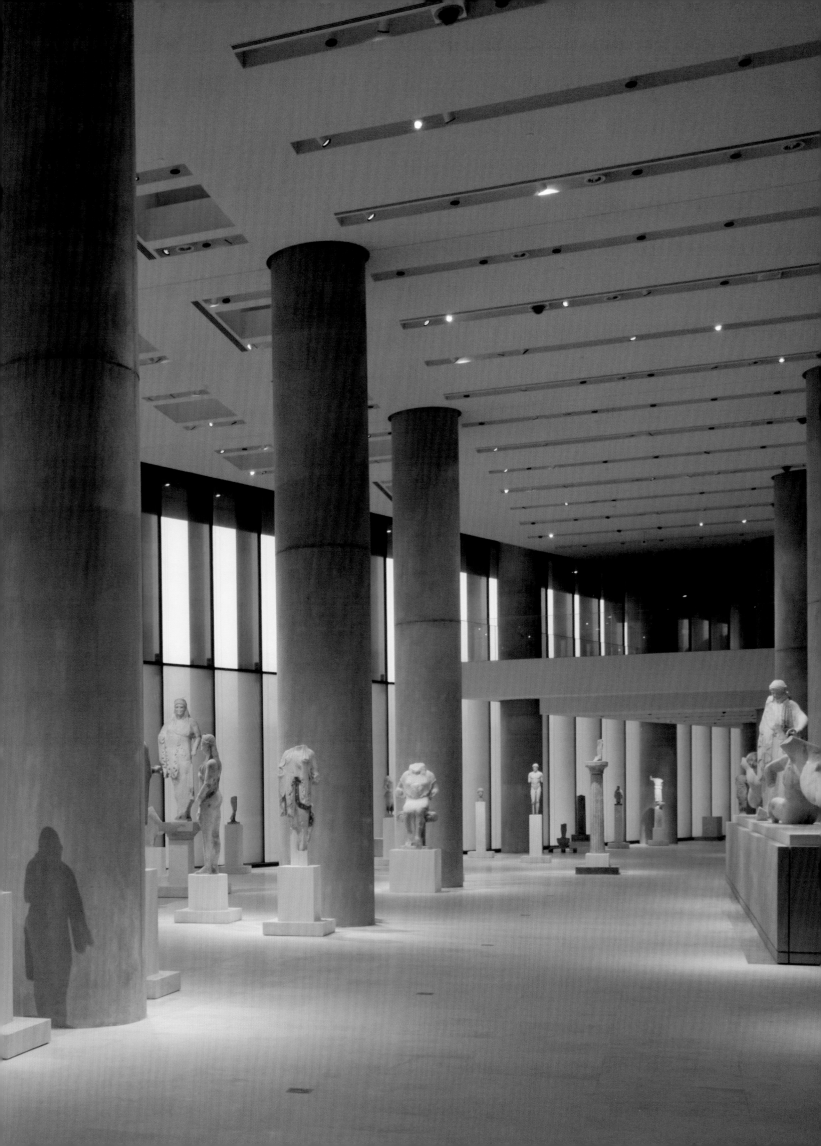

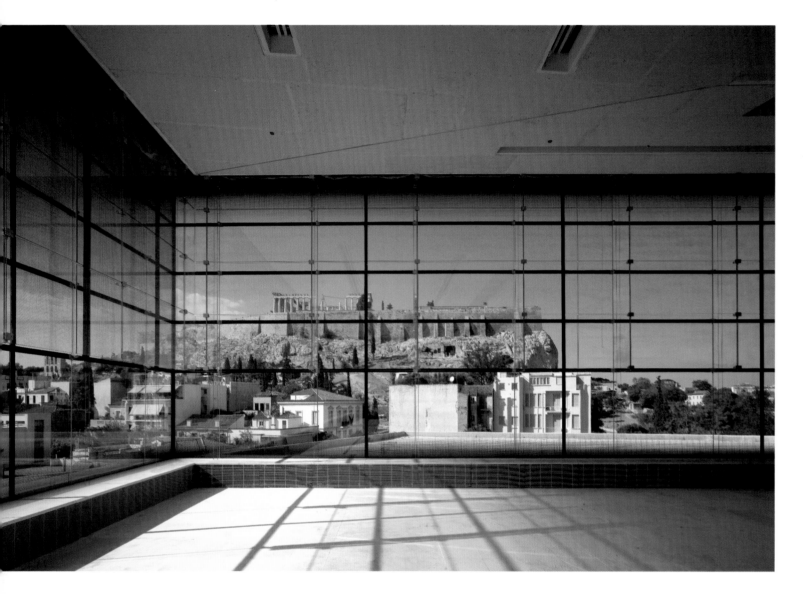

Above and opposite: The Parthenon Gallery affords views of the Acropolis and the modern city surrounding the Museum. The core of the Gallery maintains the exact dimensions of the cella of the Parthenon.

118–19: The Parthenon as seen from the Parthenon Gallery (prior to installation of the metopes)

120–21: The east facade at dawn

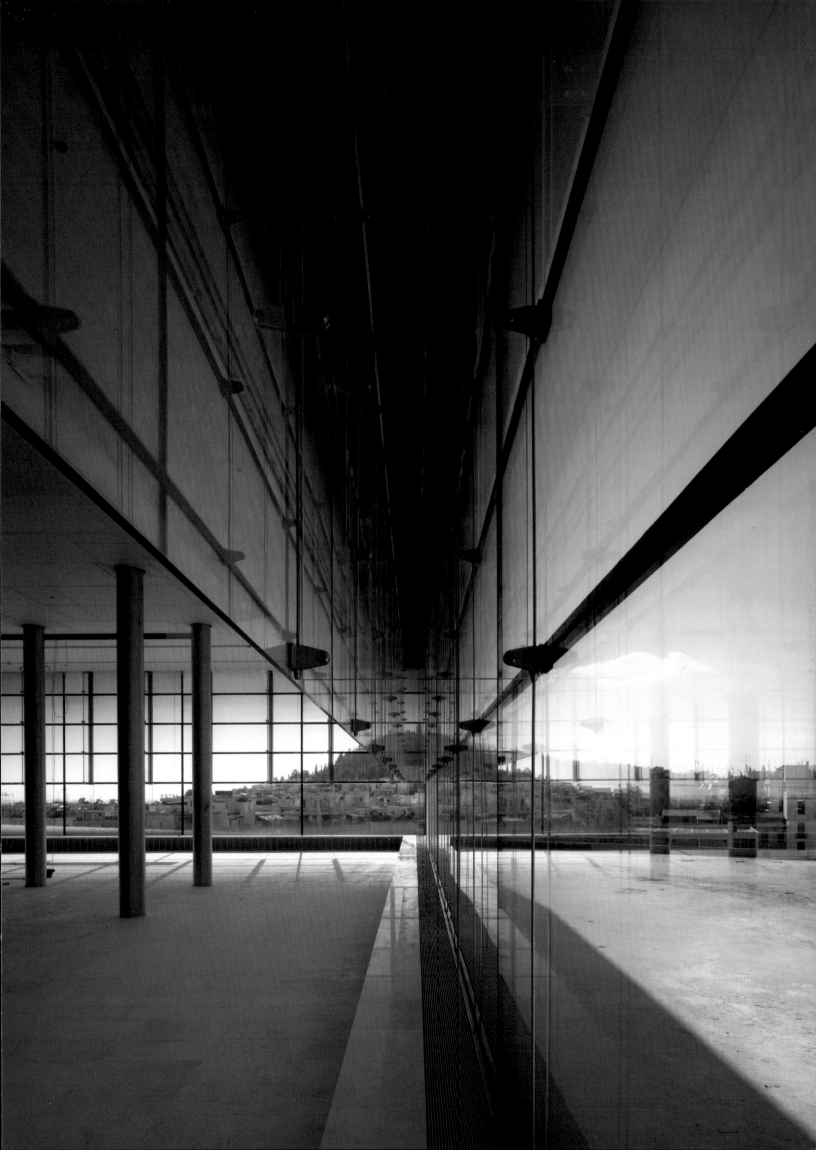

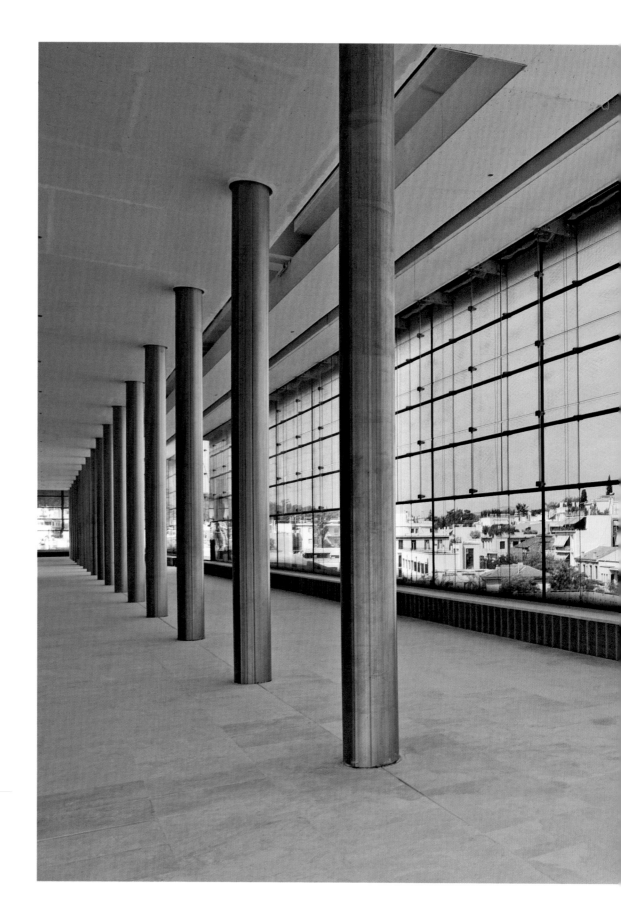

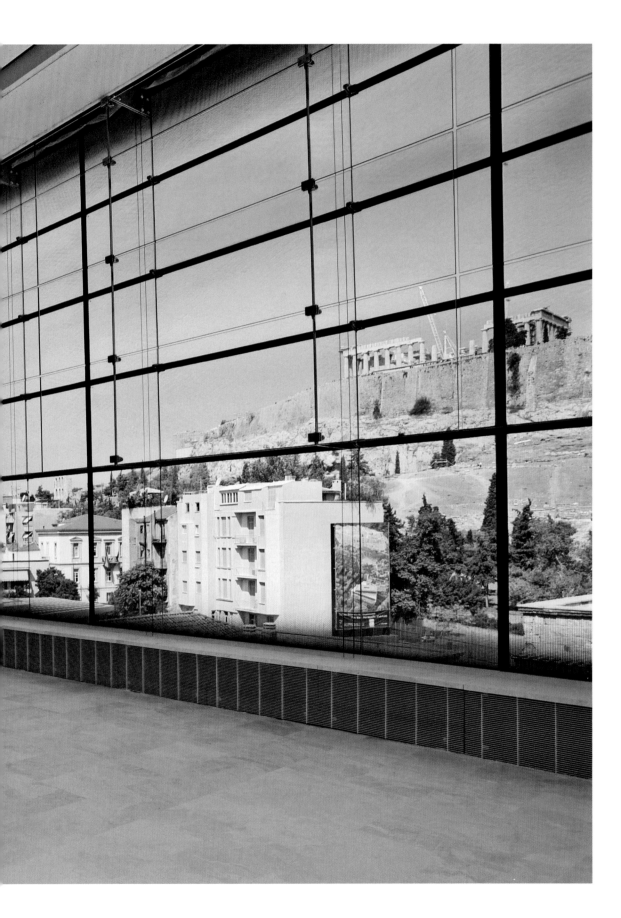

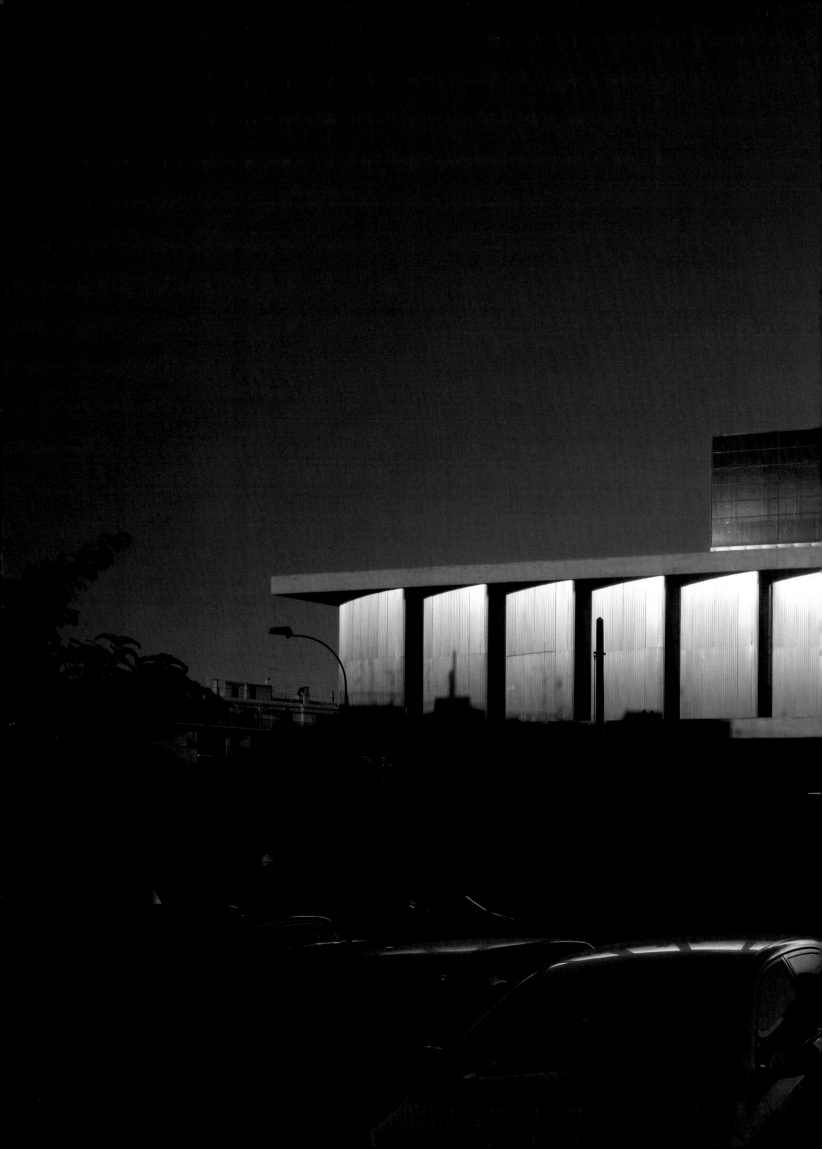

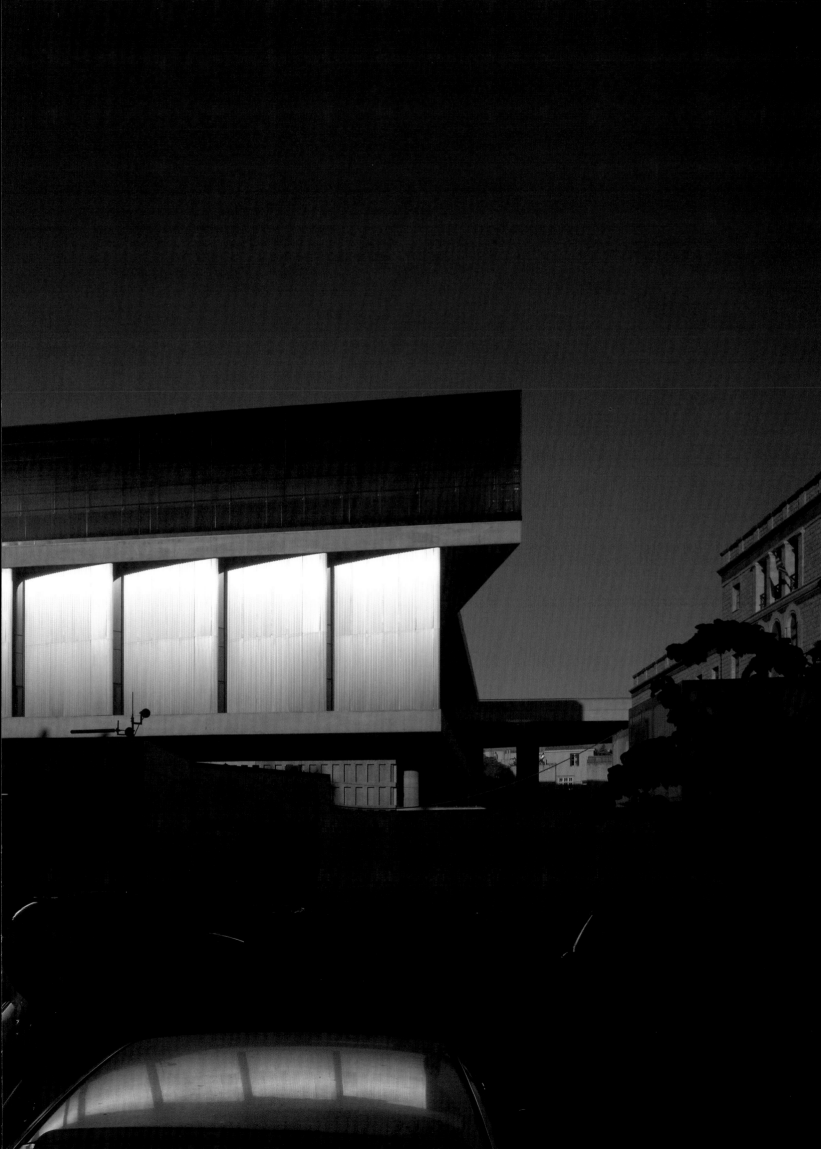

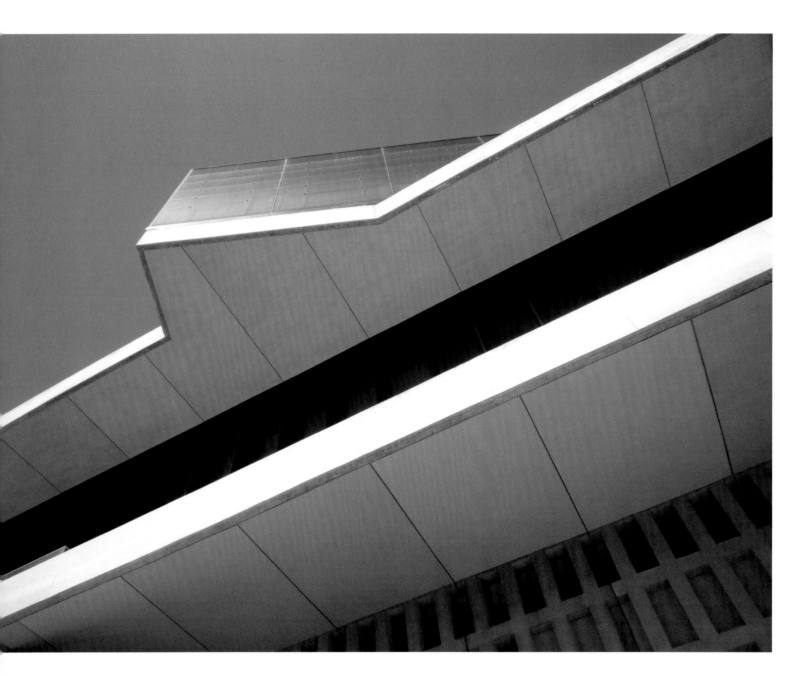

Facade detail

Opposite: The Parthenon Gallery
protrudes slightly over the south facade,
as viewed from a narrow side street.

124: Detail of fins on the west facade

125: The Parthenon Gallery (top) is aligned
with the Parthenon itself, creating
interesting moments on the Museum
facades.

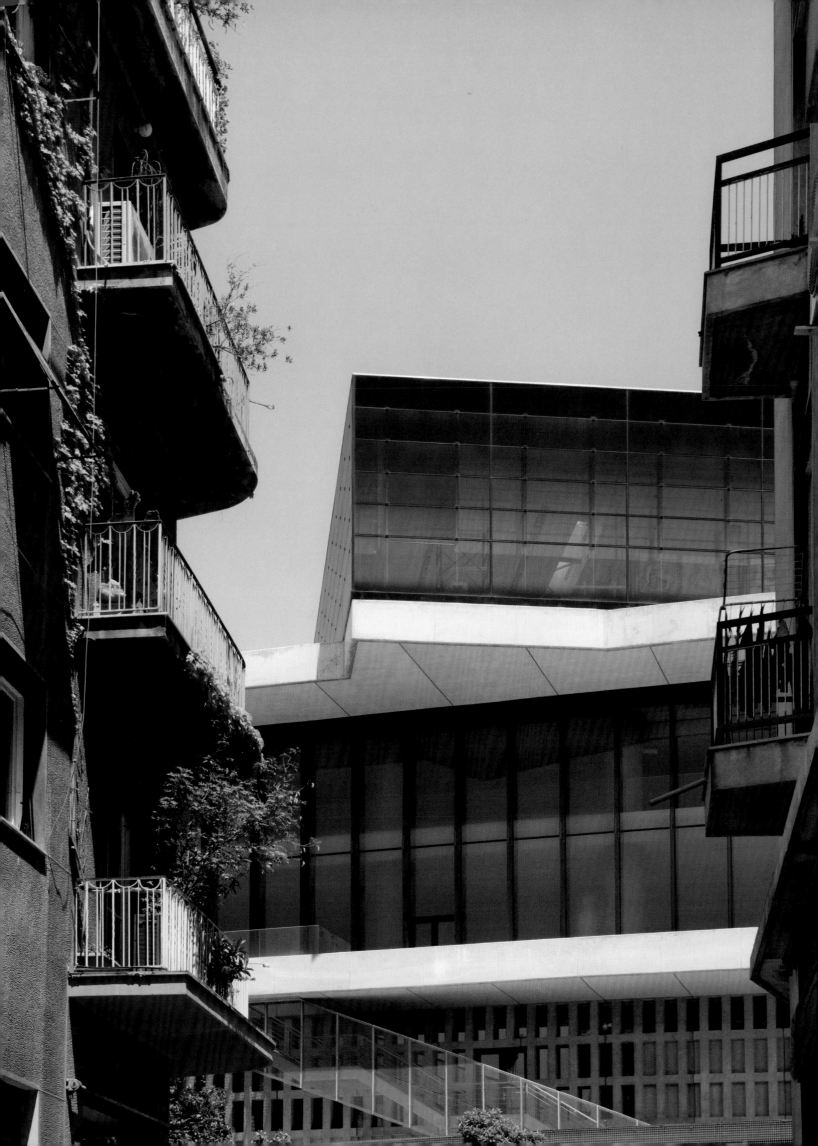

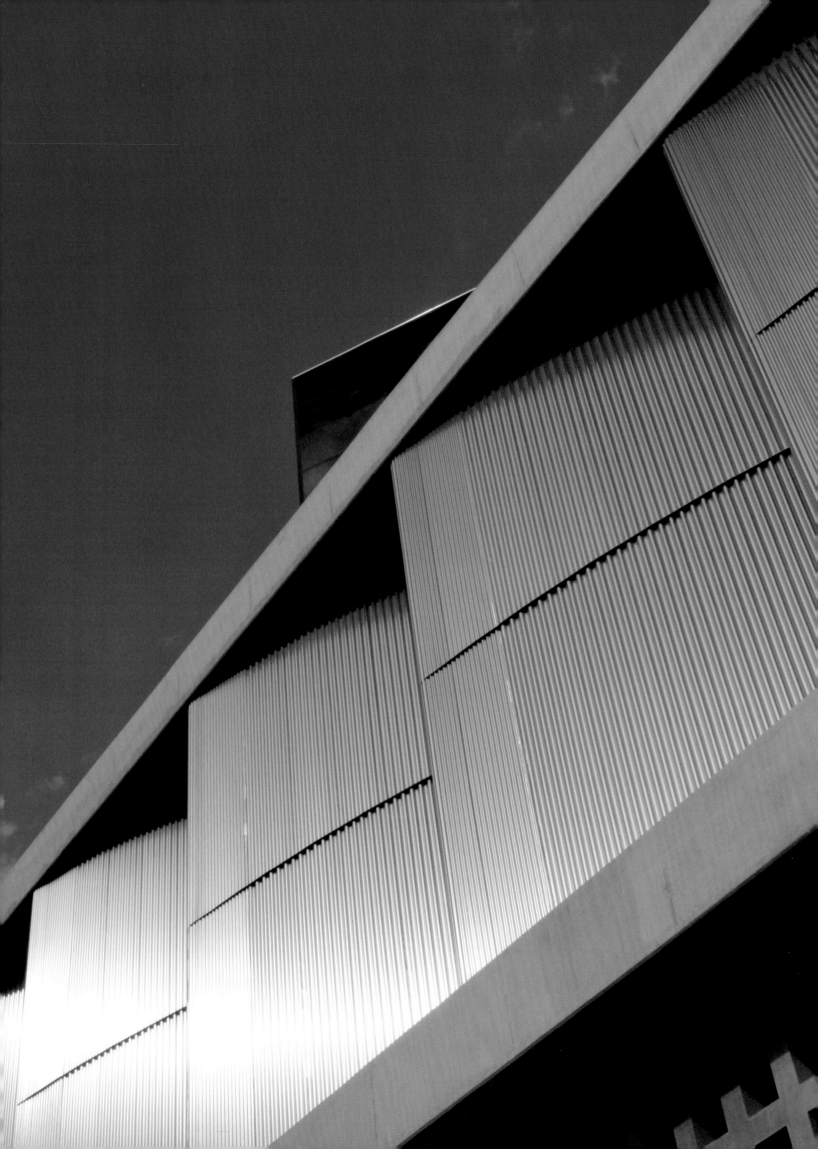

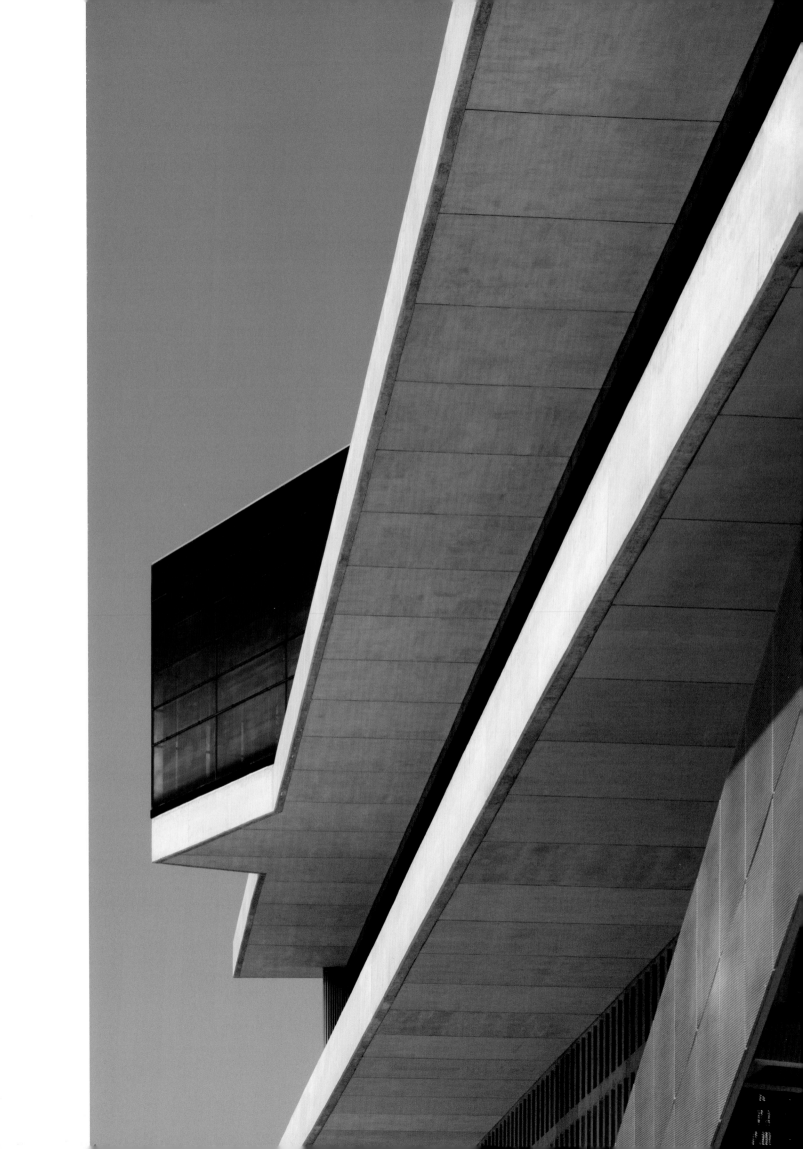

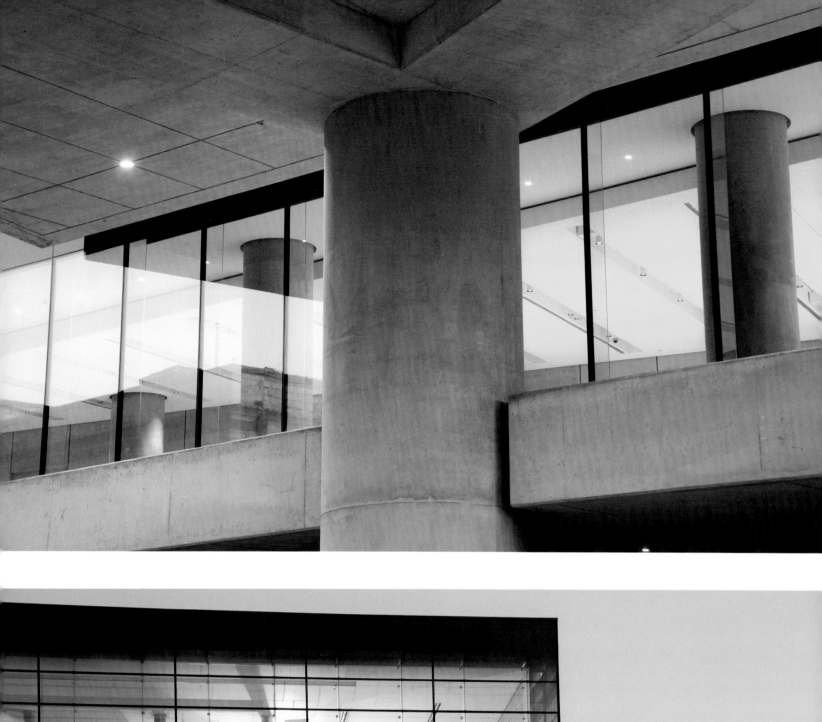
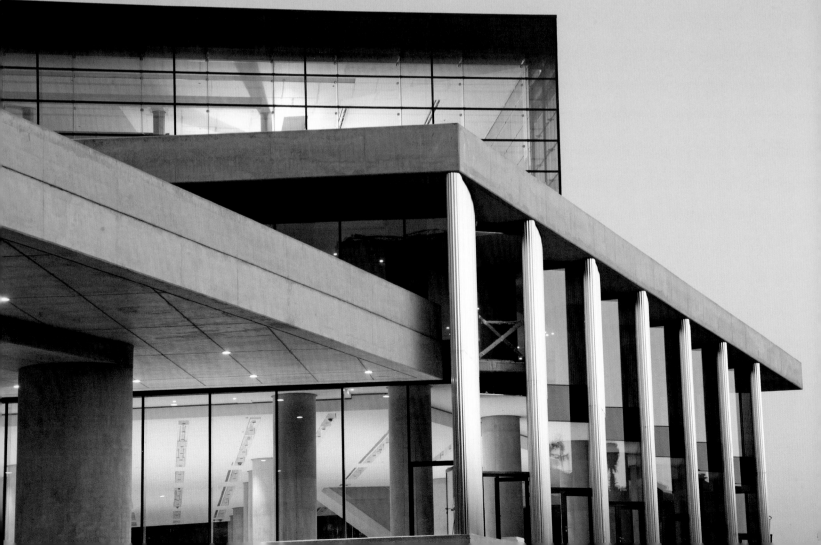

Opposite and above: Architectural details

128–29: Under the entrance canopy at dusk

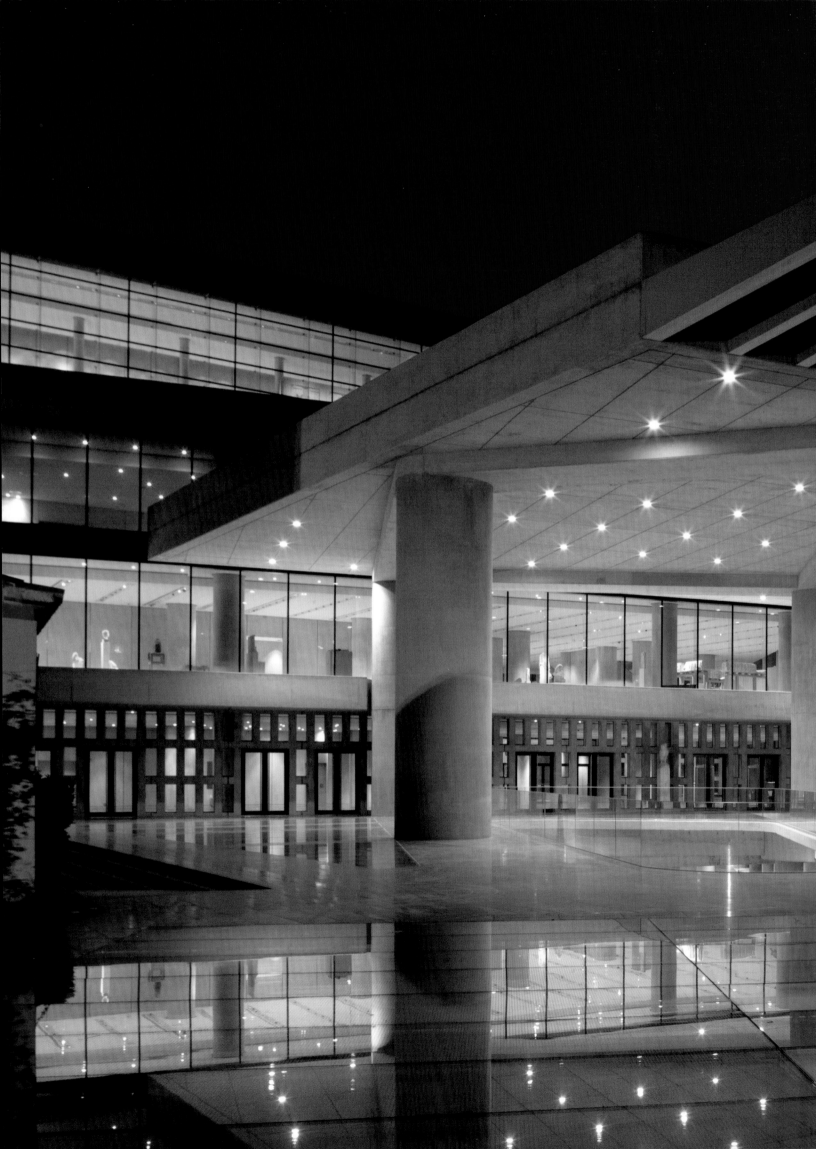

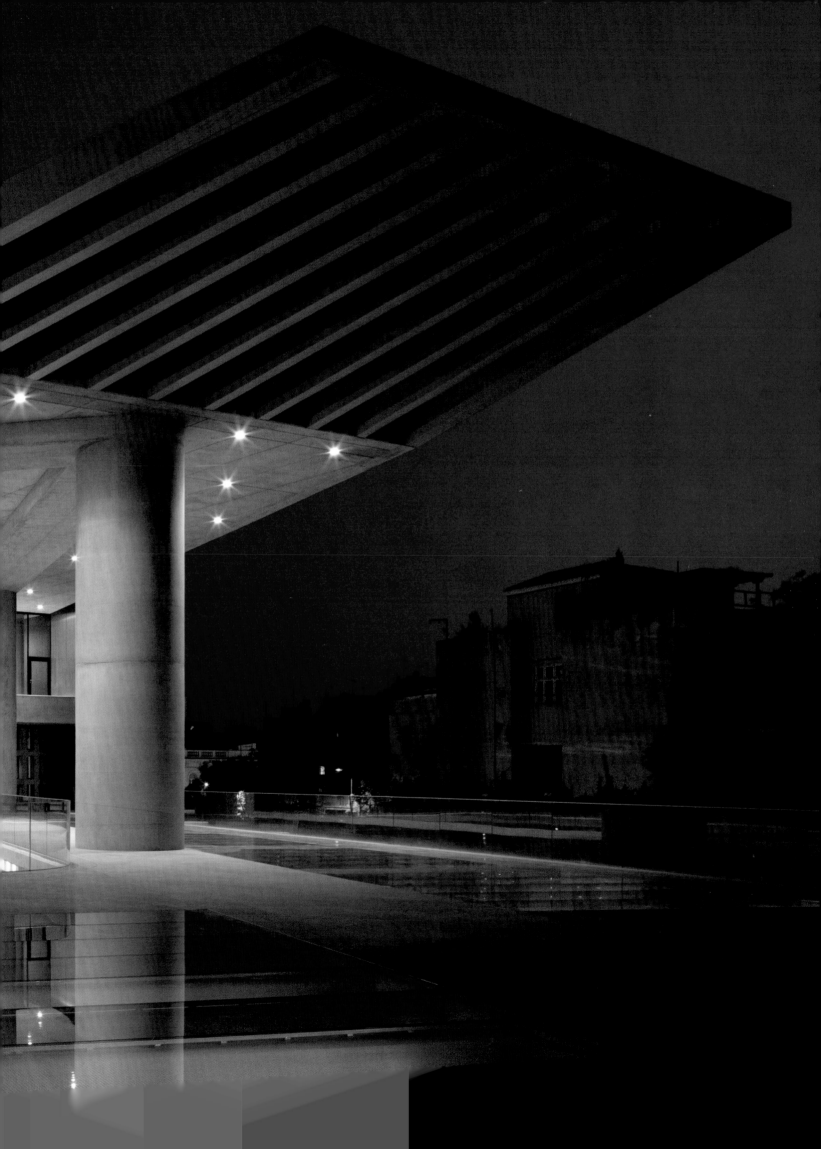

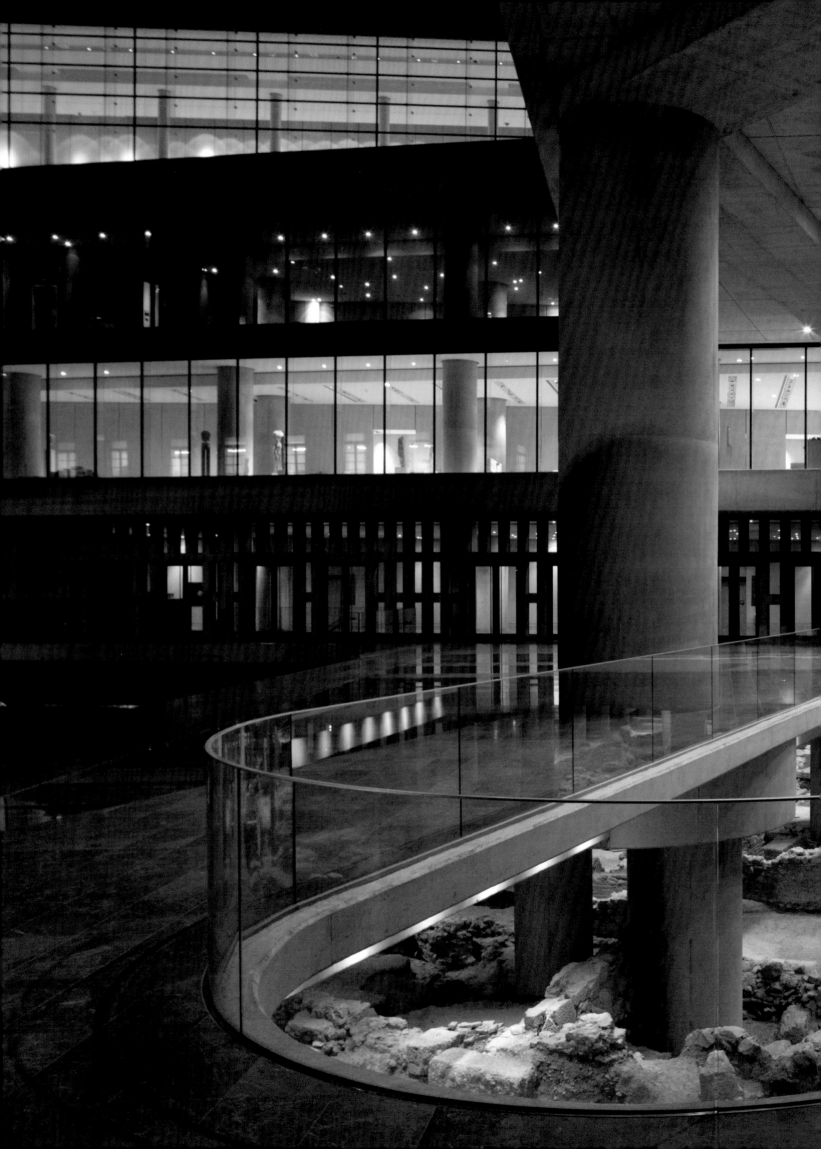

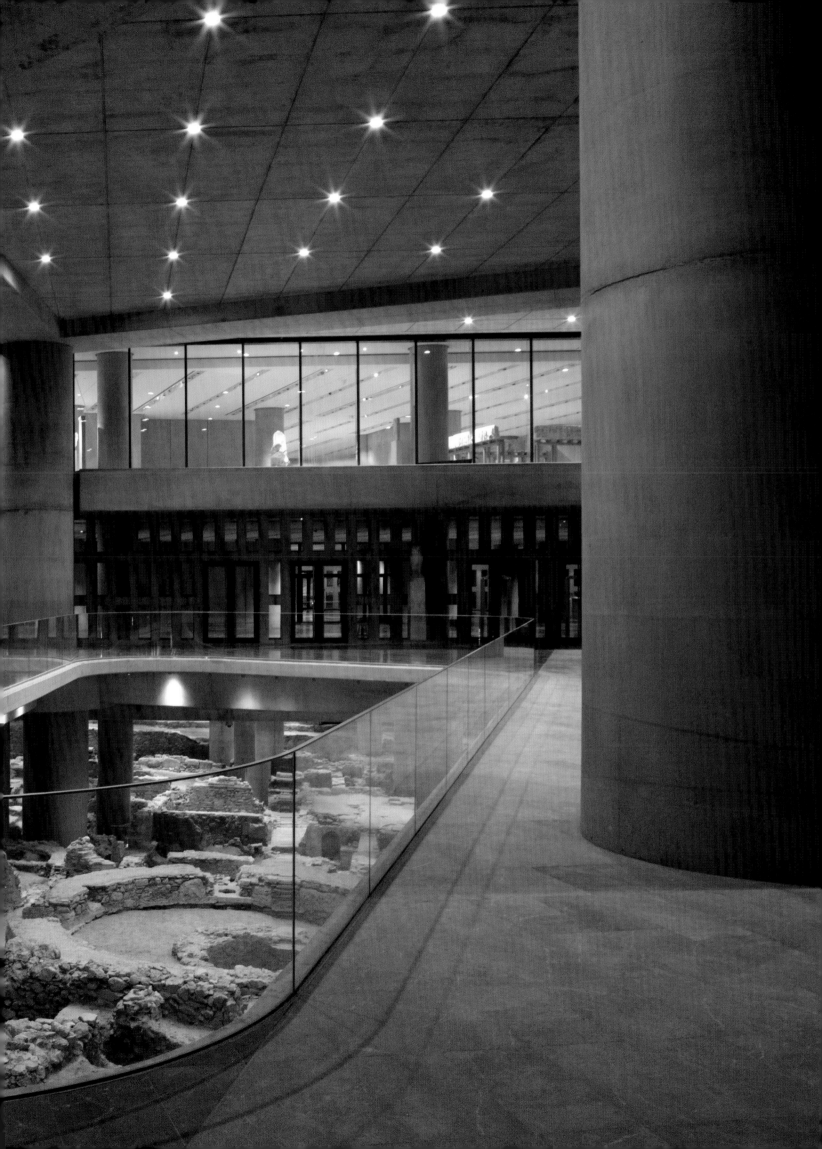

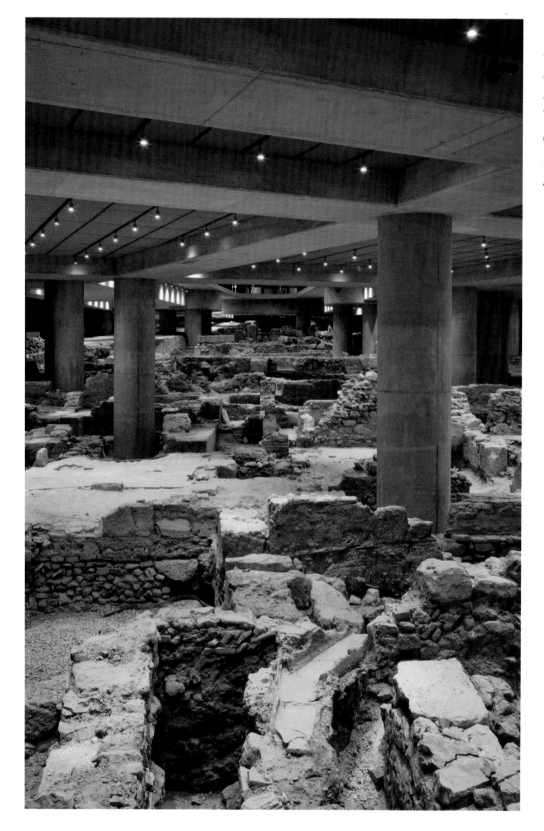

130–31: Night view of the entrance showing a detail of the glass railings around the excavations

The archaeological excavations are lit at night to allow late visitors glimpses of the excavations.

Opposite: The entrance at night

134–35: The Museum and the Acropolis, seen together

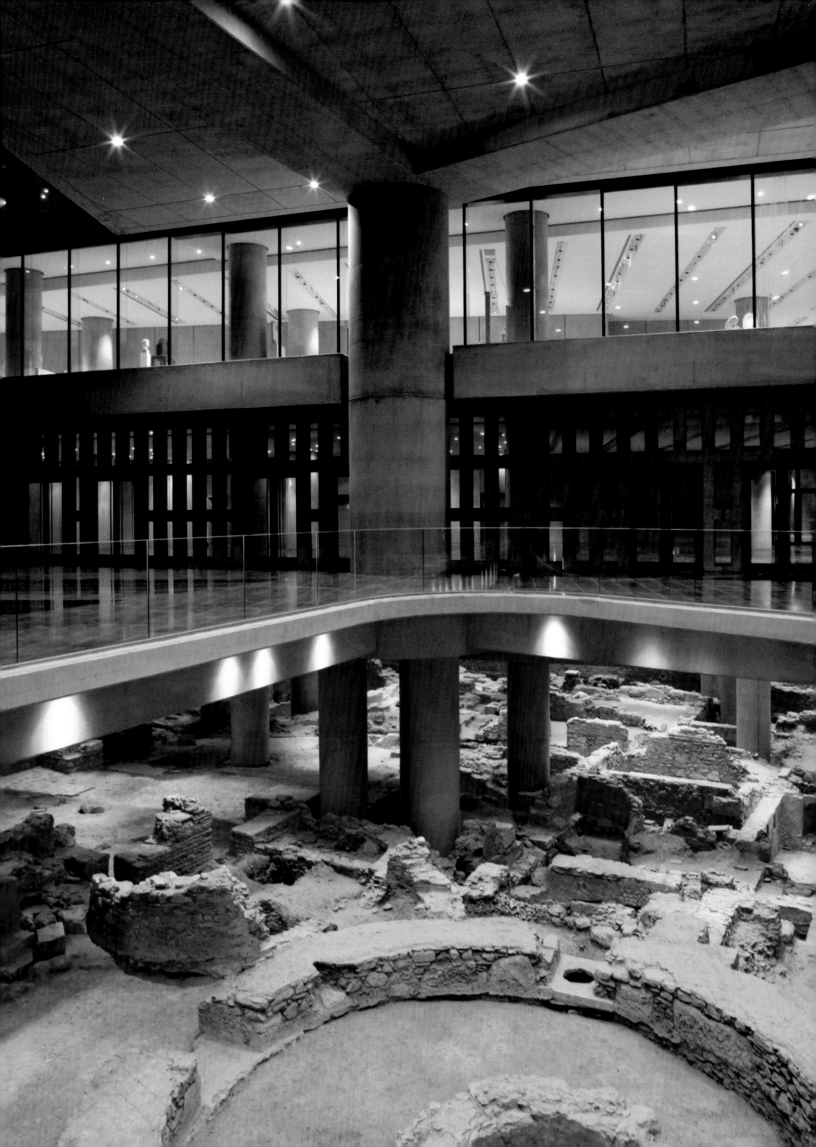

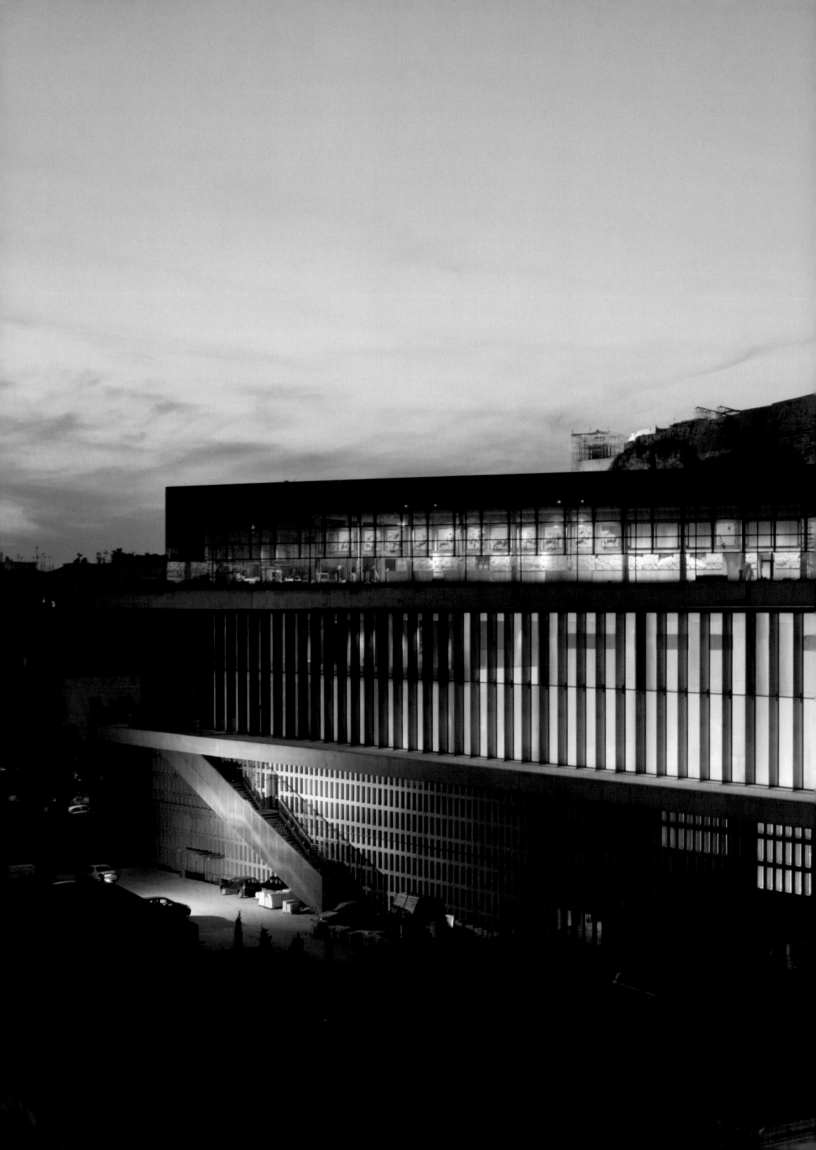

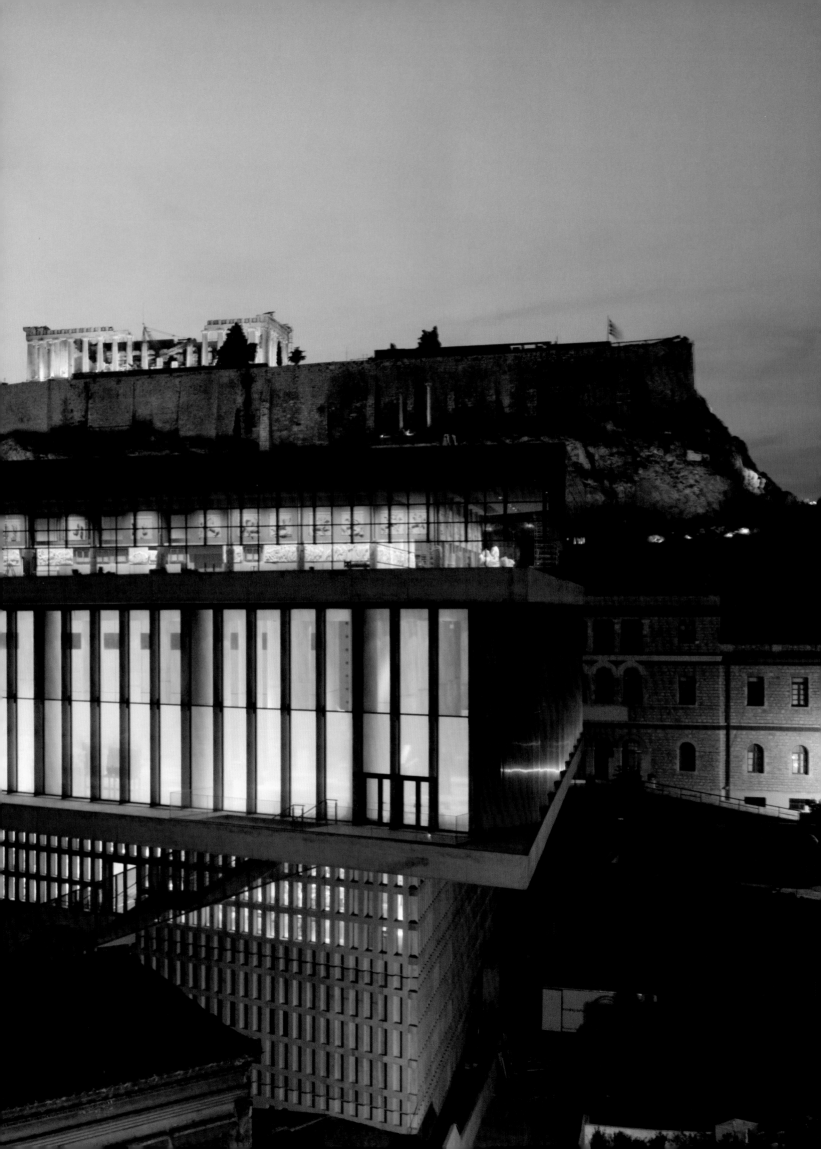

An Architectural Chronology of the New Acropolis Museum

Joel Rutten

Spring 2000

Bernard Tschumi receives a fax from Philippos Photiadis, who previously worked in the New York office of Bernard Tschumi Architects (BTA), asking if he would be interested in heading a team for the design competition for the New Acropolis Museum in association with Philippos's father, Greek architect Michael Photiadis of ARSY, Athens.

23 November 2000

Following the launch of the competition by the Minister of Culture, Evangelos Venizelos, twelve competitors are selected: Bernard Tschumi / ARSY - Michael Photiadis; Daniel Libeskind / D+L. Potiropoulos; Meletitiki / Alexandros N. Tombazis; Ahrend Burton & Koralek; Arata Isozaki & Associates / Mete Sysm SA; A66 / Antonakakis; Schweger & Partners; G. Tsiomis / G. Andreadis / Wilmotte; E. & K Skroumbelos / L. Vikelas / MEAS Ltd. / S. Vokos / P. Petrakopoulos / E. Digonis; GMP Von Gerkan, Marg architects, Doxiades Office; APEX Technical Designs SA / Pedro Ramirez Vasquez / Augusto F. Alvarez / Idea Associados; and Plias / Dem. Diamatopoulos.

BTA is the lead architect. In Athens, M. Photiadis of ARSY (MPA) has put together a team with the Greek engineering firms ADK, MMB, and Michaniki Geostatiki, led by Michael Aronis of ADK. BTA brings in the engineering firm Arup-New York. I become the project architect, with a particular interest since my wife, Kriti Siderakis, is of Greek descent.

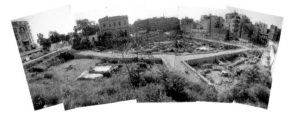

The Museum site before construction, showing partial excavations

10 May 2001

The competition program is sent to all competitors. BTA begins testing alternatives for the site and discovers that its extreme constraints will require clockwork-like precision to arrive at a strong concept while meeting all requirements, particularly respecting the valuable archaeological remnants on more than two-thirds of the site.

May–June 2001

Early on, the design concept shows the building raised up over the excavations on pilotis. A series of options is explored to integrate the many site constraints, which include managing the surrounding buildings and incorporating a mandatory setback from the nearby subway station. By early June the Parthenon Gallery has been placed at the top level and parallel to the existing temple so as to provide a view from the Gallery to the Acropolis and to establish a dialogue with the Parthenon and the city of Athens. The Gallery has proportions similar to the Parthenon. The Parthenon Frieze, depicting the Panathenaia, a religious procession dedicated to the goddess Athena, is wrapped around the core so as to retain the same linear narrative as on the original cella. As the scheme evolves, the facade of the Gallery becomes glazed so as to fulfill the dialogue between the Frieze and the Acropolis expressed in the design concept. The other exhibition galleries find their place between the excavation layer and the Parthenon Gallery.

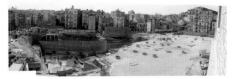

Before construction, archaeological remnants were preserved by a system of tarps and gravel so that construction could take place above without damaging them. Holes were maintained for future columns through pipes embedded in the gravel.

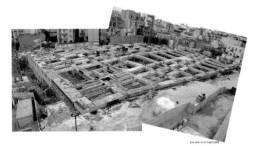

The lower part of the Museum is fixed into the earth for seismic reasons.

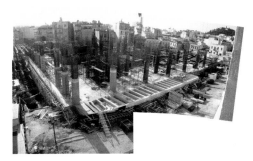

A second, independent structural system floats above the fixed foundation. Columns are heavily reinforced to ensure integrity during an earthquake.

138–39: The excavations during construction. The columns for the foundations touch the ground in select places so as to preserve the archaeological remnants and views to them from different parts of the Museum.

July 2001

After attempts to locate vertical circulation on the west side of the building, we establish a more encompassing circuit through the whole Museum that reflects the chronological progression from the Archaic period to classical and back down through the Roman and early Byzantine periods. At the center, an atrium brings light into the heart of the entire project. Two parallel linear cores (which are technical stabilizing elements) become the support. At the end of July, Leo Argiris of Arup introduces the idea of a "base isolation system," a specific anti-seismic system to insulate the building from earthquake movements on the ground. The structural engineer Natalis Petrovitch is brought onto the team to work with Nikos Marinos of ADK.

10 August 2001

Submission of competition proposal after final adjustments and coordination with Nikos Bakalbassis, who manages the project for MPA. The constraints have played to our advantage and the concept is clear, but we do not actually expect to win.

10 September 2001

The selection jury, presided over by Professor Dimitrios Pandermalis, archaeologist and President of the Organization for the Construction of the New Acropolis Museum (OCNAM), meets. We are selected as competition winners, but the results will be officially announced only later.

11 September 2001

The morning after the selection, we arrive at the office enjoying our victory. But 8:46 a.m. brings 9-11 to New York.

8 October 2001

Official announcement of the jury decision

October–December 2001

The project team organizes itself between New York and Athens as well as Paris (Hugh Dutton and Associates as glass consultant) and London (Arup as lighting consultant). Reporting on the issues to BTA in New York, George Kriparacos, project manager for MPA, will coordinate and participate in all meetings in Athens until 2006.

28 November 2001

As President of the Museum, Professor Pandermalis becomes a driving force in the project's development, traveling to New York almost every other month for meetings at the BTA office. He proves to have a rare understanding of contemporary architecture, enriched by his expertise in archaeology. At the first New York meeting, the exact height and position of the Parthenon Frieze in the topmost gallery and the relationship of the Frieze to the metopes are discussed at length in order to secure optimum viewing conditions. We decide to put skylights in the roof so as to provide natural zenithal light to illuminate the relief of the marble sculptures.

20 December 2001

As we locate columns to support the roof of the Parthenon Gallery between the core walls and the facade, Tschumi suggests placing the columns at the exact same distance from the Frieze and with the same number and rhythm as in the Parthenon itself. From this moment on, the whole structure of the Museum gallery becomes regulated by the rhythm of the Parthenon.

In a discussion with Professor Pandermalis in New York, we begin to develop the idea of a ramp between the cores in the atrium to give greater fluidity to the public route from the lobby to the Archaic Gallery. This ramp will contain the finds from the Acropolis slopes. In the following months several variations with landings, stairs, platforms, and counter-ramps will be studied.

Beginning of preliminary design.

First meeting, according to specialty. At the end of the day, a table with everyone included provides a synthesis of the progress. Tschumi, Professor Pander-

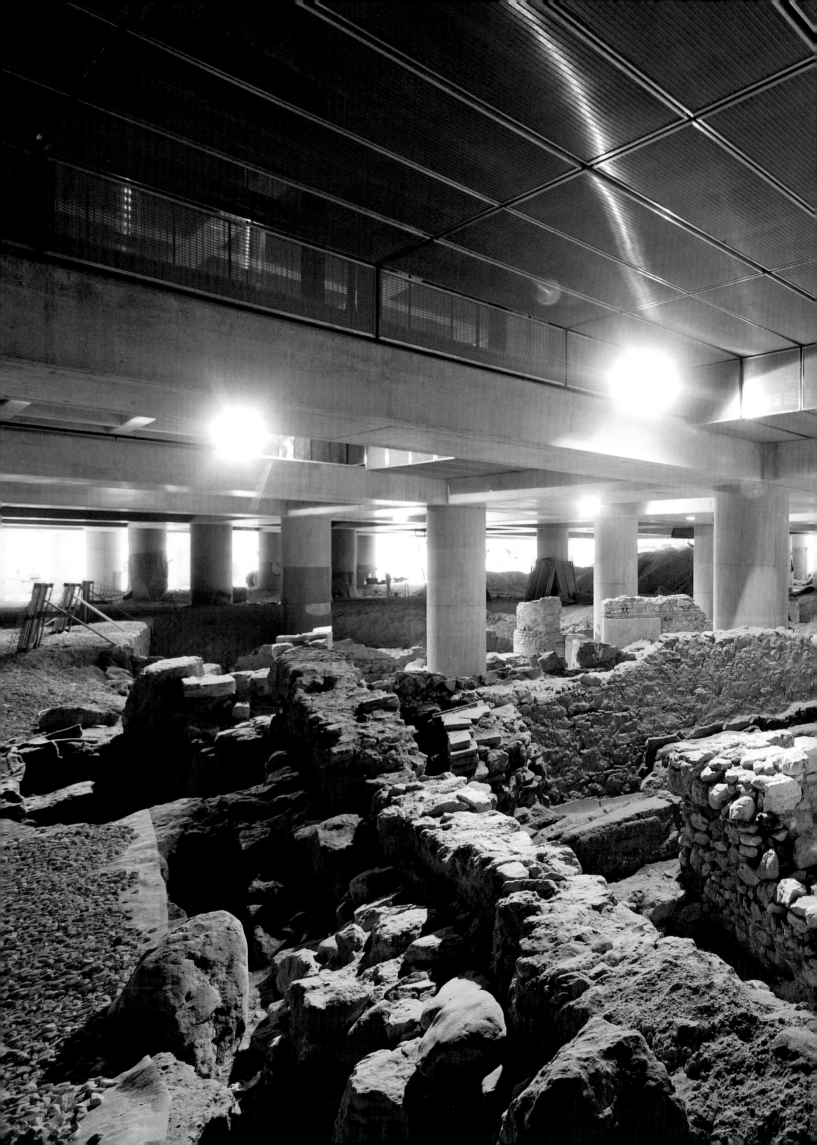

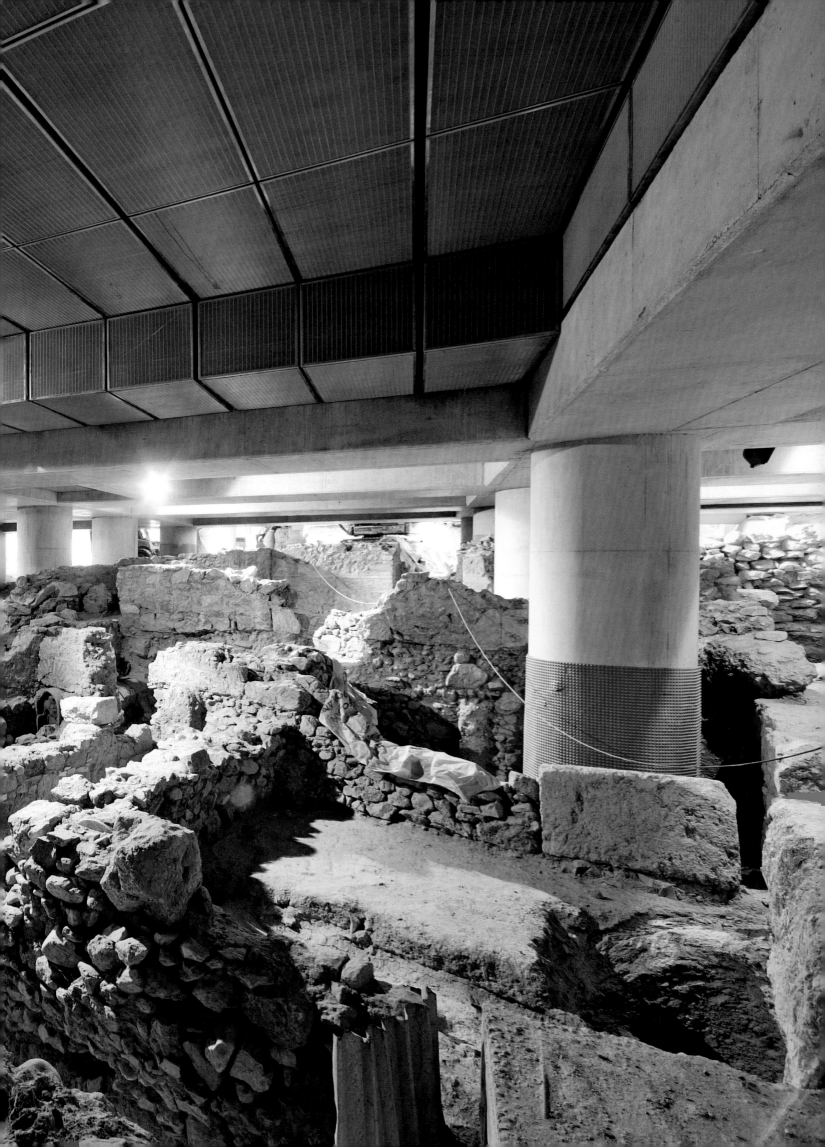

The columns are poured with absolute precision. Since there are no partition walls in the galleries, it was important to prepare every structural element with the precision of the future gallery space.

The hypostyle Archaic Gallery during construction

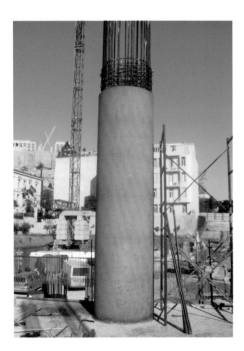

The concrete is especially smooth and homogenous. Care was taken to preserve the purity of the surface, including a sandblasting process on the steel formwork that removed irregularities.

malis, and the team of site archeologists walk for hours among the ruins on the site, methodically locating the exact placement of the structure and structural grid so as to avoid destroying precious artifacts uncovered in the excavations. After touring the site and realizing a pattern in the locations where columns are acceptable to the archaeologists, we return to the meeting room where, using a laptop computer, we rotate the plans of the lower and middle sections of the building. The strategy works well.

We remain close to our original competition entry in order to avoid potential lawsuits from other competitors.

From this point on, the structural and mechanical studies are led by Arup in coordination with BTA in New York and ADK in Athens. Structurally innovative solutions are proposed to resolve complex problems, including placing two-thirds of the building on pilotis and interrupting the cores above ground so as to anchor the building while protecting the excavations. Arup develops a strategy to avoid vertical expansion joints (which ordinarily cut buildings into two or three pieces with 2 to 3 cm-wide bands). In working out the details of the base isolation system proposed by Arup, ADK adjusts the plans to conform to a new Greek seismic code that ADK had helped elaborate.

February 2002
After studying different variations, the entrance canopy size and structure are finalized: it will be supported by only three large "pylons" placed to fit within the limited available area among the excavations, generating a spectacular cantilever.

The facade of the base is developed: among multiple options (glazed, open, wall with windows, and so on), we decide on a protective screen or claustra made out of precast concrete in order to wrap the excavations and the Museum services under one skin. The screen is open onto the excavations, penetrated by air, and glass-sealed where it passes in front of offices.

While studying different options for the public entrance to the Parthenon Gallery, Tschumi discovers an interesting "breach": the procession of the Frieze is interrupted by missing segments that were destroyed in the explosion of the Parthenon in 1687, when the temple was used as a cache for gunpowder by the Ottomans. This gap provides an ideal entrance to the Gallery, allowing it to be accessed from the center of the building rather than the periphery.

While analyzing the penetration of sun through the skylight located at the center of the Parthenon Gallery, it becomes apparent that light could be brought all the way down through the entire building to the excavations below. We therefore decide to use glass for the floors throughout this central section; the ramp has now a glass floor.

It is decided to install the Caryatids from the Erectheum on a platform overlooking the atrium. Questions arise as to which direction they should face. We eventually decide to position them facing the ramp, as if greeting the visitor in an impressive setting.

The roof of the Parthenon Gallery is designed so as to cantilever all around, removing shadows from the support structure and permitting unobstructed views to the outside. The longest cantilever reaches 9.45 meters on the west side, and the maximum deflection calculated for wind, rain, snow, and / or earthquakes indicates that the roof can move up to 80 mm vertically. (The deflection will eventually be reduced to 30 mm.) This movement will need to be controlled by the engineering of the glass facade.

March 2002
Because we wish to use glass that is as clear as possible and because Tschumi insists against undesirable green tints or strong reflections, we begin to research low-iron glass as well as silkscreen-dot technologies that filter light without adding colors or other unwanted effects.

The Parthenon Gallery facade is challenging because we want to maintain the maximum transparency in order to provide natural light for the sculptures and a direct view to the Acropolis as well as Athens' hills, mountains, and the distant port city of Piraeus. Standing in the gallery should feel almost like standing at the top of the Acropolis. Professor Pandermalis shares our concern that the sculptures and the Frieze be seen in the same orientation and unique Attic light as originally intended. To achieve this, we need to convince not only OCNAM and its consultants, but also our own consultants and associates, that there is an energy-conscious solution to the problem using the most up-to-date technology in glass and climate control. On return from Athens, we explore alternatives with Arup, eventually concluding that the success of the concept demands a transparent facade. With Arup and Hugh Dutton of HDA (who formally joins the team in March), BTA explores options and contacts specialist glass manufacturers.

The eventual solution consists of a double-glazed layer that is silkscreened with a gradient of black dots so as to control heat gain and glare, designed with a 70 cm gap for a roller blind and a layer of single glass starting two meters above the floor so that air can be evacuated from the Gallery. Since the inside air is climate-controlled and stays cool in relation to the temperature of the glass, the facade is cooled and bright light is filtered out. Lastly, a chilled water system located in the gallery floor distributes a comfortable environment throughout the space.

The next challenge involves keeping the glass facade as discreet and uncluttered as possible, using limited metal fixings so as to avoid cast shadows and interruptions in the views to the Parthenon. The system developed with HDA uses tension rods to suspend the large panes from the roof, glass fins to stabilize the facade against wind, and small stainless steel pins to tie the panes together.

Various marbles are tested for the floors; we also address the question of colors for the sculpture bases as well as the walls and columns. Our aim is to avoid sharp contrasts and over-designed elements so as not to distract attention from the art. The floor colors will also be used to delineate between galleries and circulation zones.

19 March 2002
The preliminary design is submitted to insure that the ambitious deadline of opening the Museum in time for the 2004 Olympic Games can be met.

26 March 2002
Presentation of the preliminary design scheme to Minister of Culture Evangelos Venizelos, the Central Archaeological Council (KAS), and an audience of the general public. An animated scene erupts: the audience is divided as to the location of the Museum on the site, with some people objecting to placing the Museum on top of the excavations. During this period Professor Pandermalis will be asked to testify in numerous court cases against the construction of the Museum.

17 April 2002
In a section revision, the ceiling height in the excavation areas is increased as much as possible.

Mid-April 2002
Approval of preliminary design and beginning of final design

June 2002
BTA develops a strategy for the Museum ceilings: all technical equipment will be recessed in parallel straight channels so as to mask the equipment's presence and achieve the least visual disturbance possible.

9 July 2002
Archaeological remains on the southwest side of the site force us to reduce the basement area, a change with significant structural implications. The piloti concept allows for relatively easy adjustment to the new conditions even if it

A mock-up of the seismic bearings

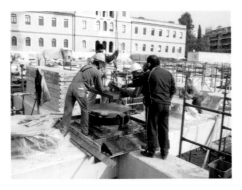
The actual seismic bearings during installation

is difficult for the structural engineers to integrate them. Heated discussions ensue over whether to preserve the ruins and hence extend the area on pilotis, or keep the basement as large as possible, as per the structural engineers' wishes. We eventually convince everyone that respecting the needs of the archaeologists coincidentally improves the project by opening up the space of the excavations.

July 2002

Plans for the different architectural, structural, and mechanical components are coordinated while hundreds of details are still evolving. The design is refined: for example, stairs leading from the lobby to the Archaic Gallery level are removed because they duplicate the ramp over the slope excavation. This clarifies and simplifies the sequence of the Museum visit. Similarly, the organizing principle for the skylights in the Archaic Gallery is finalized. The solution will bring just enough Attic light onto the sculptures while keeping the design simple and minimal.

Natural and artificial lighting are refined in order to provide optimal illumination for objects of many different sizes and circumstances, from large-scale freestanding sculptures to small vases in display cases.

The columns in the Parthenon Gallery are reduced to the minimum possible diameter.

Attention is paid to the enormous concerns raised by building in an earthquake zone. During an earthquake, the building can move 15 cm horizontally and 5 cm vertically. A movement joint between the entrance bridge and the Museum is 30 cm wide. Because the base isolation system is located in the foundations under ground level, large gaps running around the building and each column appear necessary. This generates problems for which a radical solution will be developed only later on.

Each column or wall that the engineers want to add provokes resistance: the archaeologists want to preserve all the excavations while the architects want to avoid clutter in the galleries. After months of studies, the structural engineers eventually approve the removal of huge shear walls in the middle of the Archaic Gallery, keeping the space totally open. However, to counteract the building's tendency to "rotate" due to the absence of base walls on its northwest side (reflecting the presence of on-going excavations), we position a new slab or "diaphragm" in the atrium between the two cores. The resulting space becomes a reading lounge.

The almost 9-meter cantilevered slabs are made out of prestressed concrete, and some have to be specially sized and shaped in order to admit ducts that bring cooled air into the Parthenon Gallery without increasing the overall depth of the slab. This requires precise coordination among the architects, ADK, and MMB.

Fire escape stairs that were initially located in the Archaic Gallery are now pushed outside along the south facade in order to reduce clutter.

Because the roof functions as a "fifth facade," visible from the Acropolis, attention is focused on keeping it free of chimneys and technical equipment.

16 July 2002

After elaborate studies by BTA, Arup, and HDA to develop a facade strategy for the Parthenon Gallery that conforms to our concept, Arup's calculations confirm the validity of the solution. Development of details and research on high-performance glass continues.

8 August 2002

Submission of final design

9 September 2002

Approval of final design

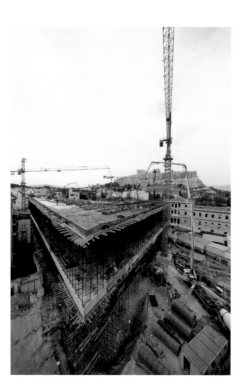

A view showing the concrete formwork

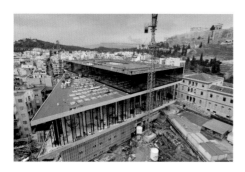

In order to allow daylight to enter the Museum, the structure is pushed to the building core so as to maintain the maximum transparency of the exterior walls.

Opposite: A truck lifted onto the roof in order to pour concrete for the upper parts of the Museum.

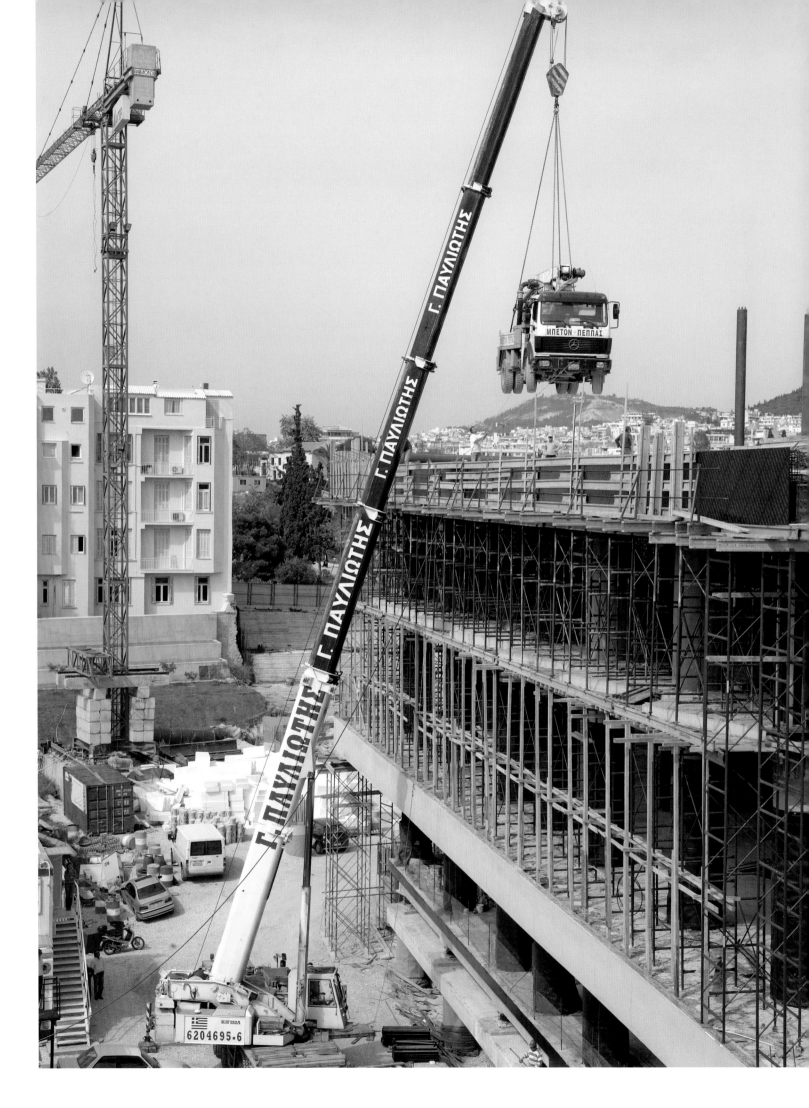

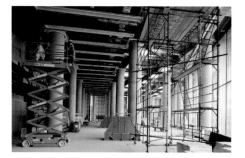

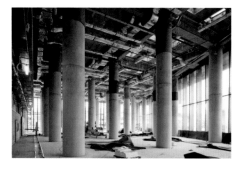

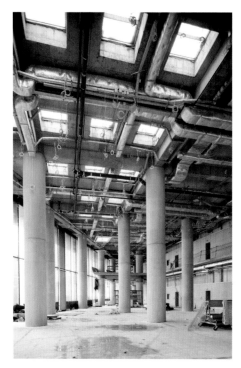

Views of the Archaic Gallery during construction

11 September 2002
Greek authorities redefine the protected archaeological area (the "red zone") by extending it into the middle of the site.

9 October 2002
The basement, structure, and foundations of the Museum have to be modified to accommodate the new "red zone" area. While the architecture is able to adapt to, and even improve from, the change, the size of the base of the Museum is nevertheless reduced and the engineering of the whole structure becomes even more difficult to calculate: the area of the building supported by pilotis is now more than half the size of the basement, without counting the entrance canopy. This development is particularly challenging in a seismic zone.

In addition, in order to protect the excavations, the overall structural principle of the building is changed: to avoid 30 cm gaps in the ground around each wall and column, the base isolation seismic system is lifted just above ground, thereby separating the Museum from its base. In consequence, the elevators and stairs will have to be adjusted so as to accommodate 15 cm horizontal seismic movements.

5 November 2002
Resubmission of the preliminary structural design first submitted in January 2002 in order to take into account changes due to new archaeological finds

20 November 2002
Meeting of the KAS. The modified project is well received by the archaeologists.

January 2003
Submission of revised final design and building permit

17 February 2003
Approval of revised final design integrating archaeological finds

6 March 2003
Opening of exhibition on the New Acropolis Museum at the Onassis Cultural Center in New York. The completed drawings by BTA are presented to the public for the first time, along with an animation.

12 March 2003
The Economist organizes an international conference in Athens on the Museum and the reunification of the Parthenon Marbles.

30 March 2003
Bidding for the construction of the retaining walls and excavation for the foundation of the Museum's basements begins.

10 April 2003
Decision to pursue an accelerated process for construction documents: the time given to develop this phase of the architectural studies is significantly reduced in order to meet the ambitious schedule of finishing in time for the Olympic Games.

May 2003
We adapt the cores to better integrate the differing thicknesses between the various pieces of the Frieze. The segments in Greece are 60 cm thick, while those in the British Museum—cut by Lord Elgin for easier transportation—are 20 cm thick.

The glass fins placed on the south glass facade of the Archaic Gallery for wind-load resistance are relocated outside so as to keep the Gallery as minimal as possible. By adding a silkscreened dot pattern, the fins provide shading during low morning and evening sun. The facade details are again kept discreet, simple, and visually untechnological.

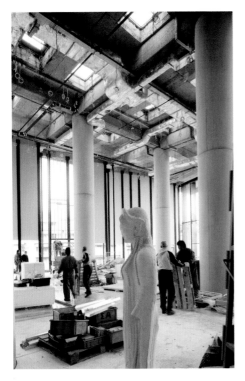

A replica statue basks in natural light at an early stage of construction.

Fixtures, electric lighting, and sprinklers are recessed to keep the ceiling as unobtrusive as possible.

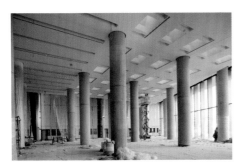

The Archaic Gallery nearing completion

146–47: The facade of the Parthenon Gallery is double-glazed for climatic reasons. The second, interior wall of glass begins above eye level to maximize the clarity of views to the Acropolis and the city.

27 June 2003
Submission of full construction documents, which include client remarks

4 July 2003
Bidding is launched. The brief calls for a lump-sum price bid that also includes the necessary detailed design.

16 July 2003
The Council of State asks for additional documents before ruling on the Museum.

29 July 2003
The Council of State rejects as "groundless" a claim against OCNAM from local residents and ICOMOS (International Council on Monuments and Sites) demanding suspension of work on the Museum.

July–August 2003
The excavations are covered with geotextiles and gravel for protection during construction. Digging of foundations in the nonarchaeological zone begins.

7 August 2003
ICOMOS appeals the ruling by the Council of State.

12 August 2003
Submission of bids by general contractors

2 September 2003
Opening of the bids after the legal qualification revision period. The lowest-bidding construction company, ALTE, is declared the "provisional" winner of the bid. Concerns immediately arise as to the company's ability to complete the job due to its fragile financial state.

October 2003
The site is now entirely covered with gravel to protect the excavations. Concrete tubes are embedded to maintain ground access at the locations of each column.

7 October 2003
Opening of the exhibition *Marbles Reunited* in London. The British Museum's strong rejection of the return of the Parthenon Marbles makes press headlines.

19 October 2003
Prime Minister Costas Simitis reminds British Prime Minister Tony Blair of Greece's desire for the Marbles' reunification at a meeting of the E.U. in Brussels.

21 November 2003
The Council of State rules the approval of preliminary design for the Museum unconstitutional. However, this judgment is still based on the initial preliminary design submission that did not include subsequently discovered excavations. The ruling is appealed on December 5.

11 December 2003
The building permit is submitted to Parliament.

January 2004
With pouring of the leveling concrete mat for the foundations, the contract for the retaining walls and the excavation is concluded.

12 January 2004
A poll indicates that 80 percent of British subjects support the return of the Parthenon Marbles to Greece.

18 January 2004
An article in the *New York Times* by Fred Bernstein presents the Museum project and discusses the polemic surrounding the Parthenon Marbles.

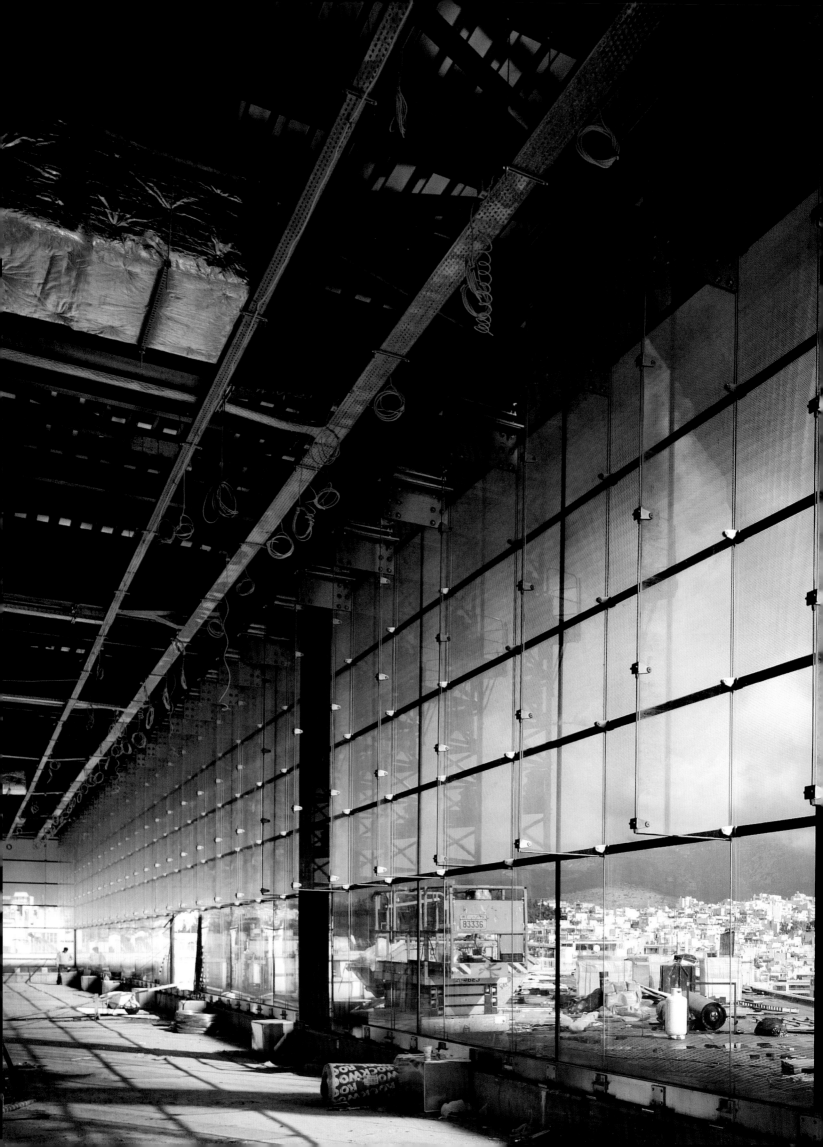

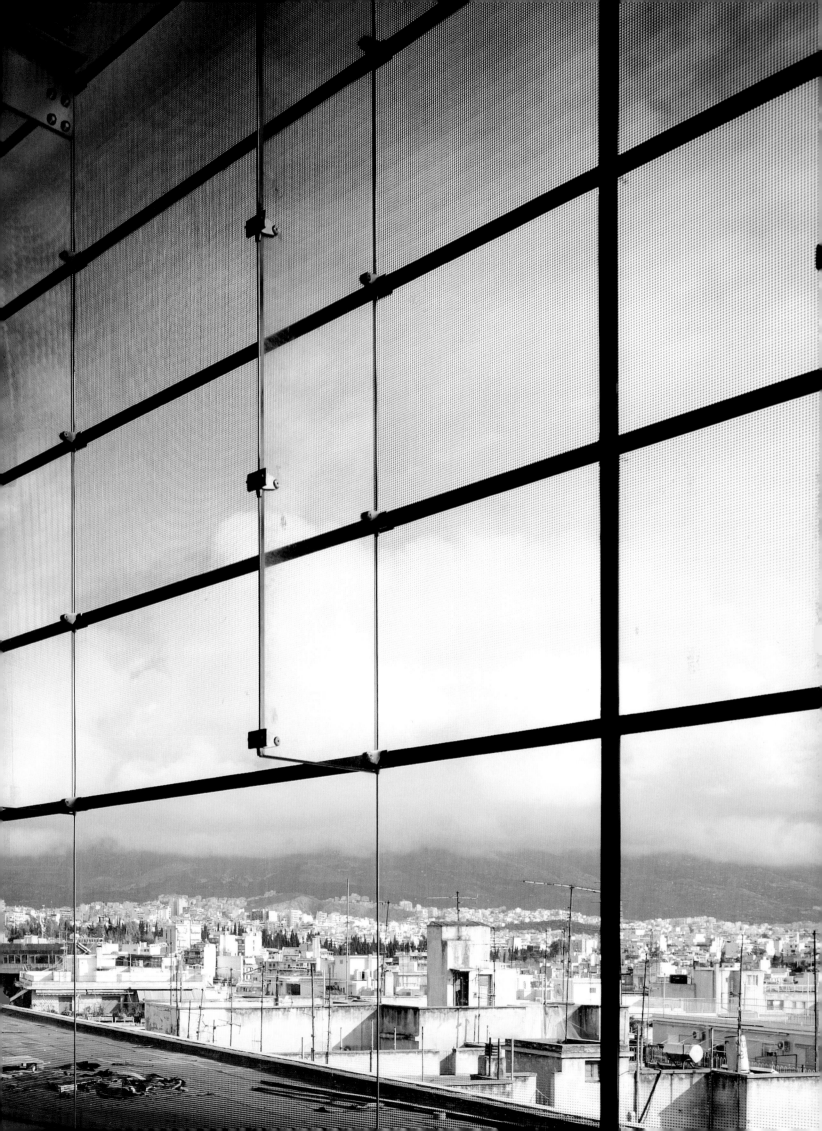

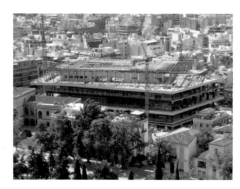

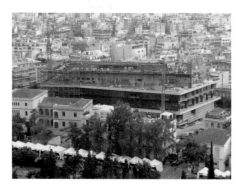

Views of construction from the Acropolis

22 January 2004
Conversation between Minister for Foreign Affairs George Papandreou and Tony Blair about the reunification of the Marbles

6 March 2004
In general elections, the ruling government of Prime Minister Costas Simitis (PASOK) is replaced by the New Democracy candidate Costas Karamanlis. The new Prime Minister names himself Minister of Culture so as to emphasize the priority given to the Olympic Games, which will open in late summer. Petros Tatoulis is named Deputy Minister of Culture.

10 March 2004
The Council of State demands suspension of construction until the second appeal is completed.

11 March 2004
A senior prosecutor orders that criminal charges be brought against officials in the Ministry of Culture who approved the Museum project. A Supreme Court deputy prosecutor asks an Athenian prosecutor to press charges for breach of duty against the committee that awarded the contract to the architects, the Central Archaeological Council, which approved the project, and all those implicated in the process, including the architects.

12 March 2004
Former Minister of Culture Venizelos and film director and actor Jules Dassin defend the Museum project on Greek television. With his wife, Melina Mercouri (1920–1994), a former Minister of Culture under the PASOK government and a renowned actress, Dassin had advocated forcefully for the return of the Parthenon Marbles to Greece.

20 March 2004
The Council of State dismisses claims from local residents and ICOMOS that the Museum project would damage excavations. The Athenian prosecutor still presses charges for breach of duty against almost everyone involved in NAM.

7 April 2004
After a meeting between Jules Dassin, Costas Karamanlis, and Petros Tatoulis, the Government issues assurances that it is committed to the construction of the Museum on its current site as planned.

August 2004
The Olympic Games are held in Athens.

November 2004
The construction contract is signed with ALTE. The contractor appoints its Detailed Design team, consisting of the MEAS of Petros Petrakopoulos and METRON of Kostis Skroumbelos as architects, Kostas Liontos as structural engineer, and Yannis Papagrigorakis as services engineer.

21 December 2004
Meeting of the new Board of Directors of OCNAM and re-launching of construction

7 February 2005
Kick-off meeting of the new supervision team of OCNAM, headed by Nicos Damalitis, a civil engineer and member of the Board of Directors with many years of experience in important public projects

February–March 2005
Studies for the design of the entrance canopy and bridge to adjust to new constraints posed by the excavations. These require a shift from the pylons to a cluster of three columns, which Tschumi refers to as "the tripartite order" after the Doric, Ionic, and Corinthian orders.

Studies of detailing of the glass envelope are pursued with prospective subcontractors. The height of the base isolation system is re-examined, resulting in minor but nevertheless complex adjustments to the overall project.

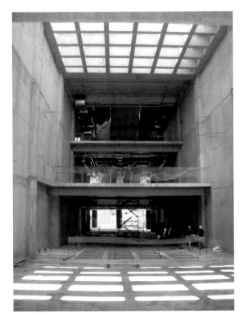

The decision to have a skylit core can be appreciated even at an early stage of construction.

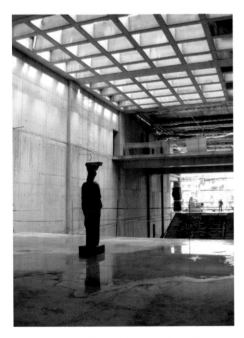

A replica of a Caryatid supervises the construction process.

March 2005
Concrete for the second basement level is poured.

May 2005
The basement concrete structure is almost complete.

June 2005
Financial problems force the suspension of the contractor, ALTE, from the Athens stock market. Work is suspended. Minister of Culture Tatoulis meets to find ways to advance work on the Museum.

August 2005
A new general contractor with excellent qualifications and experience, AKTOR, the country's largest construction firm, is named to replace ALTE, which is nearing bankruptcy and has accumulated unpaid taxes. Although AKTOR had participated in the bidding with a considerably higher bid, it agrees to maintain ALTE's contractual terms, including the lump-sum price, thus acknowledging the national priority of the Museum construction. AKTOR brings a team of excellent engineers and foremen to the site, and work restarts immediately.

A mock-up for the precast concrete facade screen (claustra), as previously executed, is reviewed.

September 2005
AKTOR decides to keep the existing Detailed Design team, with the addition of TEAM MEP, headed by Stavros Livadas, as leading services engineers. Their work is coordinated by Leonidas Pakas, AKTOR's Project Manager, a skilled and experienced architect.

October–November 2005
Seismic isolation system pieces are installed at the intersection of every beam, above each column.

November–December 2005
First discussions with Eckelt Glas, the Austrian glass facade subcontractor appointed by AKTOR. Different options to achieve the maximum performance level of the glass, including low-e coatings with minimal coloration, are compared. Mock-ups for glass, stainless steel, and fritting are reviewed on site. This will be the first of numerous sets of mock-ups by AKTOR throughout construction that allow the architects to review, test, and adjust details in a way rarely possible on other projects. Technical details for all glass work are re-examined: for example, because the panels of the Parthenon Gallery facade are suspended, the bottom detail allows for a 50 mm+ vertical movement of the whole facade, due to deflections in the roof's cantilever, while still providing horizontal stiffness for wind resistance.

December 2005
Exploration of solutions to reduce greenish tints in the glass resulting from the overall thickness of the glass layers. Tschumi makes a special trip to London on December 20 to visit a building with a type of glass recommended by Eckelt.

Construction begins on the upper part of the Museum, which includes all public spaces. The quality of the exposed concrete is monitored closely, particularly given the difficulties posed by the many steel reinforcement bars needed for earthquake resistance. Special care is given to achieving smooth seams. Tschumi insists on a specific quality: a relatively even but soft texture that will provide a non-competitive background for the marble sculptures. In addition, the concrete must absorb light while the marble reflects it. To achieve the best possible results AKTOR asks ARUP Materials to consult on the merits of fair-faced precast and cast *in situ* concrete as well as the selection of the appropriate subcontractor for manufacturing the precast panels.

All of 2006
The contractor produces hundreds of shop details that are discussed and reviewed for approval by BTA and the client. OCNAM asks BTA to continue

Installation of the stainless steel fins

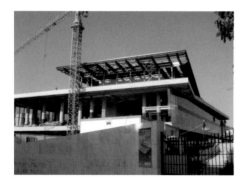

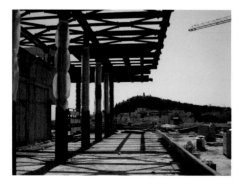

View of the Parthenon Gallery
demonstrating the roof cantilever and the
open facade before glazing

supervision of the development and finalization of all construction details. I visit the site regularly and communicate constantly with the AKTOR team, especially the architect Kostis Skroumbelos, and with Eckelt, Dutton (HDA), Arup, and other consultants. Tschumi flies to Athens every month to discuss and approve different mock-ups and prototypes. Professor Pandermalis participates in all meetings, along with Leonidas Pakas. During these meetings, thoughtful dialogue between Tschumi and Pandermalis, with the participation of all involved parties, allows complicated issues to be addressed with a calm rare on construction sites.

January 2006

Final analyses of the thermal performance of the Parthenon Gallery glass confirm that the enclosure will provide the necessary comfort level. Different glass types are still being reviewed according to their respective transparency.

Precast concrete panels for the Museum interior are still being detailed; while their general dimensions are standardized, a number of panels require adjustments to accommodate specific technical and geometric constraints.

31 January 2006

A full-size, seven-meter-tall mock-up of the fritted glass for the Parthenon Gallery facade is presented on site.

February 2006

Marble floor samples are reviewed. Based on initial research by M. Photiadis, who provided dozens of samples, AKTOR supplies a wide range of marble types with different colors and local provenances. Marble under consideration for the floors includes a large selection of white, beige, and black types from nearby regions. The architects opt for a marble whose provenance would make it historically correct. Finally, local "Helicon" marble is selected. All gallery floors will be a light beige that veers toward white, while the floors of non-gallery spaces will be black.

BTA tests options for the design of the stainless steel fins on the east and west of the Museum and chooses a wavy panel that evokes references to the cannelation of classical Greek columns while retaining a contemporary appearance.

14 February 2006

Simulations of the glass facades for the Archaic and Parthenon Galleries are reviewed by Tschumi and Dutton and successfully tested in a specialized facility in Birmingham, England. The performance tests cover water, wind, earthquakes, and high-impact breakage. For the last test, a facade fragment is brought to its breaking point, which occurs only after an elevated number of hits.

15 February 2006

A new Minister of Culture, Georgios Voulgarakis, replaces Kostas Karamanlis and his Deputy Minister of Culture, Petros Tatoulis.

March 2006

As the building takes shape, we discover surprising new views when walking through the construction site. Because of a breathtaking view down to the Archaic Gallery now visible from Level +2, we decided to adapt it into a promenade by opening a long, continuous window in the precast concrete wall overlooking the gallery.

The large quantities of glass, concrete, and other hard surfaces make us fear that the inner court located at the building's center will act as an echo chamber. We try to determine the optimal dimensions and number of holes in the precast concrete to act as acoustical absorbers. Additionally, adjustments in the transparent glass floor and stair areas are determined on site.

April 2006

For the glass stairs at the end of the ramp we decide on a stainless steel detail for the vertical segment of the steps, dismissing exposed concrete as

too busy-looking. In the meantime, a worldwide shortage of stainless steel, partially caused by a construction boom in China, imposes three-month delays as well as a price increase for the east and west fins. Design and technical simplifications keep the problem under control, but it will remain a topic of discussion until well into June.

New archaeological finds uncovered at the entrance of the site near Dionysiou Areopagitou, the pedestrian area unifying the Museum with the Acropolis, put archeologists at work alongside construction workers.

May 2006
Glazing of the facades begins from the north side of Level +1.

12 June 2006
The United Nations adopts a "cultural property returns" resolution, initiated by Greece, which asks for the return or restitution of cultural property to countries of origin.

July 2006
First adjustments of detailing for the light channels located in the exhibition gallery ceilings. Tests will be on-going and mock-ups installed until September.

The concrete structure of the building is completed.

August 2006
Glazing of the Parthenon Gallery begins.

September 2006
Construction of the marble floors of the galleries begins. It will prove one of the most difficult jobs for the contractor due to the very low percentage of the selected quarry's production that matches the approved samples and the vast continuous surfaces to be covered.

Construction begins on the concrete structure of the entrance canopy.

5 September 2006
The University of Heidelberg, Germany returns a small fragment of a foot from the Parthenon Frieze.

October 2006
The question of how to represent parts of the Frieze currently at the British Museum in the Parthenon Gallery leads to exploration of the idea of "veiled" plaster-cast simulations.

Principles related to the use of natural and artificial lighting, including specific lighting for sculptures, are reviewed and fine-tuned on site. The type of spotlight is chosen and the ceiling light channels are dimensioned precisely around it.

November 2006
Display cases in the atrium are re-dimensioned to provide more wall surface for sculptures. The metal frame system into which the frieze blocks are slid is designed to allow several-millimeter adjustments for works whose weight averages one ton each.

15 December 2006
Presentation in Athens to the Museum Council of the Ministry of Culture on the theme "Museum Architecture and Its Impact on Urban Environments and Quality of Life."

December 2006
Revisions of mock-ups for rolling blinds whose large size requires delicate and minimized details that can be concealed as much as possible

Final dimensioning of the light channels enables the go-ahead for ceiling construction.

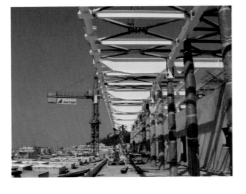
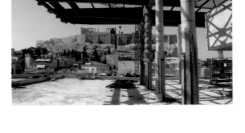
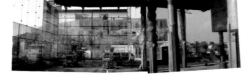

Several views showing the engineering and construction of the suspended glass facade of the Parthenon Gallery

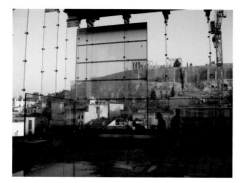

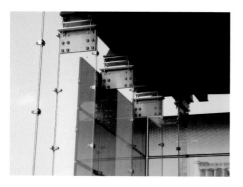

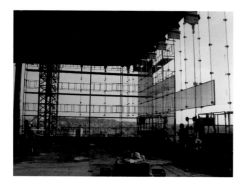

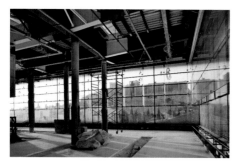

The suspended facade during installation. There are 348 individual glass panels in the facade.

Opposite: The Parthenon Gallery is surrounded by glass, but also has a recessed skylight to illuminate the Frieze.

The concrete structure of the entrance canopy is completed.

January 2007
Revisions with AKTOR of details for built-in furniture and sculpture bases, all of which must be simple marble structures.

Discussions continue as to the visitors' route through the excavation.

31 January 2007
In Athens, two hundred students wearing orange jackets form a human chain in a protest demanding the return of those segments of the Parthenon Marble currently in London.

February 2007
Numerous prototypes and tests are developed to determine how best to display the missing Parthenon Marble sections, should they not be returned by the British Museum. From holograms to thin veils positioned in front of replicas, every possible option is investigated. The skylights located above the Frieze in the Parthenon Gallery ceiling are simplified to hide all fixtures and appear very abstract from below.

March 2007
Construction drawings for the east and west stainless steel fins are approved after numerous studies aimed at simplifying the design, keeping costs low, and accommodating interior display cases.

29 March 2007
A gold sculptural wreath and a statue of a woman are returned to Greece by the Getty Museum in Los Angeles. Greece's Prime Minister takes the opportunity to reiterate Greece's claim for the return of the Parthenon Marbles before the international press.

April 2007
Studies are conducted on how to assure the stability of the sculptures in the event of earthquakes, particularly since bases are still planned for the metopes. Small metal anchors are designed to be as unobtrusive as possible.

Because OCNAM wishes for the Parthenon Gallery skylights to admit as much daylight as possible, different types of translucent panels are explored.

May 2007
OCNAM asks Tschumi to design a shade device for the terrace.

June 2007
Further investigations of skylight details in the Parthenon Gallery aimed at providing screens without blocking light. Individual mock-ups allow alternatives to be tested directly on site in real conditions of light and space.

10 June 2007
A demonstration in front of the Museum about three buildings situated at the northwest corner of the site on the Dionysiou Areopagitou points to a Greek paradox: some historians and archeologists wish to relocate the buildings so as to restore the historical and visual continuity of the excavations under the Museum with the ruins on the slope leading to the Acropolis, while preservationists aim to save a 1930s Art Deco–style building.

2 July 2007
The old Acropolis Museum is closed in order to begin transfer of sculptures to the new one.

11 July 2007
A meeting at the Ministry of Culture with the Museum board, architectural organizations, and journalists about the three contested buildings

19 July 2007
Presentation of the New Acropolis Museum to selected press in New York

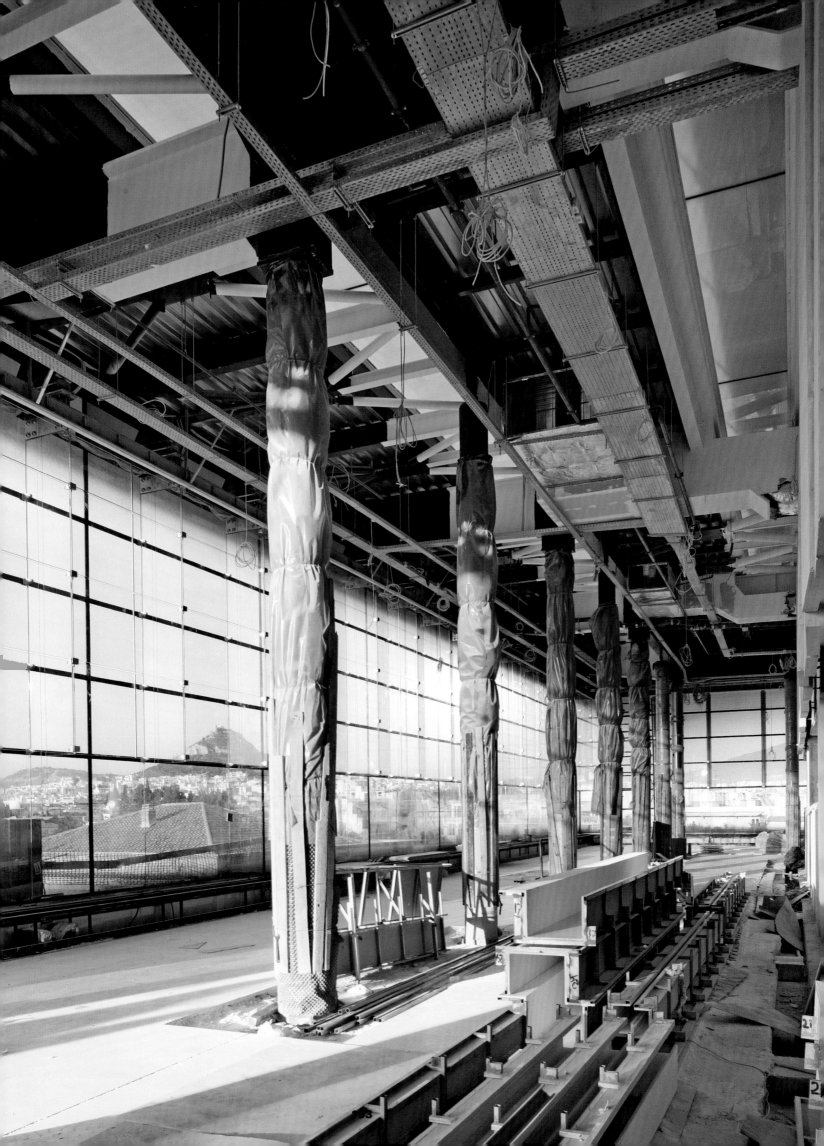

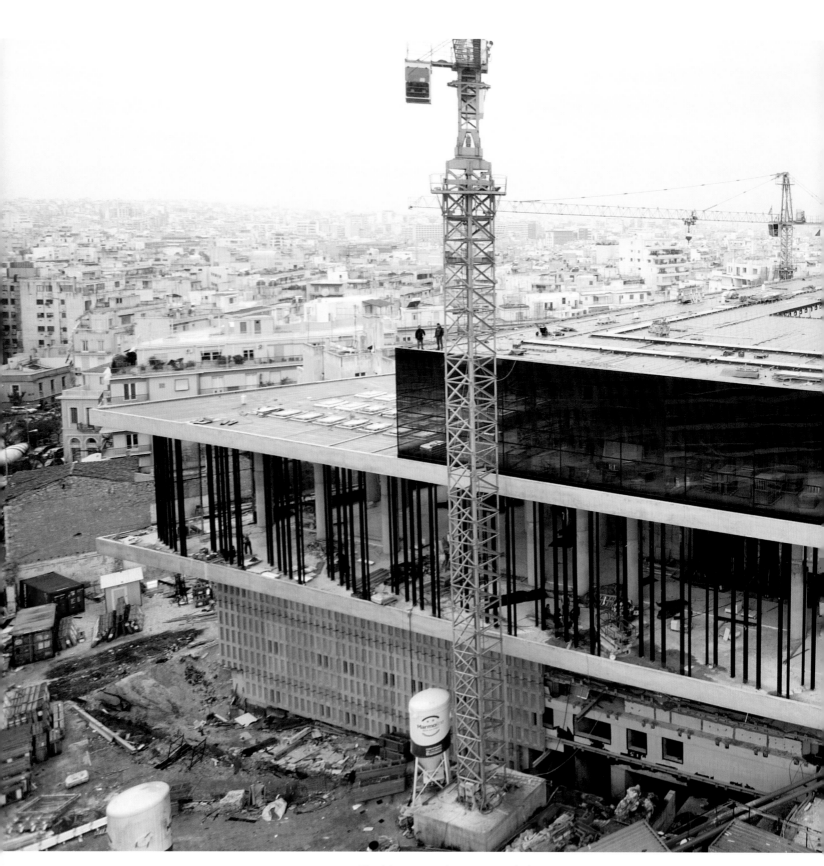

The Museum as it nears completion,
viewed from the east

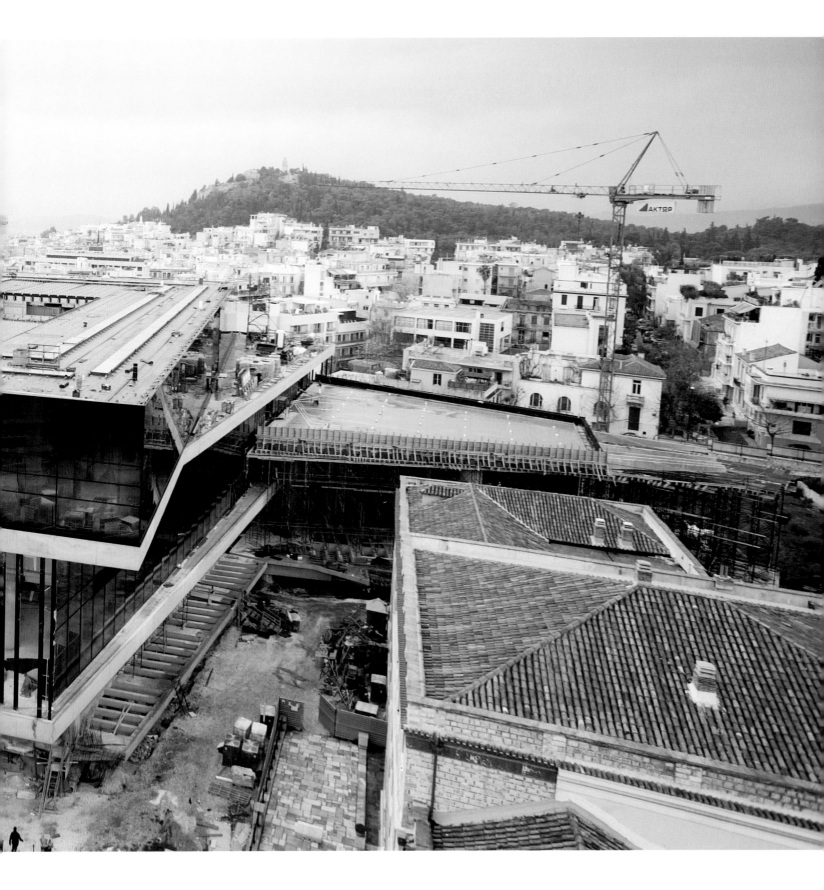

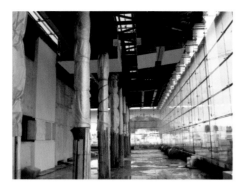

A mock-up of an exhibition strategy stands out during construction.

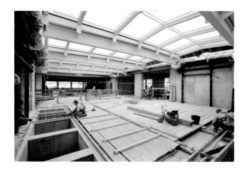

The circulation space in the building core on Level +3 inside the Parthenon Gallery

Glass ceilings

August 2007
Greece is the victim of some of the worst forest fires in the nation's history. The fires themselves create strong political turbulences.

Different options for sculpture bases are explored with the aim of keeping visitors at a safe and respectful distance from the art.

AKTOR is awarded a new contract to move the artifacts to be exhibited in the Museum from the Acropolis to their new location. The whole delicate operation is designed by the Civil Engineer Kostas Zambas, an expert in the handling of very sensitive, large ancient sculptures.

16 September 2007
Greek parliamentary elections. A new Minister of Culture, Michalis Liapis, replaces Giorgios Voulgarakis.

October 2007
We study Museum signage, aiming for it to be discreet but clear and visible.

8 October 2007
A lecture by Tschumi about his architecture in general and NAM in particular to an overflow crowd at the Athens Megaron ends with a Q&A session.

14 October 2007
Transfer of the first sculptures, some weighing 2.3 tons, from the Acropolis to the new Museum. Three giant cranes are installed by AKTOR on the slopes of the Acropolis between the existing museum at the top of the hill and NAM down below. The sculptures are encased in wood crates that are passed from one crane to the other. The spectacular event is televised worldwide and reinvigorates debates in the press about the return of the Parthenon Marbles to Greece. The transfer of all 4,500 sculptures is planned to take five months, depending on weather conditions.

28 October 2007
The *New York Times* publishes a second long article by Nicolai Ouroussoff that describes the Museum as "both an enlightening meditation on the Parthenon and a mesmerizing work in its own right."

November 2007
BTA is asked to propose a design for the streets around the Museum as well as ideas to improve the surrounding neighborhood (including how to avoid typical Athenian use of balconies for gardens, birdcages, and storage).

Work on site is reviewed in order to hand over the galleries for archeologists to begin installing the sculptures.

7 November 2007
Director of the British Museum Neil MacGregor, in answer to questions by journalist Richard Lacayo (*Time*), states that a "time-limited loan" of some of the Parthenon Marbles is not off-limits if the Greek government recognizes the title of the British Museum as owner.

8 December 2007
The first original Caryatids enter the Museum and assume their place on the gallery overlooking the ramp through the atrium.

17 December 2007
British Museum spokeswoman Hanna Boulton declares that "the Acropolis Museum, although it's a great achievement ... doesn't change the [British Museum's] position."

18 December 2007
While visiting the New Acropolis Museum, Prime Minister Kostas Karamanlis calls for the return of the Parthenon Marbles.

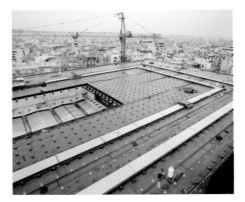

The roof is finished as cleanly as possible, without visible mechanical equipment, anticipating views from the Acropolis.

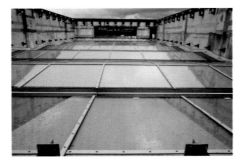

Detail of the skylights over the core

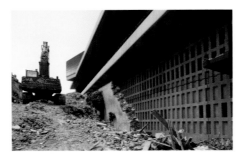

Demolition of existing buildings in anticipation of the completion of construction

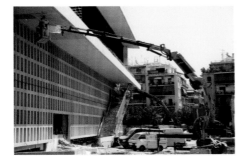

Putting the finishing touches on the south facade

21 December 2007
First opening to the public of part of the Museum for a few hours every morning. The visit affords a glimpse into the Archaic Gallery from the ramp.

January 2008
A debate among archeologists, OCNAM, and BTA on how to exhibit the metopes in the Parthenon Gallery concludes with the decision to place them high up in order for them to be seen from below, as in the original temple. With AKTOR we explore different options for elevating several tons of stone three meters above ground without changing the qualities of the Gallery.

February 2008
So as to hold the metopes at the higher level, a metal frame is designed to extend between columns in the Parthenon Gallery and tested with two full-scale on-site mockups. Attachments are concealed to avoid distraction. The height is carefully reviewed to keep the space open and views unobstructed.

27 February 2008
Opening of an exhibition displaying the New Acropolis Museum in Beijing, China

March 2008
The transportation of the artifacts from the Acropolis is concluded. The tower cranes are removed and the provisional openings left on the building facades for the ingress of the crates are closed.

2 March 2008
Artificial lighting is fine-tuned on site during a meeting with Arup.

6 March 2008
Exhibition of the New Acropolis Museum at the Pergamon in Berlin in conjunction with the traveling exhibition *Museums in the 21st Century: Concepts, Projects, Buildings*, circulated by Art Centre Basel. Presentation of the Museum before museum directors, curators, and many journalists. The Ministers of Culture and Tourism attend the opening.

11 March 2008
BTA issues a list of final changes, repairs, and work details before curators and archeologists take control of the Museum to install its collection.

17 March 2008
An international conference about the return of archaeological artifacts to their countries of origin is organized by UNESCO and held at the New Acropolis Museum.

1 April 2008
Jules Dassin, energetic advocate for the Museum, dies at the age of 96.

April-May 2008
Discussions on how to display the Parthenon Marbles currently in London increasingly favor using thin white-plaster replicas to contrast with the different-colored patina of the heavy marble-block originals. Sculptures and casts continue to be moved around the Museum galleries so as to test display strategies in real space and light.

June 2008
The results of a competition to address the back facades of the Dionysiou Areopagitou buildings are made public. Because the backs of the buildings were not intended to be exposed, most proposals attempt to hide or camouflage them. Few escape the feeling of a theatrical mask that would disfigure or ridicule the integrity of the Acropolis.

July 2008
The design for the glazed display cases is simplified. The initial glowing shelves, when tested, do not allow enough flexibility for lighting artworks.

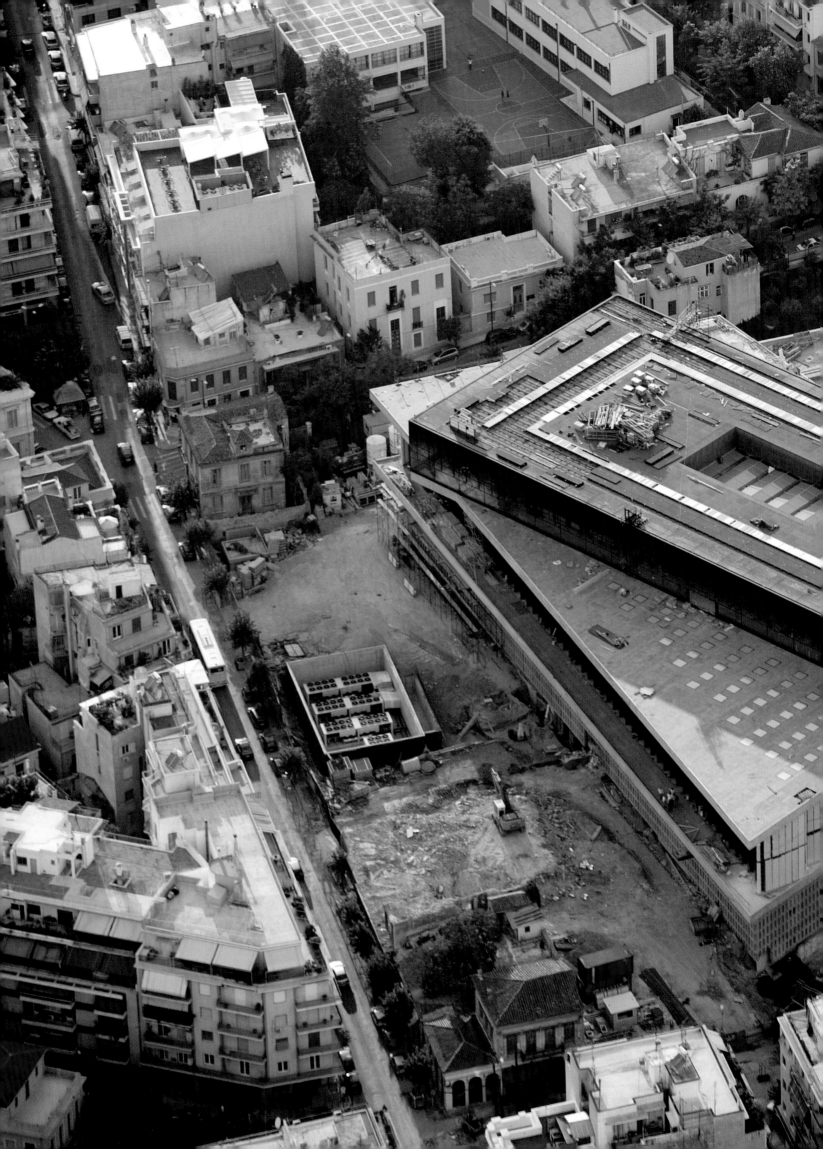

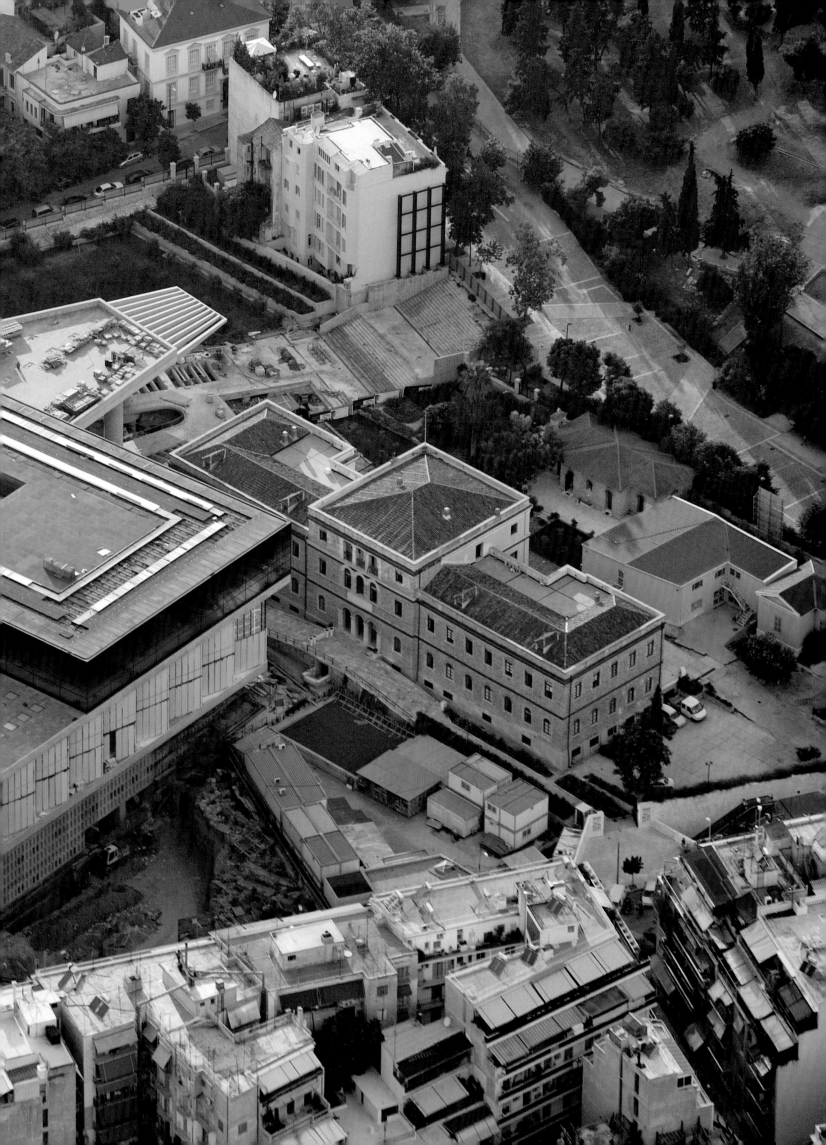

Finishing touches on the Parthenon Gallery in September 2007

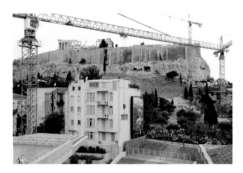

A series of three cranes transported artifacts from the old museum on the Acropolis to the new Museum in steel boxes.

Opposite: The first of the artifacts arrives on the Museum roof.

It is decided to air condition some of the display cases located inside the steel fins.

31 August 2008
A small group of pagans prays to Athena at the foot of the Acropolis, proclaiming that they do not approve of the new Museum and that the ancient sculptures should remain in the temple. Their protest is picked up in the press around the world.

24 September 2008
A fragmentary piece of the Parthenon Marbles is returned as a loan by the President of Italy at the opening of the first temporary exhibition in the Museum, *Nostoi*, showcasing more than eighty pieces illegally removed from Greece and later returned.

5 November 2008
The Vatican sends a fragment of the Parthenon Frieze to Greece.

December 2008
The final phase of the Museum budget is approved by the Ministry of Culture. An additional contract is assigned to AKTOR to design and install pedestals, showcases, frames, anchors, signage, and all other constructions required to display the exhibits. Work commences immediately.

2 December 2008
Joint lecture by Tschumi and Professor Pandermalis at the Royal Institute of British Architects (RIBA) in London. Their discussion shows the affinity between the two concerning the Museum's design and mission.

8 January 2009
A new Minister of Culture, Antonis Samaras, is named to replace Michael Liapis.

February 2009
The final design for the installation of the Museum collection is approved by the Board. The Minister of Culture announces an official opening date of June 20, 2009.

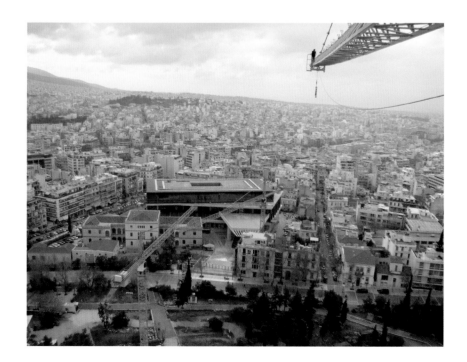

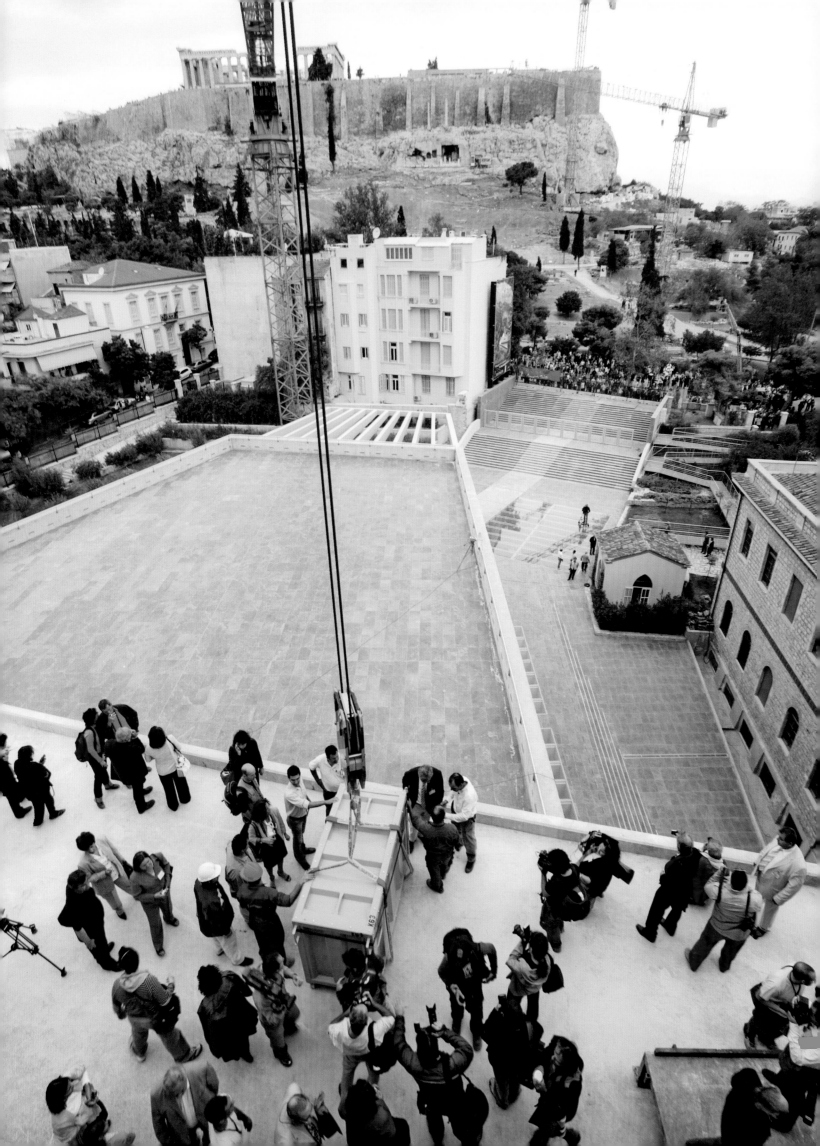

The Parthenon and the old Acropolis Museum
from the cab of a crane

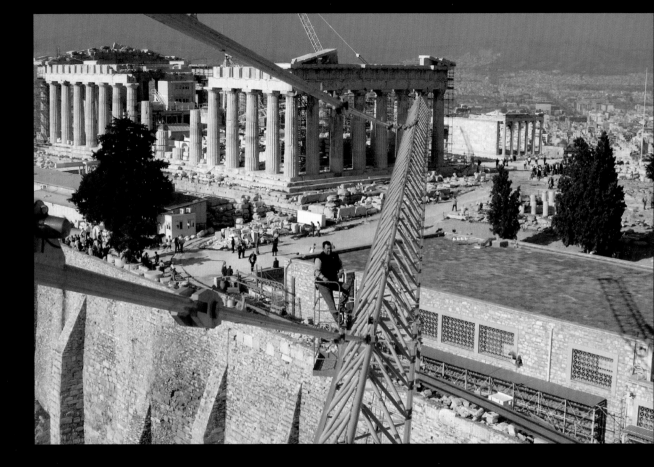

Project Credits

Project New Acropolis Museum, Athens, Greece

Site Located in the historic area of Makryianni, the Museum stands some 300 meters (980 feet) southeast of the Parthenon. The top floor (Parthenon Gallery) offers a 360-degree panoramic view of the Acropolis and modern Athens. The Museum is entered from the Dionysios Areopagitou pedestrian street, which links it to the Acropolis and other key archeological sites in Athens.

Architect Bernard Tschumi, Bernard Tschumi Architects, New York and Paris

Associate Architect Michael Photiadis, ARSY Ltd., Athens

Size 21,000 square meters (226,000 square feet) total; 14,000 square meters (150,000 square feet) of exhibition space

Construction Budget 130 million (approximately $175 million US)

Financing Construction of the Museum was co-financed by the Hellenic Republic and the European Regional Development Fund (ERDF)

Schedule *Architect announcement:* September 2001
Groundbreaking: September 2003
Building completion: September 2007
Limited public viewing of installation: January 2008
Public opening: 20 June 2009

Museum Mission To house all the surviving antiquities from the Acropolis within a single museum of international stature, located directly across from the Acropolis itself

Program With exhibition space of more than 14,000 square meters (150,000 square feet) and a full range of modern visitor amenities, the New Acropolis Museum tells the complete story of life on the Athenian Acropolis and its surroundings. It unites collections that are currently dispersed in multiple institutions, including the old Acropolis Museum (built in the nineteenth century, with gallery space of 1,450 square meters, or 15,500 square feet).

The rich collections provide visitors with a comprehensive picture of the human presence on the Acropolis, from prehistoric times through late antiquity. Integral to this program is the display of an archeological excavation on the site of the Museum itself: ruins from the fourth through seventh centuries A.D., left intact and protected beneath the building and made visible through the first floor.

Other program facilities include a 200-seat auditorium.

Grounds The Museum is surrounded by 7,000 square meters (75,000 square feet) of landscaped green space.

Amenities The Museum offers a café overlooking the archeological excavation, a museum store, and a museum restaurant, with a public terrace commanding views of the Acropolis. The Museum is fully accessible to people with physical disabilities.

Client Organization for the Construction of the New Acropolis Museum
Professor Dimitrios Pandermalis, President

Technical Supervision Team:
Nikolaos Damalitis, Civil Engineer, Director
Th. Voudiclaris, K. Karagiorgos, G. Tsangarakis, A. Kouerini, M. Chrisoulaki,
E. Kottis, D. Papanikolaou, D. Iliadakis

Archeological Team:
Dimitrios Pandermalis, Alkestis Choremi, Alexandros Mantis,
Christina Vlassopoulou, Stamatia Elrftheratou, Nicoletta Saraga

Coordinator:
Niki Dollis

Project Team, Bernard Tschumi Architects, New York and Paris
Bernard Tschumi, Architect and Lead Designer
Joel Rutten, Project Architect

Adam Dayem, Aristotelis Dimitrakopoulos, Jane Kim, Eva Sopeoglou,
Kim Starr, Anne Save de Beaurecueil, Jonathan Chace, Robert Holton,
Valentin Bontjes van Beek, Liz Kim, Daniel Holguin, Kriti Siderakis, Michaela
Metcalfe, Justin Moore, Joel Aviles, Georgia Papadavid, Allis Chee, Thomas
Goodwill, Véronique Descharrières, Christina Devizzi

Project Team, ARSY Associate Architect, Athens
Michael Photiadis, Principal
George Kriparakos, Nikos Balkalbassis, Philippos Photiadis, Jaimie Peel,
Niki Plevri, Maria Sarafidou, Makis Grivas, Elena Voutsina,
Manoulis Economou, Anastassia Gianou, Miltiadis Lazaridis, Dimitris Kosmas

General Contractor AKTOR S.A., Athens
Leonidas Pakas, Project Manager
Stathis Antonopoulos, Site Manager

Site Engineers: Iokim Pringipakis, Tassos Dafnis, Sylvia Tsitziloni, Areti
Zournatzi, Hara Lazaridou, Argyris Kambouropoulos, George Kremalis

Contractor's Design Team:
Architects: METRON, Kostis Skroumbelos, Principal; Daniel Pittman
MEAS, Petros Petrakopoulos, Principal
Structural Engineer: Kostas Liontos
Services Engineers: TEAM MEP, Stavros Livadas, Principal
Yannis Papagrigorakis
Acoustics Consultant: Theodoros Timagenis
Glass Structures Engineer: MDE, Austria, Wilfried Minniberger, Principal

Consultants *Structure:* ADK: Michael Aronis, N. Marinos, Natalis Petrovitch
Arup, New York: Leo Agiris, Raymond Queen, Brian Steby

Mechanical and Electrical: MMB Study Group S.A.: P. Maris, Nick Stavropoulos
Arup, New York
Civil: Michanniki Geostatiki
Arup, New York
Lighting: Arup, London: Florence Lam
Glass: Hugh Dutton Associates (HDA), Paris: Hugh Dutton

Photography Credits